PREFACE

As an educator, I have had the good fortune to both teach and learn from imagemakers worldwide. Thanks to their support, Photographic Global Notes is the only publication of its kind. Truly a global effort, it is available in six languages in over 36 countries. Reflecting each photographer's unique talents and methods, it provides a rare look into the studios of the world's leading photographers. Photographic Global Notes is possible because these photographers willingly shared their vision in hopes of making our industry stronger for tomorrow.

Dean Collins

Photographic Global Notes is designed to keep photographers up-to-date on the contemporary photographic techniques used by international photographers and how they use Kodak Professional Products for the best results. Global Notes, available worldwide through a variety of distribution channels, is available to Kodak ProPassport Professional Network Members at a special price. ProPassport offers not only information on Kodak Professional Products but also significant benefits for members via seminars, publications, "800" number for technical support and hotel/ shipping discounts. To obtain membership information, please write or fax:

ProPassport Network, Eastman Kodak Company, 343 State Street, Rochester N.Y. 14650-0405, Department GN-DC. Fax: USA 716-724-5629 or contact your local Kodak representative.

Text Copyright© 1994 by Photographic Global Notes, ISSN (1063-4606) Published by Dean Collins Productions, San Diego California, USA, co-published by Silver Pixel Press, a Division of The Saunders Group, Rochester, N.Y. USA, all rights reserved.

PRO PASSPORT™

KODAK Professional Network

·PHOTOGRAPHIC·
GLOBAL NOTES
Volumes 1 & 2 · A Dean Collins Production

Volume 1 ©1992 • Volume 2 ©1993

Volumes 1 & 2 ©1994

Published in the United States of America by:

DEAN COLLINS PRODUCTIONS

7515 Metropolitan Dr.
Suite 403
San Diego, CA
USA 92108-4403
Fax 619-543-9962

Co-published by:

SILVER PIXEL PRESS

Division of:
The Saunders Group
21 Jet View Drive
Rochester NY
USA 14624
Fax 716-328-5078

International
Coordination by:

7515 Metropolitan Dr.
Suite 403
San Diego, CA
USA 92108-4403
Fax 619-543-9962

Concept / Executive Producer:
DEAN COLLINS

Inernational Production Coordinator:
ELEANOR RATTRAY

Written by:
TIM MANTOANI

Graphic Design:
GARY BURNS / Burns Design Assoc.
San Diego, CA • 619-543-9951

Book Cover Design:
MARIO MACARI / Marcari
USA • 414-425-1741

Editorial Assistance:
CURRIE SILVER, BRAD DANITZ,
MICHAEL DOMINGO

Graphic & Illustration Assistants:
KIM PICHON, JOHN SHIRELING,
BRETT O'CONNELL

CONTENTS

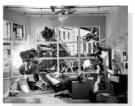

Jay P. Morgan

Eddie Adams

Dean Collins

Dan Lim

John Street

Annemarie & Peter Schudel

CONTENTS

Tim Whitehouse

Tim Mantoani

Dennis Reggie

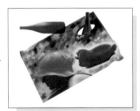

Levindo Carneiro

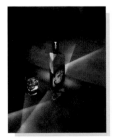

Aaron Jones

Yuri Benitez

PHOTOGRAPHERS

ACKNOWLEDGEMENTS

This book has evolved from Dean Collins' vision to keep photographers up-to-date on the contemporary photographic techniques of top international photographers. We would like to thank Dean Collins for bringing together a congress of people and providing this unique opportunity to explore and challenge personal abilities and goals.

We sincerely appreciate and acknowledge the support of Peter Rattray, Ron Pivik, Frances Lee and Kathleen Moran from Eastman Kodak for their valuable suggestions and continuing support in more than 36 countries.

Special thanks to Michael Head for the advice and encouragement to go forward with this version and to The Saunders Group for their commitment, ideas, knowledge and experience in international publishing. We also thank Partner Press for their helpful advice which contributed to this edition.

Finally, we would like to gratefully acknowledge our appreciation to THE PHOTOGRAPHERS who made this book possible. Thank you all for the extraordinary opportunity to work with you.

Eleanor Rattray

International Production Coordinator

JAY P. MORGAN

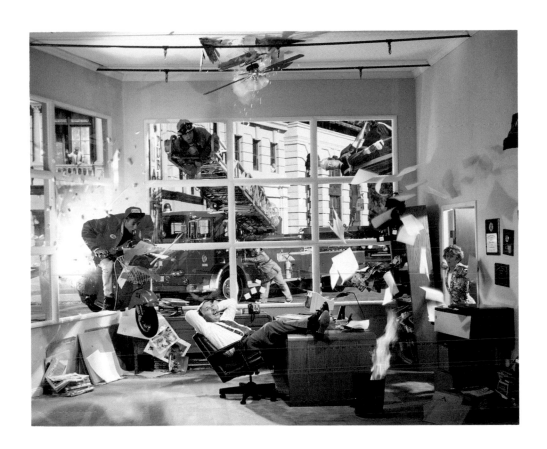

A M E R I C A

Jay P. Morgan is known for his zany, outrageous photography. Morgan's imagery is a complex mixture of tedious planning and photographic genius. Originally from Idaho, he moved to L.A. to attend the Art Center College of Design. Upon graduation, Morgan opened a studio and began developing the style that has earned him the reputation for creating impossible shots.

JAY P. MORGAN

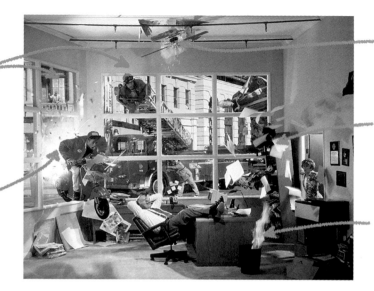

Set constructed on motion picture lot to allow large realistic background.

Air-cannon used to burst debris onto set.

Assistant on roof ignited fireworks.

Paper is actually flying during exposure.

Fire controlled by propane tank off set.

PHOTO NAME: UNTITLED.

PHOTOGRAPHER: Jay P. Morgan, Los Angeles, California. U.S.A.

ASSIGNMENT: We were approached by the client, Redgate Communications Corp., after they received a calendar we mail annually. The agency wanted to create an image that would show a printer coordinator in the midst of chaos. The only parameters they placed upon me were, "Don't get thrown in jail!"

FILM: Kodak Professional Plus (EPP), ISO 100 rated at 80 ISO.

CAMERA: 4X5 view camera.

LENS: Not recorded.

PREPRODUCTION: I wanted many of the image's elements to tie to the the theme of a printing coordinator at work. Some of the ideas which came to mind were a messenger blasting through a window, a copy machine going berserk with pile of paper all over the floor, and all of it set against the background of an industrial city. Knowing that I wanted large windows on the set, a painted background was discussed, but quickly dismissed due to the sense of reality we wanted to portray. Instead, we scouted a movie lot in Hollywood and found a street that would be ideal. (It was the Daily Planet building in *Superman*.) Working on a movie lot would allow us flexibility in time that a "real" location could not.

The set would be constructed in the street some distance from the closest building. To determine the best time of day to shoot, an assistant was hired to shoot Polaroids of the building every 30 minutes throughout the day. With this information, we determined that there would be a window of about three hours in which to shoot.

Before I ever approach a project of this size, I build the set in miniature to work out the window sizes, the height of the walls and where the large props (such as the fire truck) will be positioned. The models are built out of foam core using the scale of 1-inch = 1-foot. When complete, this model becomes a blueprint for the set. I even went so far as to purchase a toy fire truck in the right scale to use as a positioning guide. I always want to have as many decisions as I can made before the day of the shoot, because there will still be hundreds to make.

Doing this type of photography on a regular basis, I have come to know many actors in the area and called upon several of my favorites to model for the shoot. The client trusted my vision and let me make the decisions saying, "We love what you do and don't want to mess it up." This type of freedom is not typical, so I'm very thankful that it was offered on this project.

Styling was left up to my wife, Julene, who has been with me since I was in school. She was in charge of the props and furnishings, and obviously knows my likes and dislikes.

THE SETUP: I used Kodak EPP 4x5 film for the shot. Rated at ISO 80 and pushed in processing, the film saturates the color and offers a clean highlight. 4x5 is often the format of choice because I like the size and it gives me a lot of detail which a shot this complex needs. An 81A filter was placed over the lens for added warmth.

Four assistants worked for a day to complete the set, the day prior to the shoot. The walls of the office were constructed at a slight angle in order to look proper in camera. The area behind the camera, which was open to daylight, was tented with black dubateen. This

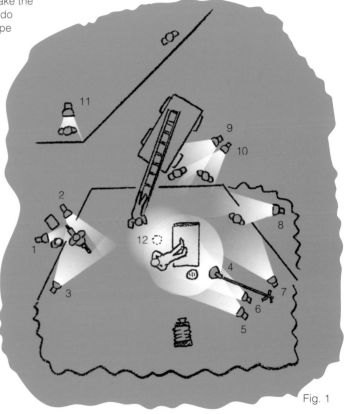

Fig. 1

gave us the ability to control the lighting of the office space and use the camera's shutter speed to control the ambient lighting outside the windows. Because the set had a ceiling, we could not light the room from above. To overcome this problem, we chose to light through the windows, creating an afternoon ambience. The first strobes placed on the set were #1 and #2. (See Fig. 1) These heads were placed outside the left side window where the scooter would fly through. Behind the scooter, an air-cannon was put into position to blow debris through the window and around the scooter at the time of exposure. (The air-cannon is controlled by a switch at the camera and is reloaded after each shot.) Head #1 and #2 backlit the debris. To light the man on the scooter, head #3 was added to the set.

Inside the office, on the right of the camera, four separate strobe heads were put into place. Each of these strobes was fitted with a grid attachment to direct the light. Lighting the firefighter on the ladder, head #4 was located on a boom just off of the ceiling. On stands, lights #5 and #6 lit the man at the desk and the garbage can. The flame in the garbage was controlled by a "burn bar" inside the can that was connected to a propane tank off set. The final light in this group, #7, was used to light the woman stepping out of the doorway.

Inside the room, light #8 with a warming gel was placed to backlight the woman and the flying paper. Some of the papers were staged to appear in motion, and others were flipped into the air during the exposure. For this technique, I use a drill with tape across the bit, which is then set on top of the paper. When the drill is turned on, the paper shoots out into the air.

Outside the set, several other lights were added to accent the people and the image's action. At the rear right of the set, just out of the camera's view, two strobes were used to both backlight the men on the street and to pump fill light into the office. These heads, #9 and #10, were each powered by their own power pack. In the building across the street, there were also two people. One of them, seen toward the back of building, was not lit. However, the person in the second story window was back lit with one strobe, #11. A very long extension cord, which extended from this head's power pack to inside the office, was used to sync the light. Finally, on the room of the set, strobe #12 was used to add light into the area where the fan was falling from the ceiling. The sparks were triggered by an assistant who remained on the roof for the shoot. On projects like this, I typically use 6 to 8 good assistants.

The shot came to an abrupt end when the lot Fire Department shut down the shoot because we were using an open flame without a permit, a question we had discussed with the lot early on and didn't feel was needed. Obviously the Fire Department did not agree. Fortunately, we had shot enough film so it was not a major problem. The art director said that he told us not to get thrown in jail, and that this was a little too close!

I really enjoy the challenge of doing large set productions. People always ask me if it is fun; I respond that it is not fun, it's not fun at all. The pressure is intense and the hours are long, plus I'm the one everyone looks to for the answers.

At 2:30 A.M., when the last truck pulled away, I walked around the Warner Brothers lot all alone thinking of the shot and what we had accomplished that day. It all seems worthwhile, especially when people compliment me on my work and my vision.

NEIL MOLINARO

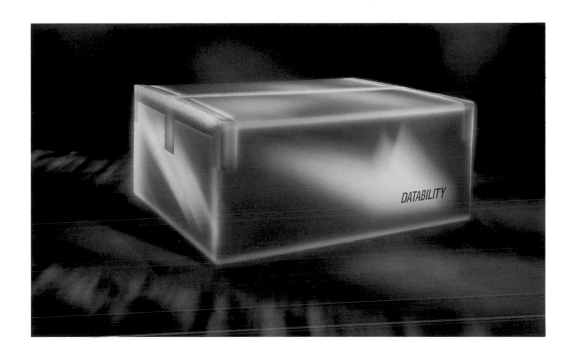

A M E R I C A

Known for his work in large format multiple imagery, Neil Molinaro has been breaking the barriers of lighting and photography for over 15 years. Although his creative imagery may appear to be the result of darkroom or computer manipulation, Molinaro's understanding of masking techniques enables him to create every image in camera on a single sheet of film.

NEIL MOLINARO

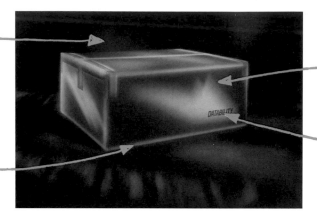

Cookies created pattern on background.

Box fabricated to meet the requirements of the art director's layout.

Homemade "pin lights" are focused down to narrow strips of light.

No diffusion used on light #4 so logo would read clearly.

PHOTO NAME: Datability.

PHOTOGRAPHER: Neil Molinaro, Neil Molinaro Photography, Clark, New Jersey. U.S.A.

ASSIGNMENT: Datability, a high end communications server, was looking for creative images which would make an all white box exciting and interesting enough to prompt the viewer to open the pamphlet. This image appeared on the front cover, 3³/₄ x 8 ¹/₂-inches. The second image, lit in a similar fashion, showed the opened package with the actual product positioned in front of the box. The background on both images needed to be able to support white type.

The client provided layouts which were extremely helpful, communicating the art directors feelings – right down to the feeling and mood to be conveyed. It was important that the art director provided more than just a thumbnail sketch because it was the first time he had worked with Datability and they would not be attending the shoot.

FILM: 4x5 Kodak Ektachrome Tungsten 64T.

CLIENT: Datability.

ART DIRECTOR: Jeff Propper, The Lunar Group.

CAMERA: Sinar P, 4x5.

LENS: 90mm, Schneider-Kreuznach super angulon f8 DB mounted to operate with the Sinar digital shutter.

DIFFUSION: Harrison & Harrison filters.

ABOUT THE SHOT: This image was lit by a total of 15 separate lights. Many of these lights will be referred to as "pin lights." These pin lights were hand made from various parts obtained from garage sales, camera swaps, and the hardware store. The light source of these lamps is a 150 watt quartz halogen lamp. Each lamp is projected through a 6-inch barrel lens which can be put in either a "focused" or "out-of-focus" position. Also fixed with a small spring tension brass shutter system, which allows a pattern of light to be projected from the lamp, a perfectly straight line of light can be thrown, even as narrow as 1/16 of an inch. (The manufacturing of these lights is currently being researched and they should be available through Molinaro Photography by mid 1993.)

Fig. 1

"Over the past two years some art directors and photographers alike have assumed that I have been using one of the popular light painting tools on the market. I am a great admirer of Aaron Jones, the system innovator. What he does and how he accomplishes it is wonderful and beautiful. I'm sad to see so many clones or imitators. I have never used a "Hose Master" nor do I have any plans to. Aaron is Aaron, and I am me. I don't think my work resembles light painting in the least. There are MAJOR differences in the results you can get from the two techniques. A personal note: For me the use of a light painting technique would be mentally disastrous. Being the meticulous person I am and one who strives for control, the thought of not having fixed and repeatable sources frightens me to no end. I know myself well enough that my chances of ending up with the results I want on one chrome is slim. The beauty of my system is that I can repeat and refine to the Nth degree, something you can't do with a moving light source."

PREPRODUCTION: The client provided the VPC1000 unit, the actual box in which it is shipped, and several logos of various size. However, the box provided was totally out of scale in relation to the layout, having an air bladder around the unit for protection. Even with a 65mm lens and the box pushed towards the background, the product was dwarfed and the image was not aesthetically pleasing. This proposed an even greater problem because there was no budget or time to have a new box fabricated.

To solve the problem an acetate of the layout was made and taped to the ground glass of the 4x5. Then, with a hot light shining through the camera, the acetate image was projected in the dark so it would be visible on the original box on the set. Measurements of the projected image where taken and box manufacturers were contacted; but still to no avail. It appeared that custom boxes are only made for unreasonable prices, at unreasonable quantities, with unreasonable turn around times. The only solution that remained was to fabricate our own box and fax test Polaroids to the client for approval.

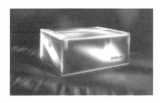

Light 1

THE SETUP: The camera was fixed with a Sinar digital shutter, which allows control of the shutter and aperture from the rear of the camera. It is calibrated in 1/3 stop increments and is self cocking and vibration free. This system is used because more often than not, the lens is inaccessible due to masks and bellows on the front of the camera. The final addition to the camera were LB# 81D (warming), B&W# 15R (red) and CC 10M (magenta) filters. These filters were placed inside the camera bellows.

Once the camera angle and perspective were approved by the art director, the lights were added to the set in the order listed below. When the entire set was lighted, a Polaroid showing the effects of each light was attached to a display board where each image was labeled with its exposure information. A detailed shoot script, grouping together exposures with the same diffusion, was developed from the Polaroids for the final film. Every Polaroid and sheet of film has its own script so the images can be studied in detail.

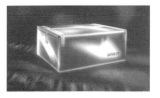

Light 2

Light #1. Pin light in focused position created a long narrow light on the bottom left side of the box. It was positioned at table height, just left of the camera.
Exposure: 4^2/$_3$ seconds, f16^1/$_3$. D-5B diffusion.

Light #2. Pin light in focused position, created a long narrow light on top left side of the box. This light was also on the left of the camera, but at camera height.
Exposure: 8^2/$_3$ seconds, f16^1/$_3$. No diffusion.

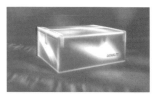

Light 3

Light #3. Mini Mole with barn doors, projected a small path of light on the table in the right rear, and also back lit the back left corner of the box.
Exposure: 4.0 seconds, f16^1/$_3$. D-3B diffusion.

Light #4. Pin light in the out-of-focus position. The small leafs in the pin light were adjusted to create the pattern on the front of the box which illuminated the Datability logo.
Exposure: 4.0 seconds, f16. No diffusion.

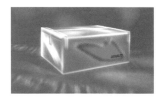

Light 4

Light #5. A Mini Mole positioned on the left of the table, at table height, created a shaft of light on the left side of the table top and the strip of light on the front left corner of the box's side. The intensity of the light hitting the table was lessened by a small scrim in front of the light source. To create the narrow strip of light on the box, a flag was placed appropriately between the source and the box. In addition, three small mirrors were used to cast highlights onto the box. These highlights are located on the box's top front corners and the center of the side.
Exposure: 8^1/$_3$ seconds, f16^1/$_3$. D-5B diffusion.

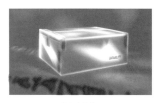

Light 5

Light #6. Pin light in focused position, shutters in place to create small narrow line of light on bottom front of box.
Exposure: 8^2/$_3$ seconds, f16^1/$_3$. D-5B diffusion.

Lights #7 (Two lights). Two 250 watt Mole Midget Solar Spot lights on opposite rear corners of the set were covered with Rosco #3410 warming gels. A cookie was placed in front of each of these lights to create the spotting pattern on the background. (A cookie is a piece of plywood cut with small holes of various shapes.) (Fig. 1)
Exposure: 2^2/$_3$ seconds, f8. D-5B diffusion.

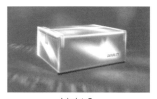

Light 6

Light #8. A Bardwell McAlister light at 200 watts was positioned above the box shining through a cookie. This source was diffused with Rosco Tuff Spun and directed by a set of barn doors. The patterns from the cookie are seen on top of the box and on the table to the front of the set.
Exposure: 4^2/$_3$ seconds, f16. D-3C diffusion.

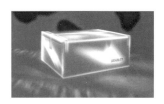

Lights 7

Lights #9 (Two lights). Two 200 watt Bardwell McAlister lights, the first positioned at table height to the left of the set and fixed with a Conical Snoot. This light created the light strip on the front right side of the box. The second light here, positioned behind the box's right corner, was directed with a set of barn doors to strike a mirror located at the front of the set. This mirror projected the "V" pattern of light on the left front of the table top.
Exposure: 4^2/$_3$ seconds, f16^1/$_3$. D-5B diffusion.

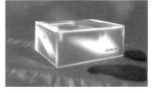

Light 8

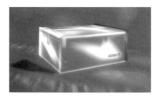

Light 9

Light 10

Lights 11

Light # 10. Again, another focused pin light was used to project the narrow strip of light on the top front of the box. The placement of the source was on the right side of the set and just above the table. **Exposure:** 8 2/3 seconds, f16 1/3. D-5B diffusion.

Lights #11 (Three lights). Light 11A was a pin spot in the out-of-focus position, located below the camera. This light projected the soft edged diagonal pattern on the center of the box's left side. The second light in this set, 11B, was a 200 watt Mini Mole with barn doors. The source located on the left of the set, a few feet above the table, was shaped by three Matthews flags which created the strip on the far top right of the box. On the top center of the box the same technique was used, with light 11C on the opposite side of the set making a strip of light. **Exposure:** 16 seconds, f16 1/3. No diffusion.

PROCESSING THE FILM: To deliver a chrome to the client that was suitable for reproduction, the set was lit so the highlight-to-shadow ratio would fall into a four stop range. It is important to understand how the image is to be reproduced and create a contrast range on your chrome that will fit the medium. These chromes are usually somewhat flat and not very pretty to view. Because of this a second set of chromes are produced. These chromes are lit beyond the four stop range because they are to be used for display, not reproduction. No meters are used; the set's lighting is evaluated through experience and by viewing Polaroids.

The use of a Jobo ATL-3 Autolab allows film to be processed in 50 minutes (dry to dry), making the decision process fast and accurate with close attention paid to color and density.

Overhead View

DEAN COLLINS

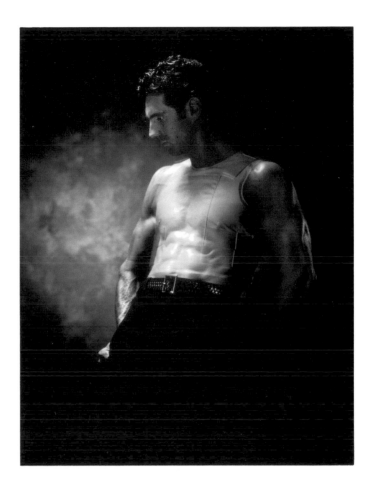

A M E R I C A

For over a decade, Dean Collins has educated photographers around the world with his informative and entertaining lectures, videos and publications. Dean's education and research in the science of photography has led to his development of numerous theories and techniques. Recent efforts have enabled him to combine his knowledge of photography and interface it with the emerging technology of digital imaging.

17

DEAN COLLINS

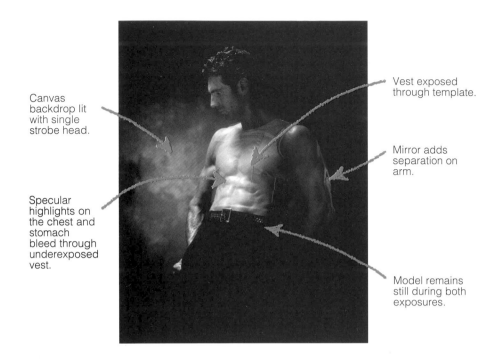

Canvas backdrop lit with single strobe head.

Specular highlights on the chest and stomach bleed through underexposed vest.

Vest exposed through template.

Mirror adds separation on arm.

Model remains still during both exposures.

IMAGE NAME: Hyperlite.

PHOTOGRAPHER: Dean Collins. Collins and Associates, San Diego, California. U.S.A.

ASSIGNMENT: Our client, Dornsife and Associates, a San Diego-based design firm, was looking for a shot to be included in a brochure promoting a bulletproof vest. The image was to emphasize the lightweight nature of the product and, at the same time, illustrate its strength and durability.

FILM: Kodak Ektachrome 100 Plus Professional (EPP). 100 ISO rated at 80.

CLIENT: Dornsife and Associates.

CAMERA: Sinar P2, 4x5.

LENS: 300mm Schneider.

SETUP: A large, grey canvas backdrop, hung at the rear of the studio, provided background for the image. Having been asked to make the background as out-of-focus as possible, the camera was moved quite far away from the background and the longest lens available was selected for the 4x5 view camera. A 300mm proved to be the best choice, utilizing the least amount of background area and compressing the perspective as much as possible. An aperture of f/8 and $^1/_3$ would later prove to be the minimum aperture to ensure a shallow depth-of-field while still maintaining focus on the model.

There were five strobe heads and two mirrors used to light the model. The first head (#1), was used to light the vest and create the first of two exposures used to create the image. To make the vest the only part of the image lit by this strobe, a template of the vest was made and placed between the model and the strobe head. (Fig.1) The template was constructed by covering a P15 Lightform Panel frame with black seamless paper and cutting out the shape of the vest. (Fig. 2) With only strobe #1 turned on and a medium spot grid added to the head's 9-inch reflector to direct the light in a narrow path, a razor blade was cut into the paper, slowly casting light onto the model's vest until just the shape of the vest was illuminated. Black tape was used to cover areas of the template that were over-cut.

Fig.1

To show the model's muscular body through the vest, a small specular light source was selected to create strong shadow form on the body. This strobe head, #2, was fixed with a 20" reflector and positioned on a boom arm above the set. The light shining down from directly over the model's head created dimension in the stomach ripples, and a hair light further helped separate the model from the background. Next, a small plexiglass mirror (A) was placed on a floor stand and positioned to bounce light from strobe #2 back onto the face and chin of the model (which otherwise appeared too dark).

These Plexiglass mirrors are simple to make. They consist of a one-square-foot piece of plastic Plexiglass mirror which is drilled onto a 2x2-inch block of wood at one end. With a one-inch hole cut in the middle of the block, a Lightform EC-1 clamp can be tightened into the hole, enabling the mirror to be attached to any light stand. (Fig. 3)

The next light added was strobe #3, which was fixed with the standard Broncolor 9" reflector and a coarse spot grid. This head was placed just to the left of the camera, front-lighting the side of the model's face. Because his ear appeared too bright, a small flag was placed in front of the light to block some light from exposing this area. Another mirror (B), positioned on a light stand at the same height as the model's head and on the opposite side of the set, caught a portion of the light which spilled past the model and bounced a highlight onto the back of his neck. (Fig. 4)

The fourth strobe head (#4), also fixed with a coarse spot grid, was placed to the right of the camera and used to add a spot of light to the left arm (which was otherwise appearing too dark). (Fig. 4)

Fig.2

The final strobe head (#5) also had the medium spot grid in place and was placed to the right rear of the set. This light source cast a large circular pattern on the backdrop and was adjusted to the perfect placement by viewing its shape through the camera. (NOTE: Strobe head #5 and backdrop are not illustrated in the diagram.)

METERING THE LIGHT: First, an incident meter reading was taken of strobe #2 (the main light) with the dome of the meter pointing at the light source. This reading, f/8 and $1/3$ at 1/60, established the subject's diffused value (true tone) and was set on the camera. Next, an incident reading was taken of strobe #1, again with the dome of the meter aimed toward the light. Because the vest was white with detail, 72% relative to 18%, and we needed the model's Caucasian flesh (36% relative to 18% grey) to show through the vest, head #1 had to be adjusted so that the vest would read lower than this 36% value. By underexposing the vest by 2 and $1/3$ stops, its value was brought down from a tonal value of 72% to 15%. This was accomplished by lowering the power pack of strobe #1 so a reflective reading of f/4 was obtained, 2 and $1/3$ stops below that of the diffused value (f/8 and 1/3).

Fig.3

EXPOSING THE FILM: For the first exposure, all modeling lights were turned off, leaving the studio in darkness. With the camera shutter set on bulb, the camera was opened and strobe #1 was fired, exposing the vest through the template. The lens was then closed. Remember that this exposure was 2 and $1/3$ below the diffused value. Two assistants then moved quickly onto the set and removed the vest from the model as he kept his position. The camera was then opened again for the second exposure, which included strobes 2 through 5, all fired simultaneously before the lens was closed.

Fig.4

A series of Polaroids was shot as a means to instantly check exposure, composition and focus. By looping the negative from a Polaroid Type 55, a black and white film which gives you both a positive and a negative, focus can be evaluated precisely. Once the client approved the Polariod, ten sheets of Kodak EPP color transparency film, 100 ISO rated at 80 ISO, were exposed.

TIM MANTOANI

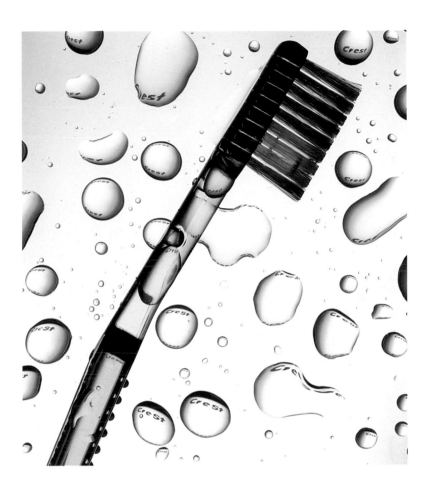

A M E R I C A

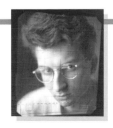

Tim has been working closely with Dean Collins since he graduated from Brooks Institute in 1991. An accomplished photographer and writer, his articles and images have appeared around the world. His current portrait study of professional athletes illustrates his strong technical and creative talents. He is based out of San Diego, California.

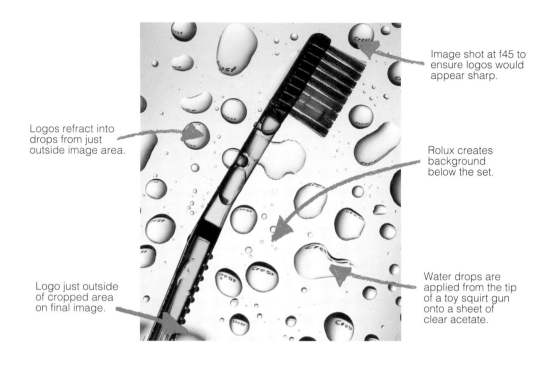

Image shot at f45 to ensure logos would appear sharp.

Logos refract into drops from just outside image area.

Rolux creates background below the set.

Logo just outside of cropped area on final image.

Water drops are applied from the tip of a toy squirt gun onto a sheet of clear acetate.

PHOTO NAME: Water Optics.

PHOTOGRAPHER: Tim Mantoani, Collins and Associates, San Diego, California. USA.

ASSIGNMENT: Originally, this image was taken as a self study assignment to better understand the optics involved when photographing water. The image later ran, along with an article titled "Water Optics" on how the image was produced, in *Petersen's Photographic Magazine.*

FILM: 4x5 Kodak Ektachrome 6105, 100 ISO rated at 80 ISO.

CAMERA: Sinar P2, 4x5.

LENS: Schneider Symmar 210mm.

PRE-PRODUCTION: Coming up with the original idea of what props and logo to use was difficult. I wanted the water to tie into the theme of the image, not using the water as a gimmick to get attention. I finally came up with this shot where the water played an important and logical roll in the design of the image. The toothbrush was ideal, being both the proper size and translucent.

CREATING THE LOGO: The image was produced in two stages. In the first stage, it was necessary to create two logos that could be projected into the drops of water. This was accomplished by shooting a Polaroid type 55, which produces an instant negative, of a Crest toothpaste box. This negative was taken into the darkroom, placed in the enlarger, and

the image was projected onto a white piece of paper. The enlarger was raised until the word "Crest" was about ten inches in length. The letters of the word were then traced onto the paper. (Fig. 1)

Next, Rosco gels, in the appropriate logo colors were placed over the traced logo and the letters were again traced, this time onto the gels. Two sets of each letter were made in order to produce two separate logos. The letters were then cut out and mounted to an 8x10-inch sheet of acetate. (I used an 8x10 transparency sleeve that was cut in half). The final result was two separate 8x10 sheets of acetate, each with the colored word "Crest" in center.

SETUP: A piece of clear glass was placed over the top of two sawhorses. A Broncolor Boxlite was positioned on the floor directly below the glass. Another sheet of glass, covered with a piece of Rosco Rolux (a milky white plastic diffusion material), was supported one foot above the Boxlight. The logos were then placed on the Rolux so they could move around freely on the surface. Because drops of water act as tiny lenses and flip what they are seeing, the logos were placed upside down from the camera view. (Fig. 2)

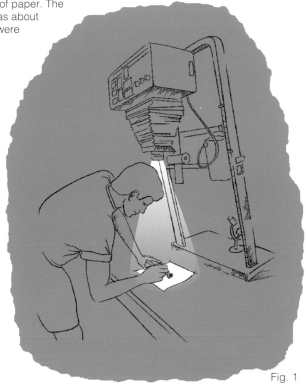

Fig. 1

The camera was then moved into position by using a Foba studio stand to support the 4 x 5 directly above the set, looking straight down. Another sheet of 8x10 acetate, placed on the top sheet of glass, provided a toothed surface to place the water drops. Without this sheet of acetate, the drops ran flat on the glass. (I first tried to use glycerine, but the body of the fluid was uneven and the logos did not refract properly in the drops.)

Testing both the size of the water drops and their relationship to the logo and camera lens was necessary to get the logo to appear in the drops at an appropriate size. I knew it would be critical to use the smallest aperture available to ensure that the focus would carry to the bottom of the set to make the logos sharp in the drops. A toy squirt gun was used to place the drops around the toothbrush.

The final step was to have an assistant slide the logos around on the Rolux until I found the best positioning of the words. In this case, one was placed to the bottom right and the other to the top right; both just out of the camera's view. This enabled the logos to appear in the water drops and still have a clean white background behind the set. The placement of the logos just out of the camera's view explains why the drops on the edges of the image only render one set of words, while the ones in the center, refracting both logos, have two.

SHOOTING: I determined the exposure by taking a reflective spot meter reading from the center of the glass. The meter ISO was set to 16 because I was rating the film at 80 ISO and there were an additional $2\frac{1}{3}$ stops of bellows extension. If I had exposed at my initial reading, f32 at 1/60, the background would have come out with a tonal value of 18%. Because I

wanted the background to appear white, I increased the power output of the strobe by 2 1/3 stops, giving the center of the background a 100% tonal value, a reflective reading of f64 1/3 at 1/60. To get the maximum depth-of-field, the power output was raised an additional stop and the aperture was closed down by the same amount. When the image was recorded at f45, the exposure gave the background the proper tonal value, illuminated the toothbrush, and made the logos easily readable.

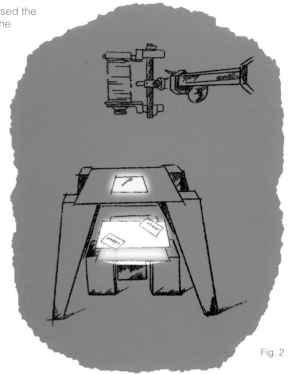

Fig. 2

DAVID KEMPINSKI

S W I T Z E R L A N D

Born in Dusseldorf, West-Germany, in 1953, David Kempinski went to the University of Zurich, in Switzerland, to study Psychology. From 1982 until 1988, Kempinski worked as a volunteer then an assistant to several photographers. He then opened his own studio, David Kempinski Fotostudio, in Zurich, where his primary focus is food, high tech and still life.

A series of exposures is used to realistically burn in read-out.

Card receives light from spot projection head above set.

Top of terminal lit from above.

Glow is created by masking system behind the set.

Low angle along with incident angle off foreground helps diminish horizon line.

"Reflo-glass" on black velvet is used for shooting surface.

PHOTO NAME: Untitled.

PHOTOGRAPHER: David Kempinski, David Kempinski Fotostudio, Zurich. Switzerland.

ASSIGNMENT: The photograph was taken for the cover of a marketing brochure. Its final size was 19 centimeters wide by 22 centimeters high. No type would be included on the image itself. The art director and client were looking to create an image which would look similar to other brochure images I had previously created for them. We needed to make a hero out of this trivial object by creating a high-tech atmosphere using blue light, intense light from behind the object and a dramatic perspective. The pictured object is a terminal which reads security cards for entrance control.

FILM: Kodak Ektachrome 64T Professional Tungsten, (EPY) ISO 64, rated ISO 80 (pushed one half stop).

CLIENT: Bauer.

ART DIRECTOR: Oliver Hafeli.

CAMERA: Sinar P2, 4x5.

LENS: Nikkor, 90mm.

ABOUT THE SHOT: This image was recorded with multiple exposures on a single sheet of film. The saturation of the blue shift was intensified by using tungsten film with daylight balanced flash and filtration.

THE SETUP: Working with one assistant, I began to create the set. A table was placed in the center of the studio and covered with black velvet. A sheet of "Reflo-glass" (a glass slightly frosted on one side) was placed on top of the velvet, frosted side up. This glass surface offers similar qualities to working on black glass, with the exception that the grainy surface creates an unsharp reflection.

Next the security terminal was placed on the table and positioned with the left side tilted slightly away from the camera. The screen desired for the image was then selected.

Mounted on a studio stand, the camera was positioned so the lens was extremely close to the terminal and only a few inches above the frosted glass. I elected to use a short focal length lens, 90mm, to allow the lens to exaggerate the perspective and thus the size of the terminal. The combination of a wide lens and low angle helped to emphasize the terminal, making it the "star" of the image.

This camera angle was important in several ways. Aside from creating a dynamic perspective, which greatly added interest to the rather trivial form of the object, this angle placed the horizon (where the tabletop and background merged) low, behind the product, making the terminal appear dominant.

Keeping in mind that the angle of incidence equals the angle of reflectance (the angle from the camera to the glass equalled the angle from the glass to the background), when the background is lit appropriately, the horizon of the image can be made to be less apparent in the image.

The background surface was a large sheet of acrylic Plexiglass, placed on the floor and secured to the table in an upright position. To create the effect of the "beams of light," a large piece of black paper was hung behind the Plexiglass. A mask, nearly the size of the actual star burst, was then carefully cut out of this paper. This mask would be illuminated by two strobe heads (#1 and #2), each creating their own projection. Fitted with small reflectors

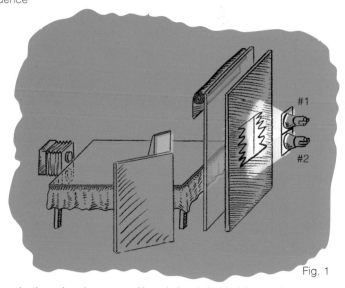

Fig. 1

and covered with blue light conversion gels, these heads were positioned closely behind the mask to create an unsharp projection onto the Plexiglass. The blue conversion gels would result in a mired shift of -215. This, in addition to the blue shift resulting from shooting daylight balanced strobes with tungsten film, created the deep blue color of the reflected background. (See Fig. 1)

Creating the shape of the mask, getting it into the proper position and placing the strobes appropriately was an extremely difficult task. The result, however, proved to be worthwhile, offering an effect not obtainable using conventional rear projection techniques. A roll of black velvet, attached to the top of the background Plexiglass, would later be pulled down during the exposure to prevent the background from receiving any unnecessary light.

From the left side of the set, two strobes were directed to the terminal. The light from these heads (#3 and #4) was diffused by a heavily frosted piece of translucent Plexiglass several

feet away from the table. The strobe heads were directed at the Plexiglass to create an extreme sidelight, nearly from behind the product. This resulted in an evenly diffused light, oriented with enough direction to reveal details and the surface texture of the terminal. (See Fig. 2)

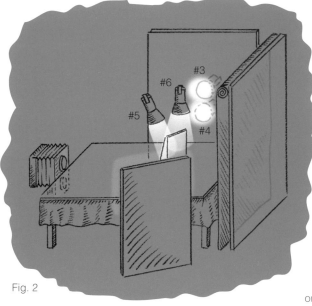

Opposite these strobes, a large white reflector was placed just behind the terminal. This fill card, which received most of its light from the background, reflected blue light onto the right side of the terminal.

Two additional strobe heads (#5 and #6) were located above and slightly behind the terminal, just out of camera view. (See Fig. 2) Strobe #5 had a grid-like filter which helped direct limited light to the upper right corner of the terminal. The other strobe (#6) was fitted with a spot projection-head and illuminated only the edges around the upper-left corner of the terminal and the security card. Because the light on the card reflected back onto the terminal, it gave the illusion that it was shining.

To expose "correctly" the color of the terminal (correct for the blue color of strobe on daylight film), strobe heads #3-#6 were partly covered with a daylight-to-tungsten correction gel. These gels produced a mired shift +109. Because this was only a slight correction, the light on the terminal still had a slight blue shift, allowing the terminal to fit with the blue background, and yet remain "neutral" enough to stand out in the image.

Fig. 2

METERING THE LIGHT: For this photograph, Polaroid film was used to adjust composition and check exposure. A light meter was not utilized.

EXPOSING THE FILM: There would be three separate exposure sections for the shot. For the first exposure, strobes #1 and #2 were fired, resulting in the background and its reflection on the table-top being recorded. Next, the black velvet curtain in front of the background was rolled down in front of the background Plexiglass. This would prevent the background Plexiglass from being struck with white light which would reduce contrast and color saturation. Strobes #3-#6 were then fired, lighting the terminal.

Finally, a long exposure of the terminal display was recorded. I wanted an impression of a display which seemed so bright, it appeared to be shining. The challenge was, however, being sure the display did not appear too bright or burned out. To achieve this look, I recorded the following series of exposures: first, an initial 60-second exposure was made. The shutter was then closed and the rear standard of the camera moved 1mm down and to the left. The lens was then opened again, this time for 30 seconds. Finally, a piece of glass which was slightly coated with a dulling spray was held in front of the lens, and another 30-second exposure was recorded. The resulting double outline exposure gave the viewer a realistic impression of the display which was bright and bold.

DAVE & MARK MONTIZAMBERT

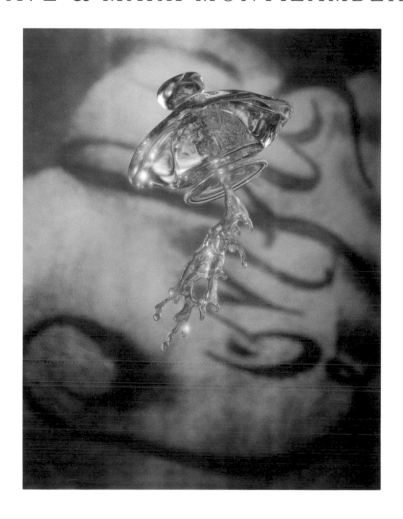

C A N A D A

Canadian photographers Dave & Mark Montizambert operate their own studio in Vancouver, B.C., Canada. Students of Dean Collins, both are active photo-educators who teach, lecture and write. Dave and Mark shoot on a national level in both Canada and the United States.

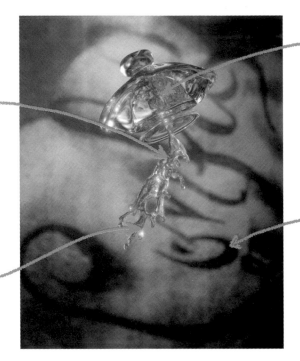

Bottle rests on "south-side glass."

Acrylic pour is made by a set builder.

Diffusion filter and specular light source create shimmering highlights.

The word "confusion" is exposed through the glass with tungsten light.

PHOTO NAME: Untitled.

PHOTOGRAPHER: Dave and Mark Montizambert, Montizambert Photography, Vancouver, British Columbia. Canada.

ASSIGNMENT: For this assignment we were asked to create a photograph that would be printed 4x5-feet in size. This image was framed and hung on an office wall on the set of the motion picture, "Look Who's Talking Now."

FILM: Kodak Ektachrome 100 Plus Professional (EPP). 100 ISO rated at 100.

EXPOSURES: Shot #1: Bulb (for two strobe pops) at f/22.
Shot #2 Bulb (for 8 seconds) at f/22.
Shot #3: Bulb (for 16 seconds) at f/22.

CAMERA: Sinar P2, 4x5.

LENS: Rodenstock, 240mm.

ABOUT THE SHOT: Three separate exposures, both flash and tungsten, were used to create the lighting for this image.

PREPRODUCTION: The props for the shoot were gathered based on tightly drawn renderings of the image to be created. This required research with a glass blower who hand-made the perfume bottle, and a movie set builder who could make the yellow acrylic splash. Instructions were given to the set builder to match the color of the splash with yellow hair gel that would be placed inside the bottle.

THE SETUP: A table was constructed using a 4x5-foot piece of black "south side" half-inch glass. This particular type of glass has a two stop density and is typically used on the south sides of buildings to help eliminate the intensity of late afternoon sun. Its color is smokey and creates no color shift. In addition, the glass eliminates any secondary reflections which appear on black plexiglass.

Filled with yellow hair gel, the bottle and the acrylic splash model were positioned on top of the black glass surface. Next, a Sinar P2 4x5 view camera with a 240mm lens was assembled and placed on a studio stand. It was positioned directly above the product and parallel to the table's top surface. From this viewpoint, the bottle would mask any of its own reflections on the black glass surface. Inside the camera, an 81A Wratten warming filter and two layers of black tulle were placed behind the lens. The black tulle, or netting, was used for a "soft focus" look.

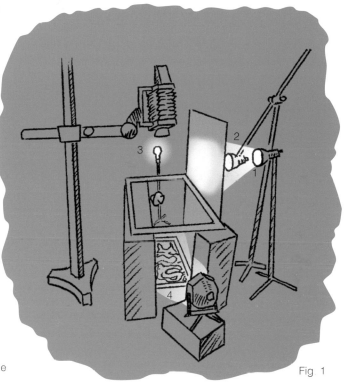

The main source of illumination was a 4x5-foot piece of 3/4-inch opaque white plexiglass, lit from behind by two closely placed strobe heads. These heads are numbered as #1 and #2 in Fig.1. This source was positioned behind the set and perpendicular to the table-top surface. Using the strobe's modeling lights for guidance, the light was directed so it puddled in the center of the plexiglass. By having the light fall off on the surface of the plexiglass, a soft-edge transfer from the specular highlight to the diffused value (or true tone) was created on the surface of the bottle.

Fig. 1

Because the light on the set was too diffused and did not create much shine on the bottle and spill, another light was added to the set. Placed just left of the camera and aimed directly at the bottle, a 250 watt tungsten bulb (#3), fitted with a projection lens, produced a narrow beam of light that made the bottle and spill "sparkle." (Fig. 1) This light, which would be exposed independently, was not color corrected for the daylight balanced film, causing a desired warm shift of color on film. During this exposure, a home-made filter, a clear acetate 4x5 film sleeve was wiped across Dave's head to pick-up skin oil and placed over the camera's lens to randomly diffuse the specular highlights.

The background was created by making a large photo-copy of the word "Confusion," which was the name of the perfume in the movie. The original copy of the type, provided by the art director, was photo-copied several times to degrade the quality and clarity of the words. Once this process was complete, the large copy was placed beneath the set, under the glass on the floor. It was lit by an unfiltered tungsten hot light (#4). Again, because a warm color was desired, the color balance of the tungsten light was not corrected. This area of the image would be exposed separately, recording the image of the word "Confusion" through the south side glass.

METERING THE LIGHT: Using an incident meter, a starting exposure for each light was determined. For the background light, it was necessary to account for the two stops of light which were lost as the light traveled through the glass. The film's reciprocity was taken into account when determining the tungsten exposures. A series of Type 59 color Polaroids was shot to make an exposure.

EXPOSING THE FILM: The exposure would be recorded in three steps. For the first exposure, only the strobes behind the plexiglass would be fired. With the camera set on "bulb," the camera was opened in total darkness and the strobes were simultaneously fired twice. It was necessary to fire the strobes twice in order to achieve a proper exposure at an aperture of f22. Next, the 4x5 acetate film sleeve (with the forehead grease) was placed over the lens and light #3 was turned on for eight seconds.

Finally, the background was exposed by turning on light #4 for 16 seconds. The camera focus was not changed, intentionally yielding an out-of-focus image of the background.

This photograph was one of several that we created for the movie set. If you wish to see the others, we encourage you to go see the movie and look on the office walls. It gives us a thrill to see them, and we hope it will do the same for you.

MARSHALL WILLIAMS

A M E R I C A

It was the obvious choice", recalls Marshall Williams on his decision to attend Brooks Institute. If not because he was born and raised in Santa Barbara, California, the home of the famed photographic school, then for his lifelong interest in photography. He apprenticed under Dean Collins who he attributes to his real education in photography and life in general. Marshall lives and works in San Diego, California.

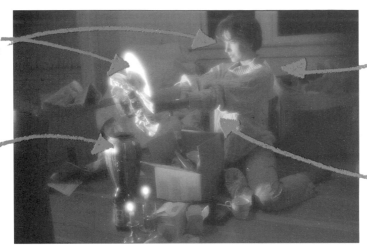

Spot grid directs light to main subject area.

Soft filter diffuses specular highlights.

Room ambience created from strobe light bounced off ceiling.

Warm light is created with a gel strip on light and 81EF warming filter on camera.

PHOTO NAME: Reflecting.

PHOTOGRAPHER: Marshall Williams, Marshall Williams Photography, San Diego, California. USA.

ASSIGNMENT: When starting a new business in a community, it's necessary to produce promotional pieces to send to art directors. The idea, in this case, was to produce an image that would speak of life's warm and intimate moments.

This promotional piece ended up as a full color, 6x4 1/2 inch postcard with the image and the business name on the front. The back face included business information and enough room for a small written message.

FILM: 35mm Kodak Ektachrome Plus 100 ISO, rated at 80 ISO.

STYLIST/ MAKE UP ARTIST: Carie Pytynia.

CAMERA: Nikon F3.

LENS: 135mm, 81 EF Kodak Wratten filter, Nikon soft filter #1.

THE SETUP: The shoot took place in an old vacant home built in the 1920s. Because the home was empty it was easy to set up lights and to find a good camera angle. The worn hardwood floors and warm white paint of the interior were ideal for the envisioned image.

The set was lit by two Broncolor Pulso 4 heads powered by a single Pulso 4 power pack. The first head, with a 9-inch reflector, was placed 12 feet away from the model on a floor stand. The head was pointed directly at her face and feathered up to avoid light from spilling onto the floor. A small 6-inch strip of Rosco 85 amber gel taped to the face on the reflector added warmth to the setting, emulating the light that would come from a lit fireplace. (Fig. 1.) By using only one light on the model, it was easy to control the areas of the image that were to be emphasized.

A second strobe was used to create ambience in the room, adding detail to the shadow areas. This head, also with a 9-inch reflector, was aimed up, two feet from the ceiling. Because both strobe heads were connected to the same power pack, they both received an equal amount of power. In order to drop the amount of ambient fill bouncing off the ceiling, a .3 neutral density filter was placed over the head. This decreased the intensity of the ambient exposure, giving the scene a more realistic feeling. There was a difference of 2 1/2 stops between the main light and fill light readings.

SHOOTING: The ISO of the meter was adjusted from ISO 80 to ISO 50 to take into account the 2/3 stop loss of light for an 81 EF filter placed over the lens. A Nikon soft filter #1 was also placed over the lens, but there was no additional compensation needed. An incident meter reading, taken of the main light from the model's face with the dome pointed towards the light, set the proper exposure for the model's skin tone.

Fig. 1

Several Polaroid test shots were taken to evaluate the lighting, exposure, and design. A series of images were then taken in both 35mm and 120 formats; however, this image captured the moment the best and was from a 35mm slide. The entire shoot took a total of four hours.

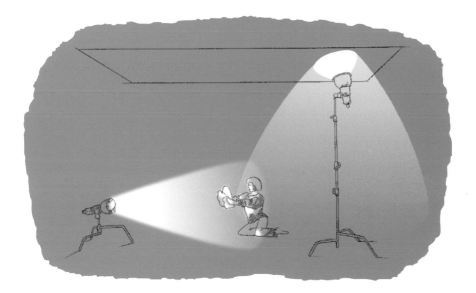

MICHEAL LLEWELLYN

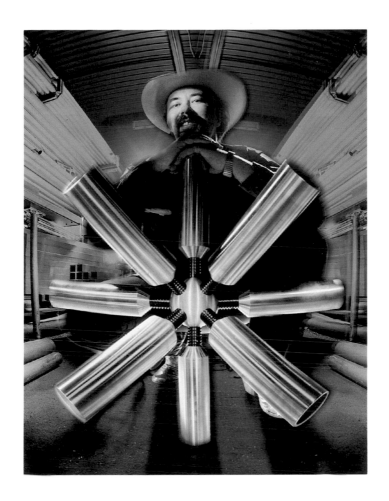

A M E R I C A

Michael Llewellyn's goal was to become an editorial photographer. An interest in Art History, particularly the Modernist period, has been a constant source of inspiration. Much of his work has been in the music industry, creating album packages. Michael's work could be considered "Photo-Illustration" since he composites images together. He shoots on location and in his Los Angeles studio.

MICHAEL LLEWELLYN

Negative of left side flipped over and printed on right to achieve mirrored image.

Mr. Wendle was lit with several pops from the altered Vivitar strobe.

30mm lens causes unique perspective.

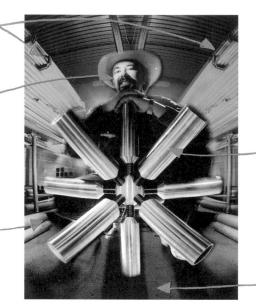

Yellow gel on strobe created colored highlights.

Low backlighting creates long shadows.

PHOTO NAME: Wendle R. Wendle.

PHOTOGRAPHER: Michael Llewellyn, Los Angeles, California. U.S.A.

ASSIGNMENT: *Futures* Magazine, a Phillip Morris Germany Publication, needed an exciting image of architect/designer Wendle R. Wendle. The shot would be used full page as the opening to a story which discussed the future of space habitats. There were no restrictions in regards to text given.

FILM: 120 Kodak VPS III 160 ISO, rated at 160 ISO.
4x5 Kodak Ektachrome Plus 100 ISO, rated at 100.
4x5 and 8x10, Kodak Kodalith EI 10 (Exposure Index).

CLIENT: *Futures* Magazine.

ART DIRECTOR: Peter Wippermann of Buro Hamburg.

CAMERA AND LENS:
Step #1: Hasselblad, 30mm fisheye.
Step #2: Sinar P2 4x5, 150mm.

THE SETUP: STEP #1, ON LOCATION: The shoot took place on location at the manufacturing facility of Starnet Structures in Babylon, New York. The material storage room provided the most interesting background, having a strong graphic quality.

The location shoot involved two separate exposures. The first was of Mr. Wendle and his modular component. The camera, a Hasselblad with a 30mm fisheye lens, was set up on a tripod to first find the angle from which the image would be taken. The ceiling, leading lines of the pipes, and unique shape of the modular component gave the image an extreme graphic design. Three Dyna Lite strobe heads were placed behind where Mr. Wendle would be positioned. These lights rim-lit the subject and cast shafts of light forward on the floor towards the camera. The modeling lights of these strobes were turned off because the exposure would last for several seconds.

Fig. 1

The star shaped modular component and Mr. Wendle were lit with several pops from a custom-modified Vivitar 285 portable strobe, set on automatic. (A 6-inch piece of 3/4 inch PVC plumbing pipe was attached to the face of the Vivitar unit and the areas around the pipe were masked off using black tape. This modification allowed only a small burst of light, directed by the pipe shaft, to create an exposure). (Fig. 1) The man's face and key body parts where exposed by hand holding this unit and painting in between seven and eight pops of light. Mr. Wendle remained holding still and a yellow gel was added to the strobe pipe and the star shape was painted with 15 to 20 pops of light. Because of limited time, Mr. Wendle could only pose for four frames.

Once Mr. Wendle left, the Dyna Lites were repositioned so they would strike the pipes and ceiling. An entire roll of negatives were then shot, bracketing to obtain a variety of highlight options. Later, the image would be made symmetrical by flopping the negative to print in the pipes on both sides of Mr. Wendle during the post production process.

Fig. 2

STEP #2, COMBINING THE IMAGES: Three 16x20-inch color prints were then made; one of Mr. Wendle, one of the right half of the background, and one of the right half of the background flipped on the left half of the paper. Next, these prints were brought to a registration stand, fixed into position with registration tabs, and re-photographed on 4x5 Kodalith film. (Kodalith is a high contrast film, used here to make a mask of each print. The standard Kodalith A&B development was used). One at a time, the 4x5 masks were placed into an enlarger and projected onto 8x10 sheets of Kodalith. When processed, this litho revealed the exact opposite of the original. (Fig. 2) During the process, not all of the areas of the mask are opaque; the remainder of the desired masked area had to be painted with Pro-black paint. Several generations of these lithos were

made until a clean positive and negative mask of each image was produced.

The final step was to shoot each image through its corresponding mask which was suspended between the camera and the print. (Fig. 3) Each element was copied in an order so that they didn't overlap incorrectly and so the negative mask of one element blocked out the image that was exposed previously until all three parts were exposed on a single sheet of film.

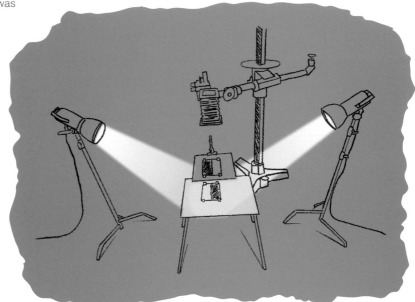

Fig. 3

NEIL MOLINARO

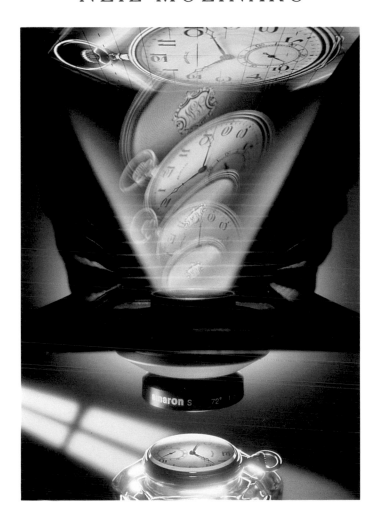

A M E R I C A

Known for his work in large format multiple imagery, Neil Molinaro has been breaking the barriers of lighting and photography for over 15 years. Although his creative imagery may appear to be the result of darkroom or computer manipulation, Molinaro's understanding of masking techniques enables him to create every image in camera on a single sheet of film.

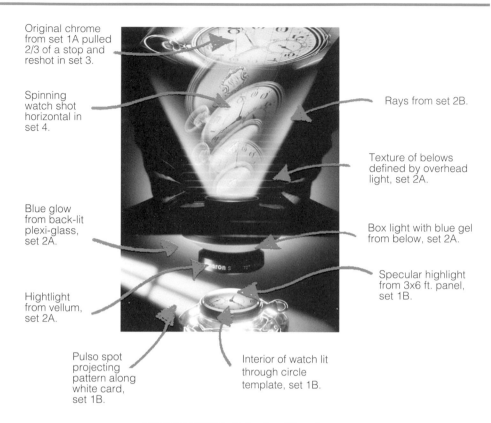

Original chrome from set 1A pulled 2/3 of a stop and reshot in set 3.

Spinning watch shot horizontal in set 4.

Rays from set 2B.

Texture of belows defined by overhead light, set 2A.

Blue glow from back-lit plexi-glass, set 2A.

Box light with blue gel from below, set 2A.

Specular highlight from 3x6 ft. panel, set 1B.

Hightlight from vellum, set 2A.

Pulso spot projecting pattern along white card, set 1B.

Interior of watch lit through circle template, set 1B.

PHOTO NAME: Spinning Watch.

PHOTOGRAPHER: Neil Molinaro. Neil Molinaro Photography, Clark, New Jersey. U.S.A.

ASSIGNMENT: Photo East, held in New York each winter, is the biggest photographic trade show in the United States. This was the first year they held a "Proshoot" to allow photographers to see first-hand a noted imagemaker at work. I suggested that a contest be held to see who could enter the best layout to be shot for the Proshoot. The image needed to utilize various multiple exposure techniques, be visually appealing, offer technical challenges, and be educationally rewarding for attendees. The winning layout was submitted by George Fulton of South Carolina. George was present at the shoot and served as the art director. The shot which took four and a half days to complete, was presented at the Proshoot in a comprehensive slide show with a live demonstration of the various sets and their effects.

FILM: Kodak Ektachrome 100 Plus Professional, #6105.

CLIENT: Photo District News, Proshoot, Photo East 1990.

ART DIRECTOR: George Fulton.

LENSES and CAMERAS:

Shot 1A: Sinar P2 4x5, 210mm
Shot 1B: Sinar P2 4x5, 90mm
Shot 2A: Sinar P2 4x5, 90mm
Shot 2B: Sinar P2 4x5, 90mm
Shot 3: Sinar P2 4x5, 90mm
Shot 4: Sinar P2 4x5, 90mm

ABOUT THE SHOT: The final image is a composite, the result of five images from five separate sets being joined on a single sheet of 4x5 film. Computers were not used to generate the image. The film holder in this case, was moved from camera to camera as the exposures were built up. No meter readings were taken; exposures were determined using Polaroid test shots and from experience.

PRE-PRODUCTION: A detailed script documented each step necessary to complete the image. The script outlined the image to be rendered on each set and gave a check list of all props, special equipment, and supplies that would be needed for the shoot. A floor plan of the studio was drawn to show where all of the sets would be located for the most efficient use of space and time.

The shot would use four 4x5 view cameras, four 90mm lenses, and a variety of strobe equipment. Sinar Bron, which is located near the studio, supported the shoot by supplying three 90mm lens.

Several types and brands of watches were available when the art director arrived to make the selection of his choice.

Set 1A

SET 1A: OVERHEAD OF WATCH FOR GROUND GLASS: ART WORK FOR SPINNING WATCH: (Fig. 1)

The first image was a 4x5 close up shot of the watch face. The actual chrome from this set would be taped into the ground glass of a 4x5 camera to be rephotographed for the final image. When this image was reshot, it would gain contrast, and lose detail. For this reason, all of the film on this set was pulled 2/3 of a stop to flatten out the contrast of the original to allow for the gain in the final image.

A Sinar P2 4x5 with a 210mm lens was placed on a Foba studio stand and positioned directly above the set. The watch was placed on top of a household water glass which was surrounded by black cloth.

Front View

Side View

Fig. 1

The camera was lowered so the watch filled the entire 4x5 image area. Because of the close focusing, it was necessary to add a second bellows to the camera.

The glass pedestal was lit from behind and below by two Broncolor heads on either side. The strobe head reflectors were covered with spot grids and then covered with #70 blue Rosco gels. Since the strobes produced specular light on the edges of the watch, a black flag was positioned above them. Behind and slightly above the set was a 3x6 foot Lightform P22 panel with a translucent fabric lit by a medium-sized softbox. This large light source created a transparent highlight on the crystal. To show the detail and shape of the sides of the watch, a strip light was placed directly below the P22 panel, at the same height of the watch. A foamcore board was placed on each side of the camera; they added fill light and created a reflection which carried the specular highlight around the entire watch.

When exposing the film there are two separate exposures, one diffused and one undiffused. A self-cocking digital shutter enabled exposures to be easily be repeated and eliminated the threat of movement. When the shutter was opened, the softbox and strip light were manually fired from the power pack. Next, a diffusion filter was placed over the lens, and the two strobes lighting the glass were triggered. The effect here was a glowing blue base under the watch.

After the film was shot, it was processed in house in a Jobo ATL-3 Auto Lab with Kodak one shot E-6 chemistry, allowing the film to be viewed in 40 minutes. These chromes were set aside to be used later in the production.

The second step was to produce images of both the front and back of the watch. Prints of these two images were glued, back to back, and later rephotographed to create the images of the spinning watch.

The watch was taken off of the glass and placed on a plain piece of white paper. The camera was refocused and an image of the front of the watch was taken on P55 Polaroid. (This type of Polaroid includes both a positive and a negative.) The negative was taken into the darkroom, and a black and white contact print was generated. The watch was then turned over, and its back shot on P59 color Polaroid film.

The black and white contact print and color Polaroid were placed upside down on top of a light table. Using a razor blade, the images were carefully cut out at a 45° angle from behind. The two prints were hinged together and set aside to be used later on set 4.

This set was then taken down, freeing up one camera and allowing room for the other sets to be built.

SET 1B: THE WATCH ON THE GLASS PEDESTAL WITH THE WINDOW LIGHT: (Fig. 2) A Sinar P2 4x5, with bag bellows and a 90mm lens, was placed on a Foba studio stand and positioned pointing down The camera faced a small set of the watch sitting on top of the water glass. A tilt on the front standard of the camera was necessary to carry the plane of focus across the top of the watch.

Four lights were used on this set, three for the watch and one for the window pattern. The window pattern was achieved by placing a small cardboard cut-out of a window in a Broncolor Pulso Spot and projecting the pattern along the surface of a white board located at the back of the set. The long opaque specular highlight along the top of the watch was the result of a strip light behind a P22 panel, four feet in back and at the same height of the watch. Another strobe head with a grid and reflector was placed on a boom arm and positioned directly above the watch. A black card with a small circle cut in the middle was placed between this light source and the watch. This allowed a small circle of light to pass through the template and illuminate only the interior of the watch.

Set 1B

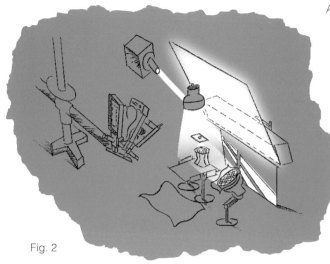

Fig. 2

A final light, another Bron head with a grid and #70 blue gel, was added just behind and below the glass pedestal. This light created the glowing base of the watch in the final shot.

A diffusion filter was used over the lens for every exposure on this set, with the exception of the small circle of light illuminating the interior of the watch's face.

SETS 2A; THE BELLOWS:

(Fig. 3) A semi-reflective mirror was crucial for the registration of the next two exposures. When positioned in front of the camera, this mirror allowed the lens to see both through the mirror and what reflected into the mirror at a 90° axis. This not only allows two sets to be photographed with only one camera, but both sets can be viewed at once to ensure the registration of both elements. In this case, the subject bellows was viewed through the mirror, and the rays were reflected in the mirror from a set 90° to the right of the camera.

The front of an 8x10 camera bellows was cut out and supported in front of the shooting camera, a Sinar P2 4x5 with a 90mm lens. One Broncolor head with a grid, positioned directly above the set funneled light down into the bellow to define its shape. A second head with a grid was placed to the left of the camera to light the side of the subject lens. A small piece of translucent vellum, placed just in front of this head, slightly diffused the light and created a specular highlight on the lens. A Broncolor Boxlight, covered with #70 blue Rosco gel, was placed on the floor directly below the set. A honeycomb grid, placed on top of the Boxlight, directed this soft light and created an even highlight on the slanted upper portion of the subject lens.

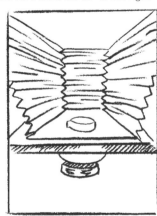

Set 2A

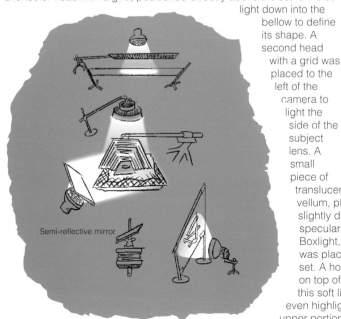

Semi-reflective mirror

Fig. 3

Finally, a large sheet of frosted, white plexiglass was moved into place behind the set. A blue circular glow was generated on the plexiglass by a single strobe head and grid backlighting the surface.

SET 3; GROUND GLASS WITH CHROME INSERT:
(Fig. 5) Before the rays could be constructed, the image of the ground glass needed to be placed into the image.

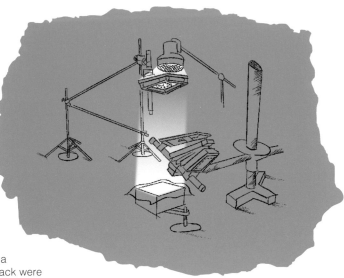

Fig. 5

The 4x5 close-up chrome of the watch from set 1A was mounted into the rear standard of a Sinar P2 4x5. The edges of the ground glass were masked out with black tape and the film code notch and emulsion number were opaqued with a black liquid. The standard and film back were supported on a monorail and attached to a stand. The shooting camera, another P2 4x5 and 90mm lens, was attached to a Foba studio stand and positioned just above the floor, looking up at the set. Getting the proper perspective was difficult, and the combination of various camera positions and experimenting with movements was essential. A Sinar Bellows Hood Mask II was attached to the front of the camera to mask out the areas around the subject. A Bellows Hood Mask II is a microdriven shading system which allows a small curtain to be dialed in towards the lens from four directions, above, below, and both sides.

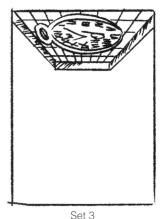

Set 3

The subject ground glass was back lit by a single head and grid above the set to illuminate the chrome, and a Boxlight covered with #70 blue gel from below. This set revealed only the image of the watch in the ground glass, found at the top of the photograph above the spinning watch.

The shape of the subject ground glass was traced onto the camera's ground glass and the entire 4x5 film back was moved over to set #2. The tracing showed the registration of the subject bellows and ground glass image.

SET 2B; THE RAYS OF LIGHT: (Fig. 3) Next, the set of the rays was constructed to the right side at the front of the camera. The tracings on the ground glass, along with the viewed image of the subject bellows now showed exactly where the rays would need to be placed in order to register with the lens' rear element and the ground glass of the image. The "V" path of the rays was then drawn onto the ground glass as well.

Once the tracing was final, a hot light was placed behind the camera and the tracing was projected through the camera, onto the mirror, and onto a piece of glass. The "V" shape projection was drawn onto a receptor sheet which was then glued to a piece of black card board. This "V" shape, the positive, was then cut out. The remaining piece, the negative, and

Set 2B

the positive were sandwiched together with a series of glass spacers between them. Colored gel strips were attached to the rear.

Sets 2A and 2B were exposed separately because the lights from set 2A were striking 2B. Black fabric covered set 2B while 2A was exposed. Diffusion was placed over the lens on set 2B to soften the rays' edges.

SET 4; SPINNING WATCH: (Fig. 6) This set proved to be the least predictable and the most challenging. A revolving mechanism with variable speeds was created to spin the cut-out prints of the back and front of the watch, created on set 1A. It was necessary to have the prints of the watch spin to capture "wisps" of light that conveyed the feeling of motion.

Set 4

A 4x5 with a 90mm, was set up on a Foba studio stand, parrallel, as opposed to perpendicular to the lateral arm of the stand. The camera was tilted sideways to an angle which allowed the watch to travel down the center of the ground glass when the arm of the Foba was moved away from the set. The effect would be a large watch at the top of the frame when the camera was in close, with a transfer to smaller and smaller watches as the camera was pulled on the Foba arm away from the set. The position for each exposure of the watch was numbered and marked on the Foba arm. Each time the camera was moved, the opposite side of the watch was exposed.

The spinning watch was lit by a Pulso Spot and the back of the set was draped with black fabric. Powering the Pulso Spot head was a Broncolor 404 Servor at maximum power (1500 watt seconds), which created a long flash duration. The digital shutter, which allows you to choose at what point in the exposure the strobe fires, was set at flash, then exposure. This enabled the peak action to be recorded with a short period of die-down following, recording the "wisps". This was also enhanced by an exposure of 1/4 of a second.

F/45 allowed focus to be carried during each step. Several tests were completed using both four and five spins for the image.

Fig. 6

SHOOTING: The film of each holder was taped down to ensure that it would not move during the exposures. The film holder was moved to each set and the exposures were built up on a single sheet of film. A total of 100 sheets of film were exposed to achieve the final image.

DAVE & MARK MONTIZAMBERT

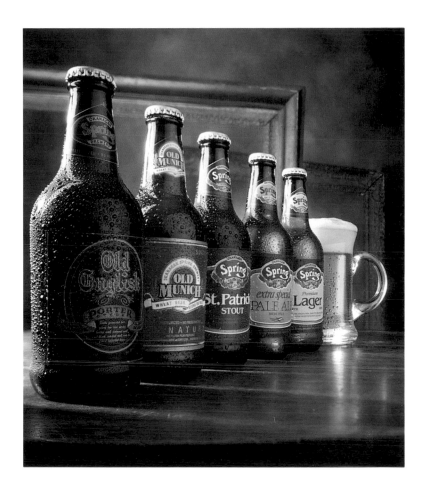

C A N A D A

Canadian photographers Dave & Mark Montizambert operate their own studio in Vancouver, B.C., Canada. Students of Dean Collins, both are active photo-educators who teach, lecture and write. Dave and Mark shoot on a national level in both Canada and the United States.

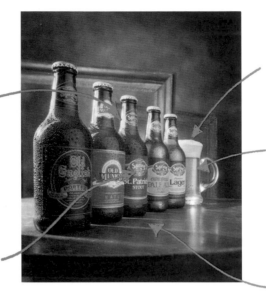

Head of beer controlled with vacuum.

Highlight separates bottles from background.

Gold reflector adds warm light to mug. Exposure determined by reflective spot meter.

Diffused value determined by incident meter.

Long shadows are from specular light behind the set.

PHOTO NAME: Line 'Em Up

PHOTOGRAPHERS: Dave and Mark Montizambert.
Montizambert Photography, Vancouver, British Columbia, Canada.

ASSIGNMENT: Create a poster to be hung in pubs and liquor stores in the brewery area. The poster would include the type, "The Great Natural Beers of British Columbia."

FILM: KODAK Ektachrome EPN, ISO 100, rate at 100 ISO 4x5.

CLIENT: Okanagan Spring Brewery.

ART DIRECTOR: None.

CAMERA: Sinar P2, 4x5.

LENS: 90mm Rodenstock Grandagon-N covered with black tulle (netting) for diffusion. Filtered with Roscolux bastard amber behind the lens.

SETUP: For this particular shot, it was determined that 4x5 format and a 90mm lens would work best. The 4x5 ensured that fine detail would remain when the transparency was enlarged to the 16 x 20 inch final poster. The 90mm lens was selected because it offered a dynamic perspective that forced the viewer into the image and emphasized the products.

Once the camera was set up in front of the rustic table, the mug and bottles were placed to determine composition and perspective. The camera angle was adjusted and mug and bottles were rearranged until a desirable positioning was found. The Foba camera stand was then secured to avoid any movement. Next, an old painted portrait backdrop, along with two eighteenth century picture frames were positioned in the background. These props added to the natural and classic ambience the advertisement was to capture.

The mug and bottles then had to be prepared. To ensure that the bottles looked perfect, the brewery provided several sets of labels which were placed by hand onto the bottles. The labels were coated with matte spray to minimize the specularity of their surfaces. Both the bottles and the mug were rubbed with car wax so water would bead up on the glass surfaces, simulating condensation.

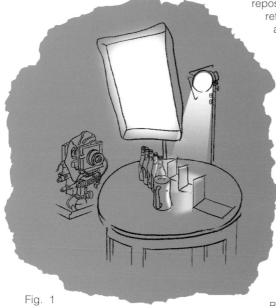

Fig. 1

Once the mug and bottle were prepared, they were repositioned in front of the camera. Three small reflector cards, made of foil board, were then cut and placed behind the bottles. Two silver foil cards reflected light into the bottles, and the gold card reflected warmer light into the mug. A single strobe head with a 9-inch reflector was then placed off to the left of the camera and slightly behind the bottles.(Fig. 1) This light was aimed so that the path of light would hit the reticulated surface of the small cards and then reflect light into the backs of the mug and bottles. This method of lighting the beer gave the liquid a natural and rich feeling and appearance.

The same 9-inch strobe head that was placed off to the left of the camera and slightly behind the bottles also created the strong, hard-edged shadows falling in front of the bottles and the round rim light on the bottle necks.

Next, a Super Chimera softbox was positioned on a stand just to the right of the camera. Because the softbox at its vertical position was creating an opaque highlight, the box was rotated horizontally. (Fig 2) This increased the horizontal height from four feet to six feet, thus diminishing the specular contrast by spreading out the energy over a greater area. The result was a highlight which was no longer opaque, but one that revealed detail on the entire face of the bottles. This Super softbox acted as the mainlight for the image.

A small Chimera softbox was placed between the camera and the hardlight. To hide the round specular highlight of the bare strobe, this light was positioned vertically so that an opaque highlight ran down the neck of the bottles.

The background was lit from the spill light from all three strobes.

METERING THE LIGHT: The mainlight exposure was determined by using an incident meter with the dome pointed at the main source of illumination, the Super Chimera box. The reading, f32 at 1/60 of a second, placed a hypothetical 18% value for the subjects true tonality or diffused value. Next, reflective spot meter readings were taken of the brightest glow of the mug and of the background. Both of these readings were two stops over that of the mainlight (f64 at 1/60). Because the film was exposed at f32 at 1/60, these areas had 72% tonal brightness values in the final image.

SHOOTING: It was necessary to swing both the front and rear standards for this shot. A total swing of 17° was needed to carry the plane of focus down the front of the bottles. With the entire 17° swing on only on standard, there was apparent image cut off. (Cut off occurs when a severe camera movement keeps the lens' circle of illumination from seeing the film plane.) This problem was corrected by having the swing split so the front standard carried 6° and the back standard the other 11°.

51

Next, the lens was removed and a Roscolux bastard amber gel was taped to the rear element. The lens was placed back onto the camera and black tulle (netting) was stretched over the front element to slightly diffuse the specular highlights and to decrease the overall contrast of the image.

The final touches were in the styling of the beverages. The waxed bottles and mug were sprayed with water to simulate condensation and make them appear refreshing. A film holder was then placed into the camera and the dark slide pulled. A warm beer was poured into the mug and the film was exposed. The head and amount of beer in the mug were controlled by using a wet/dry vacuum. Several pours and exposures were needed to capture this image.

Fig. 2

EDDIE ADAMS

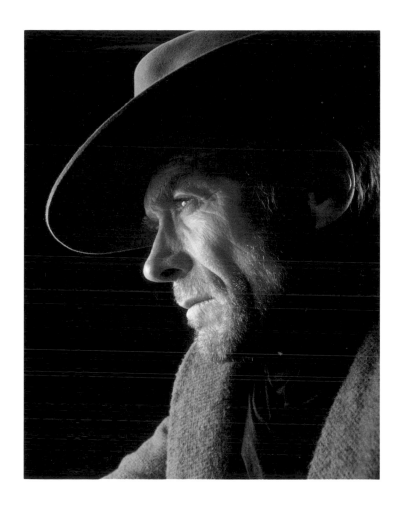

A M E R I C A

Eddie Adams, winner of the 1969 Pulitzer Prize and many other awards for photography, has covered wars, politics, sports, entertainment and high fashion. His photographs have appeared in many newspapers and magazines around the world, including Paris Match, Parade, the London Sunday Times, Life Stern, Vanity Fair, US News and World Report, and Asahi Shimbun.

EDDIE ADAMS

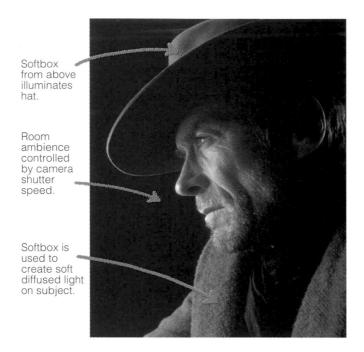

Softbox from above illuminates hat.

Room ambience controlled by camera shutter speed.

Softbox is used to create soft diffused light on subject.

PHOTO NAME: Clint Eastwood in "Unforgiven."

PHOTOGRAPHER: Eddie Adams, represented by Elain Laffont, New York, New York. U.S.A.

ASSIGNMENT: I was hired by Warner Brothers to create a photograph of Clint Eastwood that could be used for both magazine covers and a poster for the motion picture, "Unforgiven."

CLIENT: Warner Brothers.

FILM: Ektachrome Professional Plus 100 (EPP), 100 ISO rated at 100.

CAMERA: 120mm format.

LENS: 60mm lens.

ABOUT THE SHOT: This image was made in the middle of winter, on location in Northwestern Canada. The only available spot was 10-foot by 12-foot, in the back of a movie set's general store.

THE SET-UP: One major problem with doing this type of photography is time! Having more than five minutes is a luxury. Preparation is the key to allow you to get the most out of the little time you get. I chose 120mm format for the shoot to allow me quick shooting capabilities as well as an image that could be enlarged to poster size. I had not been given any specific instructions regarding layout or text that would be incorporated into the image, but knew that the image had to be in a vertical format.

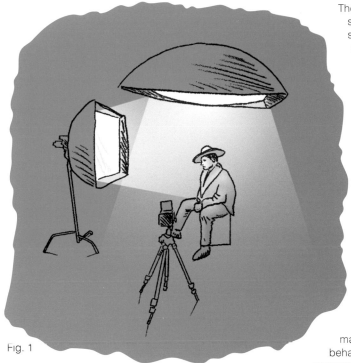

Fig. 1

The lighting consisted of two softboxes, each illuminated by a single strobe and power pack. In this case, working on location, I used two Dynalite 1000 power packs. The strobes were set up so that one would front light Clint while the other would light him from above. These large light sources, when used close to the subject, would give the image a soft or "window" light look. (See Fig. 1)

Metering was determined by the use of an incident flash meter. Everything that could be determined was set-up prior to Clint's arrival on the set. Like many actors who hate getting their still photograph taken, Clint is one of those people who feel they freeze up in front of a still camera. I remember asking actor Cliff Robertson, many years ago, why good actors behave so badly in front of still cameras. His response was, "Eddie, you have just taken our clothes off - you're photographing me - I am not acting." In this case, Clint Eastwood was not only acting in, but directing the movie. So he gave me less than five minutes, and said to do either the Polaroid or the real picture. I chose to do the real shot and got less than one roll of 120mm film.

In the end, everyone was happy, Clint, Warner Brothers, even me!

DAVID DOUBILET

A M E R I C A

David Doubilet began snorkeling at eight; by the time he was 12, he'd decided to work for National Geographic. After attending a pilot program in underwater photography and graduating from Boston University, David got the "reef and shark beat" with National Geographic. With his wife, Anne, David operates Doubilet Photography, Inc., "a mom and pop visual fish store."

DAVID DOUBILET

¹/₂ diopter with ¹/₂ neutral density filter used to properly focus and expose both subject areas.

Clouds add to the interest of the image.

The surface of the water hides split in filter system.

PHOTO NAME: Stingrays And Clouds

PHOTOGRAPHER: David Doubilet, Doublet Photography Inc., New York. U.S.A.

ASSIGNMENT: Self Study at "The Sand Bar," North Island, Grand Cayman Island.

FILM: Kodachrome 64 (PKR). ISO 64 rated at 80 ISO.

EXPOSURE: ¹/₂₅₀ second at f/8

CAMERA: Nikon F4.

LENS: Nikkor, 18mm f/3.5.

ABOUT THE SHOT: This single exposure image recorded subjects both below and above the water using only natural lighting. Special modifications had to be made to the normal underwater camera equipment to correct for the split in both exposure and field-of-focus.

If you have ever tried this split or "half-and-half" technique with a normal underwater camera setup, you've noticed that some problems occur due to the focus and exposure differences of the two subject areas. When focusing and exposing underwater on an up-close subject, the surface exposure, typically, is greatly overexposed and out-of-focus. Likewise, if you focused and exposed for the surface subject, the underwater subject was underexposed and out-of-focus. To correct for these problems, my regular underwater gear is modified.

For this shot, my basic underwater camera setup included a Nikon F4 camera with a Sportsfinder (DA2) eyepiece and a wide-angle, 18mm, Nikkor lens. On the lens I attached a

Cokin filter holder which holds an optical diopter filter. These diopter filters range in strength from +3 to -3 depending on the amount of magnification or demagnification needed. Since only half (the underwater area in this case) of the entire image needed to be corrected, the diopter is cut in half and secured into the lower piece of the filter holder using silicone cement. Now, with camera lens focused on infinity for the surface, the underwater plain-of-focus fell about five feet from the camera.

Next it would be necessary to correct for the difference in exposures between the two areas of the image. This was simply corrected by adding a .03 Tiffen graduated Neutral Density filter. This filter, which has a .03 or one stop density across one-half of the entire filter area, allowed the exposure for the sky to be dropped. This filter was placed in the filter holder, in front of the diopter, and with the exposure correction, half of the filter oriented to the top. Now properly adapted for this unique shooting situation, the camera was placed inside an AquaVision, Aquatica 4 underwater housing. This particular housing had a standard eight-inch dome.

Fig. 1

METERING THE LIGHT: I was positioned in about three feet of water with the sunlight behind me and slightly to the side. With this type of photography it is essential that the subject is front lit; back lighting will not work since water droplets on the dome of the housing cause unwanted reflections. (See Fig. 1)

Metering was accomplished by using the camera's Through The Lens (TTL) meter. For an approximate exposure reading, I elected to meter the sandy bottom which was about the equivalent of 18% gray in value. I chose to use Kodachrome 64 film because it produces the most accurate blue in shallow waters, and the hue of my subjects dictated the importance of this factor. Other films result in the water looking much greener.

I have worked regularly at The Sand Bar for the past five years. Some of this work resulted in a 1989 cover story on "Stingray City" for The *National Geographic Magazine* .

DAVID HISER

A M E R I C A

Over the past 30 years, David Hiser has completed over 65 assignments for National Geographic, as well as photographing for Audubon, Life, Smithsonian Stern and many other international publications. An owner of Photographers/Aspen, a stock photo agency, Hiser is represented worldwide by Tony Stone Images. As a teacher he has given over 30 workshops and seminars.

Star trails recorded during the night exposure.

Wide angle lens offers dramatic perspective to the shot.

Flash with warm gel used to paint the dwelling walls with light.

PHOTO NAME: Star Tracks Over Pueblo Bonito.

PHOTOGRAPHER: David Hiser, Aspen, Colorado. U.S.A.

ASSIGNMENT: This image was originally taken as part of an editorial assignment for *Travel Holiday Magazine* on Four Corners National Parks. This is an area of the United States where New Mexico, Arizona, Utah, and Colorado meet at a point.

FILM: Kodak Kodachrome 64 Professional (PKR). 64 ISO rated at 64.

CAMERA: Nikon F4.

LENS: 20mm f/2.8.

PREPRODUCTION: A 20-year history of over 60 assignments for *National Geographic* has taught me the importance of working with local authorities, especially when I'm going to be taking weird pictures in the middle of the night. In this case, it meant getting special permission from the Park Ranger to enter the ruin after dark and to park my van on site.

SETUP: This image was made in Chaco Culture National Historical Park in Northwest, New Mexico. The park preserves and protects an important cluster of structures from the Anasazi culture which was active there until the 15th century. The largest of the Anasazi buildings, pictured here, is called Pueblo Bonito. It is nearly two stories high and has an open roof area where a ceiling once stood. Shooting from the interior of the building, I used a long exposure technique to record the trails of stars. Their apparent motion is caused by Earth's rotation which leaves tracks or trails on the film. I wanted the image to allude to the 1000 years which have passed since the Anasazi departed the site. I like using this technique to convey the feeling of passing time and a closeness to nature.

Just after sunset, I entered the ruin and began to search for a desirable camera angle. A steady tripod would be essential to record the exposure which would take nearly 7 hours. The idea was to select an angle which would feature a large section of the building and still allow the sky to be an integral part of the image. I chose a 20mm f 2.8 lens, which offered both a wide angle of view and a fast aperture to record the stars. A Nikon F4 was the camera of choice because of its "T" setting, which, unlike a "B" or bulb setting, locks the shutter open without consuming battery power.

The walls were lit with a Nikon SB24 strobe, covered with a full tungsten gel (85). To condense the path of the light, the strobe was adjusted to the 85mm zoom position. Each of the visible walls was exposed with a pop from the hand-held strobe. This warm lighting would suggest the firelight of the Anasazi. To check the exposure for the walls of the structure, a series of tests were shot with another Nikon body and Polaroid back. The final image was exposed on Professional Kodachrome 64. I used this film for its fine grain, and because I like its color rendition in multi-hour exposures. It doesn't have the heavy green shift you find in Fujichrome under these circumstances.

Once the flash was exposed on film, I returned to my van for the entire night, leaving the shutter open to expose the stars. In the darkness of early morning, I was awakened by my alarm. It was nearly an hour before sunrise, just enough time to close the shutter and complete the image.

ABOUT STAR TRAILS: (The following information was provided and is copyrighted by Jerry Schad, an astronomer and photographer.) Like an ethereal roulette wheel, the heavens spin silently about an invisible axis, giving us both a sense of time and direction. Look north (if you're in the Northern Hemisphere) at night to find a part of the sky that seems relatively fixed - it rotates slowly about a point in the sky called the North Celestial Pole. Polaris, the North Star, stands very close to this pole (less than one degree from it). As hours pass, the stars trace counterclockwise around the North Celestial Pole. These so-called circumpolar stars never set, but doggedly follow their endless circuits just as surely as the Earth spins on its axis.

As long as you can find Polaris and the circumpolar stars, you can easily determine the direction in which the stars will travel, no matter which direction you are facing. (Fig. 1) NOTE: The star movements here are appropriate for mid-Northern latitudes only. Notice how stars in the south travel in clockwise arcs about a pivot point that seems to be located below the horizon. That point, the South Celestial Pole, lies as far below the south horizon as the North Celestial Pole is above the north horizon. If you travel south, Polaris will sink; travel north and Polaris will ascend.

A FEW MORE TIPS:

1. Use a wide-angle lens. "Normal" lenses are acceptable but more difficult to use when attempting to capture both the earth and sky at the same time.

2. Set your lens focus to infinity, and use an aperture setting about f/2.8 to f/4.

3. Use an average speed film with an ISO near 100-200. Fast film, particularly when used with a fast lens, collects too much "sky fog" (background light) during long exposures, and thus creates an overexposed image.

4. Start by experimenting with timed exposures in the range of one-half to two hours. Longer exposures yield longer star trails, but at the same time, they record increasing levels of sky fog. Sky fog can be reduced during an all night exposure by shooting at f/4 or f/5.6.

5. Take photographs from sites well away from the light pollution of cities, preferably on moonless nights.

6. Use a camera with a shutter that will operate without battery power. Unfortunately, most newer cameras have electromagnetic shutter mechanisms that greatly shorten battery life when long timed exposures are being used.

Fig.1

URS BUHLMAN

A U S T R A L I A

Born in Switzerland in 1962, Urs Buhlman moved to Australia when he was 10. Influenced by his father, a graphic designer, Buhlman started his photography career in 1983. After working with top advertising companies he freelanced, specializing in Annual Reports. A change of focus toward advertising photography led Buhlman to open his own studio in Mosman, New South Wales, in 1991.

Beam of light added in studio.

Blue sky due to tungsten film shot in daylight.

3 stop ND filter over the lens for long exposure to blur water at dusk.

Lighthouse interior exposed with yellow filter after sunset.

Vantage point on small island accessible at low tide.

PHOTO: South Head Lighthouse

PHOTOGRAPHER: Urs Buhlman, Urs Buhlman Photography, Mosman, Sydney. Australia.

ASSIGNMENT: The Maritime Service Board was looking for a shot of this lighthouse to include in an informational brochure about lighthouses on Australia's east coast. The final image only took up a quarter of the page with the remainder being filled with type describing the location.

FILM: 4x5 Kodak tungsten EPT (3200 degrees Kelvin(K)).

EXPOSURE: #1: f/32, 45 seconds: Light source - ambient daylight (5500°K).

#2: f/32, 10 seconds: Light source - interior tungsten (3200°K).

#3: f/32, 1/60 second: Light source - strobe (5500°K).

CLIENT: Maritime Services Board of New South Wales.

CAMERA: Sinar P2, 4x5.

LENS: 75mm f5.6 Schneider superangulon.

ABOUT THE SHOT: This image is the result of three exposures, both location and studio, placed on a single sheet of 4x5 film.

THE SET-UP: The rocks below the lighthouse offered an interesting vantage point for the image. However, most of the larger rocks were some distance into the water. After consulting a tide book, the date of the shoot was set so that a low tide coincided with the appropriate time of day.

The format of choice was 4x5 because it offered a large Polaroid which allowed close estimations about how the three images would merge.

Once the tide began to go out and the large rocks could be reached, the camera was set up on a tripod and taken out to one of the small formations. A 75mm was selected to give a wide view of the scene. Tungsten film was used to make the sky dark blue, contrasting the warm beam and light house interior. (Tungsten film is balanced for tungsten lighting which has a color temperature of $3200°$ Kelvin. Daylight has a temperature $5500°$Kelvin. When tungsten film is shot in daylight, an extreme blue shift in color occurs.

The position of the rocks and lighthouse were traced on the ground glass with a grease pencil to later position the beam of light.

SHOOTING: The first exposure was of the blue sky. To achieve the feeling of a long exposure at night, the water was blurred by placing a 3 stop neutral density filter over the lens and increased the duration of the exposure accordingly. An ambient meter reading, with the meter set on aperture priority, was taken at f32 for depth of field. Taking into account the 3 stop filter the exposure time was 45 seconds. A type 54 Polaroid was shot to check the exposure. Type 54, a black and white Polaroid , was used because it has less reciprocity failure than type 59 color Polaroid. Additionally, if type 59 was used, it would have been necessary to convert its color temperature ($5500°$K daylight) to tungsten to match the tungsten film.

Once darkness fell, a $2/3$ stop yellow gel (normally used for black and white photography) was placed over the lens to enhance the glow of the light inside the lighthouse. The $2/3$ stop filter compensation was accounted for by adjusting the ISO of the $5°$ spot meter. The exposure reading, $2 1/2$ seconds at f32, placed this area at 18%. To exaggerate the glow, this light was brought up to a 72% value by exposing this area for 10 seconds at f32, an increase of two full stops.

The final step was to burn in the light beam coming from the tower. This third exposure was done in the studio. A black piece of matte board was cut out in a triangular pattern specified by the client. Once the pattern was cut out, it was placed by looking through the camera and lining up the opening with the tracing on the ground glass. A softbox, placed behind the opening, facing the camera, created the light pattern. To soften the edges of the glow a diffusion filter was added to the camera. The color of the light beam was controlled by again placing a yellow filter over the lens. A spot reading was taken of the beam and over exposed two stops to give its value the same 72% tone as the lighthouse interior. (Fig. 1)

Fig.1

JAY MAISEL

AMERICA

A freelance photographer since 1954, Jay Maisel has been shown in more than 16 books, 50 publications and 30 group exhibits and one-man shows. His extensive education in graphic design, painting and the science of art and photography have earned him tremendous respect. He has taught at the School of Visual Arts in NYC, and conducted lectures and several annual workshops.

JAY MAISEL

Clouds diffuse the sun, creating soft light throughout the image.

General exposure evaluated by in-camera reflective meter.

Subtle changes in man's pose adds to the mood of the image.

PHOTO NAME: Farmer In Blue Denim.

ASSIGNMENT: This image was taken in Virginia as a personal photograph.

PHOTOGRAPHER: Jay Maisel. Jay Maisel Photography, New York, New York. U.S.A.

FILM: Kodak Kodachrome 64, rated at 100 ISO.

EXPOSURE: Not Recorded.

CAMERA: Nikon F3.

LENS: 90mm Macro.

SHOOTING: In photography there can be a major difference between "making" an image and "taking" an image. A commercial shooter, setting up and lighting a particular shot, usually works within a controlled environment, in essense, "making" the shot. However, in a reactive situation, such as photojournalism, the photographer first needs to locate a scene to shoot, quickly evaluate options, and then document what is already existing, "taking" a photograph.

This is an example of a reactive situation. When coming upon a farmer in Virginia, and wanting to take a picture of him, it was necessary to move quickly to capture the authenticity of the scene. First, I had to get his permission and cooperation. He was reluctant and shy at first, but after some convincing words, he was coaxed into a few poses which helped to make the image much stronger.

The lighting was limited to the available outdoor ambience, and was not manipulated in any way. The exposure, determined by the reflective meter in the camera, was used as a starting point. Bracketed exposures around this main exposure ensured the proper image brightness had been recorded. Several exposures were taken as the man changed poses in order to capture the most appealing expression and mood.

The shoot took about five minutes. Sometimes capturing a dynamic image only requires a sharp eye and quick reflexes. This image was a favorite from the series.

GAIL MOONEY

A M E R I C A

GAIL MOONEY

Phone booth tells the story of the image location.

Exposure determined by in-camera reflective meter.

Character of the man supports the mood and environment.

Overcast sky from rainy day creates soft light and a low lighting ratio. This allowed the man inside the booth and the outside environment to both be exposed properly.

PHOTO NAME: Man In Phone Booth.

PHOTOGRAPHER: Gail Mooney, Kelly/Mooney Photography, North Plainfield, New Jersey. USA.

ASSIGNMENT: This image was taken as part of a self-assigned project in the British Isles. It was later sold as a stock image for an editorial article in *Travel and Leisure* Magazine's "Special Section." The image ran a little more than 1/2 page in size.

FILM: 35mm Kodakchrome 64 ISO rated at 64.

CAMERA: 35mm Nikon FE2.

LENS: 105mm.

THE SETUP: Luck played a major role in capturing this image; we were at the right place at the right time. My husband and I were on a self assignment in England where we spent some time in Blackpool. It was here, on a seaside boardwalk, where we came upon this man in the phone booth. The overcast day created extremely soft ambient light; the quality of light was perfect for the setting. The man, looking for a number inside the booth, was there for what seemed to be almost 20 minutes. This allowed for enough time to really think out the image and its composition.

The trip we were on lasted five weeks, limiting the amount of film we could shoot a day. Because of this, only a few cautious frames were taken. The exposure was determined by the camera's reflective metering system. Kodachrome was the film of choice because of its slightly warm color balance and soft tonal reproduction.

Looking back on taking this shot, there was one major flaw, a model release was not obtained from the man. Without a model release, the usage of the image has been limited to editorial "newsworthy" publication. On several occasions it was requested for advertising, but without the proper release information the shot could not be published. Even with a strong possibility that the man has deceased, his estate could present problems.

In the United States you must have written permission to use recognizable persons or property in a photograph that is used for advertising purposes. This release is a document which documents the fact that the person being photographed has given their consent to the sale of an image and its uses. This protects the photographer against an invasion-of-privacy lawsuit. Another suit which a release can protect against is libel which alleges that the person in the image has been subjected to improper embarrassment, loss of status, or loss of income as a result of the publication of the photograph.

This release, provided by *The American Society of Magazine Photographers* (ASMP)*, covers a variety of issues which may arise from the use of an image. Many photographers adjust a release such as this to the needs of their own business. It is important photographers understand the specific laws enforced by each country or state in which they are producing work.

*ASMP is a professional organization which researches business practices.

ADULT RELEASE

In consideration of my engagement as a model and for other good and valuable consideration herein acknowledged as received, I hereby grant to [PHOTOGRAPHER], his/her heirs legal representatives and assigns, those for whom [PHOTOGRAPHER] is acting, and those acting with his/her authority and permission, the absolute right and permission to copyright, in his her own name or otherwise, and use, re-use, publish, and re-publish photographic portraits or pictures of me or in which I may be included in whole or in part, or composite or distorted in character or form, without restriction as to changes or alterations, in conjunction with my own or a fictitious name, or reproductions thereof in color and otherwise, made through any medium at his/her studios or elsewhere, and in any and all media now or hereafter known for illustration, promotion, art, advertising, trade, or any other purpose whatsoever. I also consent to the use of any printed matter in conjunction therewith.

I hereby waive any right that I may have to inspect or approve the finished product heirs, or products and the advertising copy or other matter that may be used in connection therewith or the use to which it may be applied.

I hereby release, discharge and agree to save harmless [PHOTOGRAPHER], his/her heirs, legal representatives and assigns, and all persons acting, from any liability by virtue of any blurring, distortion, alteration, optical illusion, or use in composite form, whether intentional or otherwise, that may occur or be produced in the taking of said picture or in any subsequent processing thereof, as well as any publication, thereof, including without limitation any claims for liable or invasion of privacy.

I hereby warrant that I am of full age and have the right to contract in my own name. I have read the above authorization, release, and agreement, prior to its execution, and I am fully familiar with the contents thereof. This release shall be binding upon me and my heirs, legal representatives, and assigns.

DATE_____

(NAME)

(WITNESS) (ADDRESS)

PAUL LIEBHARDT

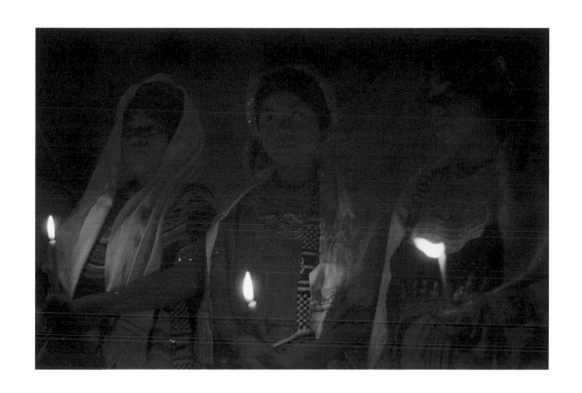

A M E R I C A

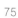

PAUL LIEBHARDT

Subjects' faces fall into darkness, adding to the mood.

Three candles are the only source of illumination. Exposure determined by BDE rule.

1/30 second exposure captures motion of candle flame.

PHOTO NAME: Mayan Easter.

PHOTOGRAPHER: Paul Liebhardt, Brooks Institute of Photography, Santa Barbara, California. U.S.A.

ASSIGNMENT: Self assigned shoot in Guatemala with the intent of using the images for stock, print exhibitions, and education.

FILM: 35mm Kodachrome 200, rated at 200 ISO.

CAMERA: Leica SL.

LENS: 50mm, f2.

THE SETTING: On an Easter Sunday 1992, I was in Guatemala where I attended an evening mass celebration. The church, located in a remote village east of Santa Cruz del Quiche, had no lights and the only illumination came from candles held by the "Indigenas", Indians attending the mass. There were about 400 people huddled in the crowded structure.

Because the candles were the only source of illumination. I relied on experience to help determine my exposure. I knew that the exposure outside in bright sunlight with ISO 200 film would be 1/250 at f11 2/3. This exposure principle, known at Basic Daylight Exposure (BDE), tells a photographer that the correct f-stop will be f16 if you use the ISO of your film as the shutter speed. In this situation the exposure would have been 1/200 at f16. However, 1/250 was the closest shutter speed setting (to ISO 200) available on the fully mechanical camera I was using. Therefore, the basic f16 exposure had to be increased by 1/3 of a stop to f11 2/3 to compensate for the loss of light due to the faster shutter speed. The understanding of BDE allowed me to visually interpret the light and adjust my exposure for the scene which I knew would be between nine to eleven stops darker than outside sun. Because I have shot in many candlelit environments, I increased my exposure 8 2/3 stops to 1/30 at f2. I took about 50 exposures during the mass and did not bracket.

The mass was very solemn and the participants were not very animated. This made looking for that "telling moment" difficult, and I consequently made a variety of exposures hoping to find some which would be representative of the event.

Below is a Basic Daylight Exposure Guide for a variety of light situations which is given to students at Brooks Institute as a reference. As an instructor, I stress the importance of mastering exposure, not through the camera, but through visual interpretation. In the final analysis the correct exposure is the one that the photographer wants, and in many cases, that may be totally different than the exposure the camera provides.

BASIC DAYLIGHT EXPOSURE

Exposures may be determined by their distance from the Basic Daylight Exposure which will always remain constant. The formula for computing this Basic Daylight Exposure is easy to remember. The correct f/stop will be f/16 if you use the ISO of the film as the shutter speed.

EXAMPLE

ISO	125	ISO	64
Shutter Speed	1/125	Shutter Speed	1/64
f/stop	f/16	f/stop	f/16

Any other comparable combination shutter speed and f/stop will give you the same exposure results.

ISO	125	1/125	second	@ f/16
ISO	125	1/500	second	@ f/22
ISO	125	1/250	second	@ f/11
ISO	125	1/2000	second	@ f/4
ISO	125	1/15	second	@ f/45

SITUATION GUIDE

SITUATION	EXPOSURE	SITUATION	EXPOSURE
Sunlight – normal subject in sunlight	BDE	Store Windows at Night	+6
Sunlight – silhouette	-2	Fireworks	+6
Sunlight – bright snow or sand	-1	Night Football, Boxing, etc.	+6
Sunlight – backlit, exposing for shadow	+2	Office – fluorescents	+6
Overcast – weak, hazy	+1	Brightly Lit Downtown - night	+7
Overcast – normal, cloudy, bright	+2	Fairs, Amusement Parks	+8
Overcast – heavy or open shade	+3	Swimming Pool – indoor tungsten lights	+8
Neon, Lighted Signs	+5	Home Interior – at night	+8
Stage Shows	+5 – +7	School, Church – stage and auditorium	+9
Flood Light Acts	+6	Christmas Lighting at Night	+10
Flood-Lit Acts	+7	City Skyline at Night	+13
Brightly-Lit Theatre Districts	+6		

"Basic Daylight Exposure" guide provided courtesy of Brooks Institute of Photography.

DEAN COLLINS

A M E R I C A

For over a decade, Dean Collins has educated photographers around the world with his informative and entertaining lectures, videos and publications. Dean's education and research in the science of photography has led to his development of numerous theories and techniques. Recent efforts have enabled him to combine his knowledge of photography and interface it with the emerging technology of digital imaging.

DEAN COLLINS

Large main-light used close to models creates soft light.

Strobe burst onto the white wall.

Image data stored on camera's hard drive, then imported at the Macintosh computer.

Fan blows hair away from the faces.

PHOTO NAME: Rosanne and Natasha.

PHOTOGRAPHER: Dean Collins, Collins and Associates, San Diego, California. U.S.A.

ASSIGNMENT: In hopes of increasing the global awareness of Kodak's role in the future of photography, I was invited to join them in one of their several educational projects. The project was to produce a seminar on digital photography discussing both the coming of the computer age in the photographic industry and its effect on the common photographer. Kodak's DCS 200 Digital 35mm camera was one of the products I was to test, after which I would explain its performance and limitations.

FILM: NONE!

COMPUTER: Macintosh Quadra 700, 20 megabytes of RAM, 535 MB hard disk.

CLIENT: Eastman Kodak Company.

CAMERA: Kodak DCS 200.

LENS: Nikkor 200mm f/3.5.

ABOUT THE SHOT: This image is the result of a completely digital process; no film was used.

THE SET-UP: An hour prior to the arrival of the talent and make-up artist, the lighting for the shoot was set and a series of test images were exposed. The lighting consisted of two strobe heads, a Broncolor hazy light and a bare head with a nine-inch reflector. The reflector, fixed with a wide grid attachment, was used to illuminate a small portion of a white wall behind the subject. This light was positioned to the right of the camera at about five feet from the floor.

The next step was moving the Hazylight, a 3x3-foot contained light source, into place. This large diffused source was used as the main light. Its position was camera left and slightly in front of the models. The placement of the Hazylight was such that the light illuminated both models evenly. In order to avoid getting a square reflection ("catch lights") of the light source in the eyes of the models, a mask of a circle was placed inside the source over the plastic diffusion. (See fig. 1) This mask created circular "catch lights" in the eyes of the models.

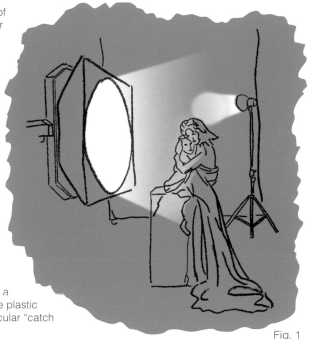

Fig. 1

A Bogen Turbo Fan would later be used to blow the subjects' hair away from their faces and add some life to the image.

EXPOSING THE IMAGE: Incident flash meter readings were taken of the main light with the meter's dome aimed toward the main source of illumination. This reading, f/5.6 at 1/60, set the subjects' true tone, or what we call the "diffused value." It was important to meter both faces of the models to ensure that the exposure was even across the set.

SHOOTING: The camera, a Kodak DCS200, (which is a Nikon 8008s camera body fixed with a two-dimensional CCD array, 14mm x 9.3mm in size), was attached to a Foba studio stand for easy positioning. The camera can store approximately 50 compressed image 24-bit color files on its 80 megabyte internal hard drive. Connected with a SCSI cable to a Macintosh Quadra 700 Computer and a 20-inch color monitor, the image could be recorded to the camera, a process which takes about three seconds, and then a few moments later to the monitor via Adobe Photoshop. This provided an instant contact sheet of the images as they were recorded. The undesirable images were simply deleted to make space for the heroes.

The final hero images from the shoot were saved to an 88 megabyte SyQuest disk, with a "contact sheet" of the shoot being printed out on an XL700 thermal printer. The "contact sheet" was made by a screen capture on the Macintosh using a software device called Capture by Mainstay.

KODAK
DCS 200
Camera

Macintosh
Computer

The Digital Imaging Process.

KODAK XL7700
Color Printer

RICK SMOLAN

A M E R I C A

A former Time, Life and National Geographic photographer, Rick Smolan has found the key to placing himself and his projects directly in the path of the converging worlds of photography, design, publishing and technology. He created the bestselling Day in the Life photography series; From Alice to Ocean, the world's first interactive coffee table book; and Passage to Vietnam, a photographic project involving 70 photojournalists from 14 countries.

Perspective exaggerated with wide angle lens.

Sweeping clouds add to impact of image.

Exposure determined by in camera meter.

PHOTO NAME: Untitled.

PHOTOGRAPHER: Rick Smolan, Against All Odds Productions, Sausalito, CA. U.S.A.

ASSIGNMENT: I was originally assigned by *National Geographic* to fly out 6 times during Robyn Davidson's eight month, 1700-mile camel trek through the Australian Outback, from Alice Springs to the Indian Ocean. This shot was later digitally scanned and written onto a Kodak Photo CD Master for inclusion into one of the first interactive multimedia books ever published, *From Alice To Ocean* (Addison-Wesly).

FILM: Kodak Kodachrome 64 Professional (PKR). 64 ISO rated at 80.

EXPOSURES: Unrecorded.

CLIENT: National Geographic Society.

CAMERA: Nikon FM2.

SCANNER: Kodak Photo Imaging Workstation.

HARDWARE: Kodak Photo Imaging Workstation, Kodak PCD Writer 200.

SOFTWARE: Kodak Photo Imaging Workstation.

ABOUT THE SHOT: I recorded this image during a moment of triumph at the end of the eight month trek. It captured what, for Robyn, had begun as a dream and had become, both a reality, and a tremendous success.

METERING THE LIGHT: Almost everything I shot on this assignment was recorded using only natural light. I rated the Kodachrome 64 at ISO 80 and often used a polarizing filter. The TTL metering of the camera was utilized for this shot. From the 500 rolls of Kodachrome film, *National Geographic* used 32 images, including the cover shot.

ON LOCATION: Throughout the project I worked alone. The biggest problem I faced was keeping the film cool during the weeks spent in the desert. Daytime temperatures blazed over 110° (F) at times, making it exceptionally difficult to protect the film. The only relief from the heat came in the evenings when temperatures plunged to the low 40's (F). Without the aid of ice, I controlled the temperature of the film by storing it in an insulated cooler with a locking lid. In the cool night air, I would leave the cooler open for several hours, allowing the film and the interior of the cooler to be naturally chilled. Because this scheme worked on the assumption that I would not need to open the cooler during the day, I had to carefully plan each day's film requirements, taking out enough each morning before closing up the cooler.

Another problem that I had to contend with was the fine red dust of the Gibson Desert which got into everything and often caused scratches on the film. Part of the solution was to gently remove the dust using a soft hair photo brush, rather than a cloth or even canned air. I also had to have the cameras completely rebuilt by Nikon in Sydney after each two week trip to join Robyn.

DIGITAL IMAGING: A little over ten years after the actual camel trek, I was working on a multimedia project sponsored in part by Apple Computers and Eastman Kodak. We were trying to showcase the latest technology for digital imaging and point to possibly the future of interactive publishing. My photographs of Robyn's trip would be used to produce a high quality book, embellished with two interactive compact disks—one a Photo CD, the other a CD-ROM. The Photo CD disk plays on either a Kodak PhotoCD player (for display on a television) or a CD-ROM drive that is PhotoCD compatible with appropriate Photo CD software (for display on a computer graphic monitor). The CD-ROM disk plays only on an Apple Macintosh CD-ROM drive. The CD's are designed to augment, rather than replace, the experience of reading the book with photographs, narration and music.

GETTING THE IMAGES ON PHOTO CD: In order to place the 35mm slides on a PhotoCD disk, they had to be converted from an analog representation (i.e. the actual Kodachrome transparency) to a digital representation (which would be placed onto the actual Photo CD). This is done on a Kodak "Photo Imaging Workstation" (PIW). These workstations have all the computing power and peripherals necessary to input images from positive or negative 35mm film and output the images on a Master Photo CD. Because Kodak was one of the sponsors of this project, I had the good fortune of being able to actually travel to Rochester, New York, and be one of the first artists to utilize these workstations. The film was placed into a film scanner which scans the transparency and creates a digital file. This file is a digital representation of the actual image. Five different files of varying resolutions are created for each image scanned, from the lowest resolution to the highest resolution. The PIW outputs all of these digital files onto a Master Photo CD disk. If any of you have sent your photographs into Kodalux, or any other Photo CD service bureau, you have received back a Master Photo CD from a PIW. In my case, we had the additional good fortune of being able to use Kodak's PCD Writer 200 (scheduled for commercial release in the second half of 1993) which takes the files directly off of the hard disk storage and writes them onto a Pro Photo CD. This CD allows the mixing of different digital media types, e.g. photographs, sound bites, etc.

MASS PRODUCTION: In the past it was very expensive to generate a CD master for high volume reproduction manufacturing. But, with the introduction of Kodak's Photo CD, that is changing dramatically. Compact disk manufacturers can now use a Kodak Photo CD Master, which already contains the digital information as input media for their systems. This eliminates many of the prior costs.

RICK SMOLAN

Next, my Pro Photo CD was sent off to a company that manufactures compact disk duplicates. To generate a large number of duplicates requires a two step process to create a master mold. First, a glass disk is made containing the digital information, using their specialized manufacturing system. Second, this is used to manufacture a "stamp". The glass disk is actually destroyed in making the stamp. The digital information is transferred physically onto the surface of the stamp. The stamp is then used to mass produce the Photo CDs for our book. In our case, the copies were made and included in the back cover of each book. For added value, our disk contains images not included in the book.

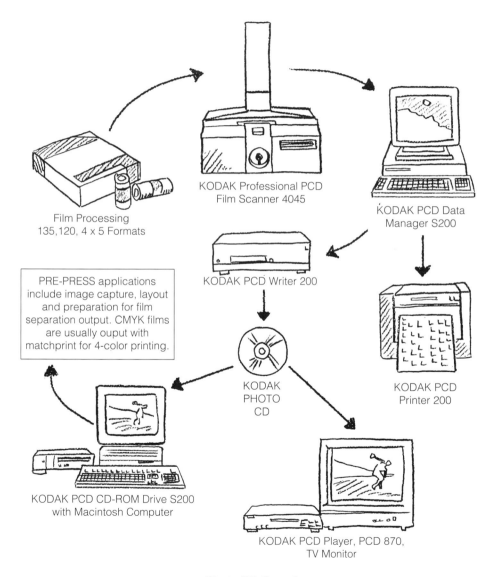

Film Processing
135,120, 4 x 5 Formats

KODAK Professional PCD
Film Scanner 4045

KODAK PCD Data
Manager S200

PRE-PRESS applications
include image capture, layout
and preparation for film
separation output. CMYK films
are usually ouput with
matchprint for 4-color printing.

KODAK PCD Writer 200

KODAK
PHOTO
CD

KODAK PCD
Printer 200

KODAK PCD CD-ROM Drive S200
with Macintosh Computer

KODAK PCD Player, PCD 870,
TV Monitor

Photo CD Overview

LYNN SUGARMAN

A M E R I C A

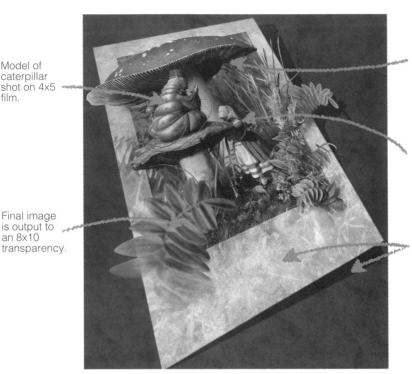

Model of caterpillar shot on 4x5 film.

Mushroom landscape shot on 4x5 film.

Alice is shot in studio on 120 film.

Final image is output to an 8x10 transparency.

Digital artist creates borders and 3-dimensional look in the Kodak Premier system.

PHOTO NAME: A Return To Wonder.

PHOTOGRAPHER: Lynn Sugarman, Sugarman Productions, Dallas, Texas. U.S.A.

DIGITAL ARTIST: Mary Brandt at Dallas Photo Imaging, Dallas, Texas. U.S.A.

SHOOT FILM: Kodak Ektachrome 100 Plus Professional (EPP).

OUTPUT FILM: Kodak Ektachrome 100 Professional (EPN). 8x10 sheet, 6122.

CLIENT: Eastman Kodak Company.

HARDWARE: Kodak Premier Image Enhancement System.

SOFTWARE: Kodak Premier System Software.

FILM SCANNER: Kodak Premier Reader.

FILM WRITER: Kodak Premier Writer.

OUTPUT PROOFS: Kodak XL7700 Thermal Printer.

ABOUT THE SHOT: The final image is the result of three different images (two 4x5's and one 120) that were scanned into the Kodak Premier System and then digitally enhanced, combined and output to an 8x10 transparency.

PRE-PRODUCTION: Initially, conversations were conducted over the phone with the art director, photographer and digital artist. These were followed by a series of meetings in New York with the same individuals. Discussions centered around correct proportional sizing of the elements to be photographed, precise lighting direction, background color selection and system capabilities versus extra camera work and model making.

THE SETUP: There would be a total of three images shot. It was critical for the image perspective and lighting of each to match in order to realistically merge the images together.

Fig. 1

The first shot taken was of the young girl portraying Alice. She was lit with a bare bulb strobe head covered with a 1/2 CTO (orange) gel. The light was positioned directly in front of and above her. A light brown colored background was selected to give the bounce light of the image a proper color for the final scene. A small round platform, which would later be replaced with the image of the mushrooms, was constructed to give the model a place to rest her hands and support her weight so she could stand on her toes. This platform was covered with a burlap fabric, again to bounce a neutral and warm light into the shadow of her face. (Fig. 1)

A series of images was shot of the model on 120 format film to get a variety of expressions and body positions. The exposure was checked by shooting Type 669 Polaroids.

Next, against the same background, the image of the caterpillar was taken. The model of the caterpillar was approximately 10 inches in size. The lighting again originated above and from the left of the set. This time, two Mole Richardson covered with 1/4 CTB (blue) gels were used. A large gold fill card was used at the right of the set to add warm fill light to the shadows, reducing contrast. (Fig. 2) This time the image was recorded on 4x5 film, again checking the lighting and exposure by shooting color Polaroid proofs.

The final image of the mushrooms was taken on 4x5 as well. This set would provide the landscape onto which the other elements would be placed. The actual size of the large mushrooms was about10 inches tall. (Fig. 3) The lighting from the previous shot of the caterpillar remained.

Fig. 2

INTO THE COMPUTER: Once all the film was processed, three hero images from the studio sessions were selected for scanning. Each of the images was scanned into the Kodak Premier System with the Premier Reader, the system's film input device. The 4x5 image of the caterpillar was scanned at 2000 pixels per inch, the 4x5 film image of the mushroom at 1000 pixels per inch and the image of Alice at 2000 pixels per inch. The image of the caterpillar was scanned at a lower resolution based on the size that was used in the final image.

LYNN SUGARMAN

The next step would involve selecting the caterpillar and Alice from two of the images and digitally compositing them onto the landscape of the mushrooms. First the file containing the mushroom background image was opened and brought to the system's 19-inch monitor in what is called "window #1." The other two images were also opened and displayed in windows (#3 and #4) on the screen.

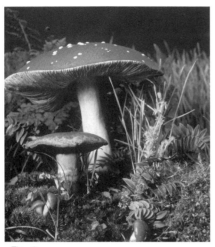

Fig. 3

Using a software tool to differentiate the pixels of the caterpillar from its surrounding background, a mask was created around the caterpillar, red tube and Hookah. (Note: This step is simplified by isolating any objects to be masked on a highly distinct color background when shooting the original films. (In this case the even light brown color used in the studio.) Once the mask was created the masked area of the caterpillar was copied and dropped into window #1. The same steps were followed with the image of Alice to isolate and then place her into the mushroom landscape. This "copy" function is nondestructive meaning that if these windows are again opened, the original scanned images will still be intact.

With Caterpillar and Alice as part of the landscape image, their placement was precisely adjusted. Each element was repositioned by being selected with a mouse pointer device and then dragged to its proper position. The edges of the masked elements were feathered using a special software tool to create a more natural and seamless quality to the composition. Further enhancements made to add realism to the image included the "cloning" or duplicating of grass and foliage to allow selected pieces of the image to be duplicated repeatedly and adding grass to areas which were appearing too sparse. Also, the texture on the top of the large mushroom was cloned and added to the top of the small mushroom. Using the "paint" application software, fine hairs and spots were added to the caterpillar's back and an eye added to his face. Final touches on this section of the image included the addition of details to the caterpillar's face and hands and the smoke curling from the Hookah. Missing in the original shot of Alice were portions of her arm and dress. The elements were airbrushed into the image. Without this touch-up, the image would have contained obvious composite defects. The hair color of the model was also altered from natural brunette to shining blonde.

Throughout the manipulation process, slide bars from the system were used to adjust the luminance, saturation and hue independently. Repeated adjustments were made to each slide bar, independently, and the results were viewed on the monitor.

FINISHING TOUCHES: Mary, the computer artist, took it upon herself to make the final manipulations by ghosting part of the image border and using perspective controls in the computer to achieve a three-dimensional border effect. Output proofing was achieved with a Kodak XL7700 thermal printer. This device is a part of the Premier system and is calibrated for color matching the final film writer. This allows the thermal print to closely match the colors achieved on the final film output. This approach is less expensive than proofing on actual 8x10 film.

FINAL OUTPUT: While beginning with a standard 8x10-inch image file of 250 megabytes, the "A Return To Wonder" files at times exceeded 500 megabytes during digital enhancement. Files this large are necessary to produce images with output resolutions of 1000 pixels per inch. The image was written onto Ektachrome 100 film (EPN). The final result was truly amazing.

LOOKING BACK: The communication between Art Director, Photographer and Digital Artist is paramount to produce images that collectively appear singular in the final composite.

T. KEVIN SMYTH

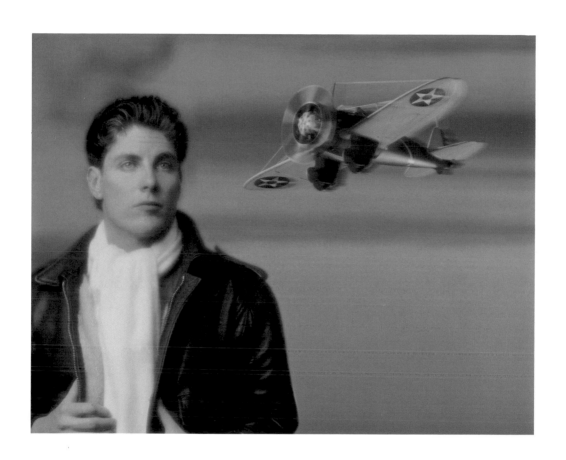

A M E R I C A

Propeller and blur created in Photoshop.

Model plane photographed outside.

Model photographed vertically in studio.

Background digitally extended to cover horizontal image area.

PHOTO NAME: The Immortal Aviator.

PHOTOGRAPHER: T. Kevin Smyth, Kevin Smyth Productions, Basking Ridge, New Jersey. U.S.A.

ASSIGNMENT: I became involved in a project with Glenn Russen of Chromewerk Graphics. A traditional photo-composer and transparency retoucher, Glenn was looking to setup a digital computer manipulation system and needed to produce a series of images to illustrate his capabilities. Being familiar with my work, he asked about using the portrait of the aviator for a composite.

CLIENT: Chromewerk Graphics.

FILM: Kodak Ektachrome100 Plus Professional (EPP).100 ISO rated at 100.

CAMERA: Nikon F4s.

LENS: Nikkor, AF Micro,105mm f/2.8.

HARDWARE: Apple Macintosh IIfx.

SCANNER: ISC-2010 drum scanner.

FILM RECORDER: Kodak LVT 8x10 Film Recorder.

SOFTWARE: Adobe PhotoShop 2.0.

ABOUT THE SHOT: This image is the result of combining two photographs in a computer system. The head shot of Michael Pierce came from a test shoot for Classic Models during a period when I was trying to bring a cinematic look and feel to my work. His features lent themselves to the timeless quality I wanted the image to evoke.

The second shot, of the model airplane, was photographed specifically for this computer project.

PREPRODUCTION: Having always loved the emotion seen in the Works Projects Administration Era allegorical murals of flight, I wanted to create an image which would incorporate elements from that time.

Knowing we would want to incorporate an image of a plane with the existing portrait, I began by searching several hobby stores in my area. After some time I came across a high quality model kit of a Boeing P-26A "Peashooter." This plane had what I felt were some romanticized details: the open cockpit, the fairing behind the pilot's head and the fixed, streamlined landing gear. (TIP: Always buy two kits of any model! Decals and small pieces are easy to ruin.)

SHOT #1: The first shot of Michael was lit in the studio using five strobe heads. For the mainlight, a Droncolor flooter used to the right of the camera provided directional lighting and bright, defined "catch lights" in the eyes. (This source is labeled in the diagram as #1.) The source needed to give the feeling of outdoor light without creating too much specularity. To reduce the contrast created by this main source, a Broncolor Starflex (#2) was set just left of the camera to add fill light to the shadows and soften the overall mood of the image.

Fig. 1

Strobe #3 was positioned at the rear of the set and aimed at the model to provide separation between the model and the background. This strobe's reflector was covered with a warming gel. The warm directional backlight would again help give the image a late, outdoor feeling.

Across the back of the set, a hand-painted canvas background of a sky was lit by strobes, one on either side of the set. These heads, #4 and #5, evenly illuminated the canvas. The background and lighting were diffused with a Nikon Soft #1 filter on the lens, which extended the image's sense of time.

SHOT #2: The model of the plane was attached to a small wooden dowel and taken outside. The dowel, which was later removed with computer retouching, allowed the plane to be supported so an even background of blue sky was visible through the camera. It was critical

to keep in mind the perspective and camera angle of the first shot. This prevented the image from taking on an awkward feeling when the composite was complete.

The lighting consisted of sunlight, which struck the plane from the rear, right hand side. When bounced into the front of the plane with a gold reflector, this warm fill light matched the softness and mood of the first shot. (See Fig. 2) Like the camera angle, keeping the temperature and specularity of the lighting the same was critical for the post production manipulation.

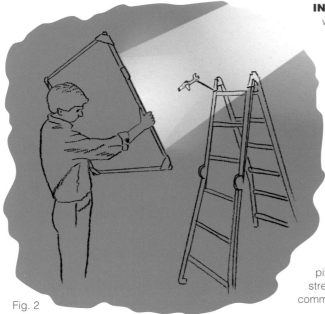

INTO THE COMPUTER: Both images were scanned using a DS Screen ISC-2010 drum scanner. Because we intended to show the capabilities of Adobe's PhotoShop Software vs. Scitex, SuperSet and other high end workstations, we scanned the images at very high resolution. The final file size was 60 megabytes.

The first stage of the manipulation process was to extend the background behind the pilot. (Keep in mind, shot #1 was originally vertical.) A section of the background was selected in Photoshop and then pasted into the appropriate area next to the pilot, using the "stretch effects" command. To disguise the elliptical shape of the pixels, originally round prior to being stretched, the "add noise" and "blur" commands within the program were used.

Fig. 2

Next, the image of the plane was brought to the screen and the model of the "peashooter" was outlined and "selected." This "selected" area was then pasted into the newly enlarged image of the pilot. The plane was given a sense of motion by "selecting" the trailing edges of the wings and tail and then applying the "motion blur" filter. "Motion blur," along with Photoshop's painting features, were used to create the propeller. The final image was output onto 8x10 film using a Kodak LVT film recorder.

BRIAN LAWLER

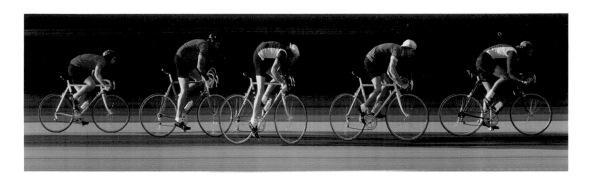

A M E R I C A

An owner-manager of a graphic arts firm, Brian Lawler is an expert at turning digital photographic data into film for printing. Past editor of Ballooning, an international magazine for balloon enthusiasts, Lawler's design and photographic talents there twice earned him positions in the Design Annuals of Communication Arts. A regular columnist, Lawler also has several books in print.

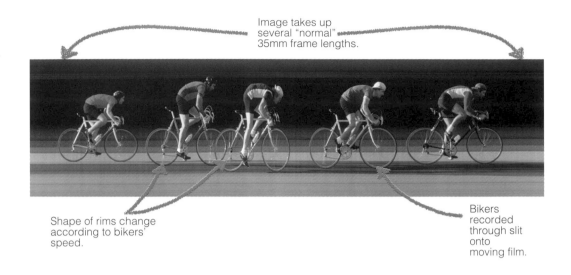

Image takes up several "normal" 35mm frame lengths.

Shape of rims change according to bikers' speed.

Bikers recorded through slit onto moving film.

PHOTO NAME: Rumpelslitscan.

PHOTOGRAPHER: Brian P. Lawler

ASSIGNMENT: Self study.

Film: Kodak Ektachrome 64(EPR). ISO 64, rated 64.

CAMERA: Nikon F 35mm.

LENS: Nikon 55 Micro.

ABOUT THE SHOT: I wanted an image of racing bicyclists for a poster. I had been inspired by a photo-finish of a horse race, and decided to build a camera to photograph cyclists in the same manner.

PREPRODUCTION: The first phase of the project was the actual building of the camera system. Starting with a standard Nikon F camera body, I needed to devise a means of altering the recording area of the camera. To do this, I cut a sheet of Rubylith red gelatin film and removed a .25-inch slit down the middle. This film was then photographed on a large horizontal process camera at 10 percent to create a precise .0025-inch slit on a piece of Kodalith film. To prevent any edge noise on the exposure, I still-developed the film in Kodalith RT developer which yields a virtually grainless image.

Next, I glued this piece of film onto the film plane of the camera with the slit oriented vertically. (Fig. 1) This created a masked area in front of the film that would allow only the .0025-inch vertical area of the film to be exposed as the film passed behind it, recording the image. The idea was to have the film move behind the mask at the same speed the subject passed in front of the camera, recording a continuous image of the subject.

In order for this to occur, I had to further modify the camera with a small DC motor which attached to the shaft of the rewind knob (it was possible to machine the the motor mount so that the rewind knob could be replaced and the film slit removed after use, with no damage to the camera).

The speed of the motor would vary depending on the voltage supplied to it by a battery pack. (See Fig. 2) The DC motor could run on voltages from about .7V to about 9V. The voltages varied proportionately with the number of batteries put into the circuit. In other words, the more batteries used, the faster the motor would turn, and vice versa.

Keep in mind that to make the exposure, the film was first advanced, unexposed, through the camera, and then with the shutter open, electrically rewound (with the shutter on "bulb") back into the film cassette.

TESTING THE SLIT CAMERA: Before exposing the final image, it was necessary to determine the effects of the different voltages. To do this, I tested various battery arrangements to determine the exposure based on voltage variations. Once that was accomplished, I was able to make some test exposures. For this, I encouraged a group of bicyclists that I knew to ride by my house on the morning of their next team ride and "pose" for photos in front of the camera.

Fig. 1

I had the bicyclists ride past the camera a number of times, first left-to-right and then right-to-left. Exposures were bracketed by changing either the voltage or aperture on each pass, being certain to leave the ISO setting constant.

When we were finished, the team continued on their ride and I took the film in for processing. I had made notes of my exposures indicating voltage, aperture, and which pass was being recorded — left-to-right or right-to-left. The processed film, however, had all the images recorded left-to-right! There were no images going the other direction. Analysis of this mystery led me to the discovery that the film's direction of travel determines the direction of the recorded image, not the moving objects in front of the camera. If you operate a slit-scan camera in this fashion, and photograph people walking in front of the camera in both left-to-right and right-to-left directions, all of the people will come out facing left-to-right! This is what happened with the bicyclists.

Another interesting phenomenon is the distortion that occurs in this image. Bicycles traveling faster than others in the group are distorted — their wheels appear to be narrow ellipses – while normal round wheels belong to those traveling at the proper speed for this voltage. Bicyclists traveling slower have wide elliptical wheels. One cyclist has two differently shaped wheels, indicating that he accelerated while passing the camera.

Fig. 2

In all of the images I took during testing, the bicyclists weren't working hard enough to appear to be racing. To solve this problem, I chose to have the pack ride past the camera on an upward slope — racing against gravity. I mounted the camera on a tripod and tilted the head to match the slope of the hill.

With the pack approaching position, the shutter was opened and the motor was turned on. Several passes were recorded, again bracketing the voltage and exposure. This final image was recorded with a voltage of 4.9V DC at f/8.

DIGITAL REBIRTH: Because the film moved roughly through the camera, the original film had some "chatter." To correct this problem, I scanned the image on the Leafscan 45 scanner. The size of the image is 35mm x 4.5-inches in length, so I taped it tightly across the opening of the scanner's 4x5 film holder. The resulting image was scanned for reproduction at 1.25 x halftone frequency x enlargement (in this case it resulted in an image just over 11 megabytes).

Using an Apple Macintosh Quadra 700 and Adobe Photoshop, I reduced the chatter to an acceptable level, slightly brightened the image, sharpened it with Photoshop's Unsharp Mask filter and made it ready for reproduction. Taking into account the characteristics of the press that would be printing the job, I manipulated the curve controls to correct for effective dot-gain. The press and paper combination have a total dot-gain at 50% of about 18%, so I bent my 50% point in curves to 32%. In addition, the press in question plugs the shadows at about 96%, so I opened up the shadows in my image to limit the shadow dot to that percentage. The offset process also creates loss in the highlight dots, so I put a highlight limit of 4% into the curves. The resulting image appears flat on-screen, but prints beautifully on press.

The ability to fine-tune the image digitally made me considerably happier with the image, as it made the annoying chatter less noticeable and the image more attractive overall.

LOOKING BACK: This photograph was used on a promotional poster advertising my company in San Luis Obispo. Under the image was a host of advertising copy. I have since seen the poster in many far away places, and I'm always pleased.

After the bicycle photo, I photographed an entire steam-driven train on a single roll of Ektachrome. It's more distorted than this image because I couldn't move the film fast enough to match the speed, but it's an amusing image that is 36-exposures long! After that, I eventually disassembled the camera and returned it to regular duty.

Every great camera needs a name. Since this camera used a slit, and scanned the image onto moving film, I dubbed it Rumpelslitscan.

PAUL HOPKINS

A M E R I C A

PAUL HOPKINS

Woman photographed on location with available light and flash fill.

Cat photographed in studio with strobe light.

Set, jewelry and illustration added in the computer.

Cat & woman images merged in computer.

IMAGE NAME: "The Sphinx of Disappointment."

PHOTOGRAPHER: Paul Hopkins, D.S.P. Productions, Los Angeles, California. U.S.A.

ASSIGNMENT: This piece belongs to a fine art series entitled, "The Darker Side of Passion." The image represents the strength of patience by disappointment.

FILM: Kodak T-Max 100 Professional (TMX). ISO 100 rated at 32.

ART DIRECTOR/ILLUSTRATOR: Kino.

CAMERA: 35mm.

LENS: 85mm.

Scanner: Leaf 45.

Hardware: Macintosh Quadra 700.

Software: Adobe Photoshop 2.0.

ABOUT THE SHOT: This image was created by combining two images on a computer system. The images were enhanced and combined with illustrations to create the image's environment. Final enlargements were done off of an Iris Inkjet printer onto watercolor paper.

PREPRODUCTION: The art director developed a rough sketch of the desired image. We then discussed different ideas, locations and props to be used in the shot. We also scouted five or six locations before selecting one, just outside of Hollywood. During our location visits, we determined that the best light would occur between 5-6 p.m. The model was selected by the art director from two models I had suggested.

SHOT #1: LOCATION SETUP: My assistant and I arrived on location early to ensure that we would have enough time to set up the shot. I used a 35mm camera system with an 85mm lens. 35mm lent itself to the project and would be sufficient for a 16x20-inch final print. I selected a low camera angle to help give the model a larger-than-life appearance.

Since the model would face directly into the sunlight, a small portable flash unit was set up to provide fill light for shadow detail. (Fig. 1) This strobe was located just to the right of the camera and about six-feet off the ground. An incident meter was used to determine the exposures of both light sources. The reading of the sun which acted at the main source was f8 at $^1/_{60}$ second, and the fill was placed to read f4.5 at $^1/_{60}$ second.

Fig. 1

The art director, model and make-up artist arrived at around 4 p.m. to prepare for the shoot. Appropriate styling of the model's hair and makeup were critical to the success of the shot. She was not wearing jewelry at the time the image was shot, these features were added by the illustrator in the computer. The preparation of the model took about one hour which allowed us to shoot from 5:00 to 6:00 P.M.

Several rolls of film were shot to provide us with a variety of poses from which to choose.

SHOT #2: STUDIO SETUP: The studio shoot was arranged in order to capture an appropriate image of a cat. We used a piece of white, seamless background paper to create a sweep on which the cat was placed. The same camera, lens and camera angle were used to ensure that the subjects would be correctly sized and appear from the same perspective when merged in the computer.

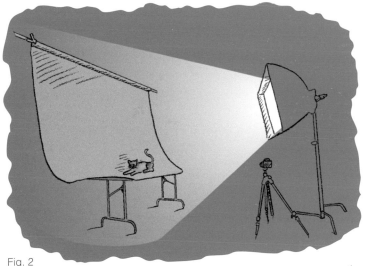

Fig. 2

A strobe head fixed with a small softbox was positioned above the camera and to the right to match the fill light from the first shot. (Fig. 2) Because we would only be using the rear half of the cat, we were only concerned with the lighting on that side of the cat. This is why only one light was used for this shot.

Again an incident meter was used to determine the proper exposure for T-max 100 film. Once the light was set, the cat was placed on its stomach, on the paper, and several frames were recorded. When everything was ready, the image was recorded on film.

INTO THE COMPUTER: The film was processed using a Kodak T-max reversal kit which yields positive black and white images. The art director and I then selected the two photographs to be used for the final image, and worked on a final sketch before working on the computer.

The film images were scanned into the computer creating a digital representation of the photographic image for manipulation. The photograph of the model was opened in window #1 on the screen, and the photograph of the cat in window #2. Next, the rear half of the cat was selected and mask-generated around this portion of the image. Using the computer's "copy" feature, the mask portion of the cat was copied onto the computer's clipboard. This copied portion was then "pasted" into window #1 of the woman, and moved until it was appropriately positioned over the legs of the model. The pixels which created the border between the model's body and the cat's body were then "blurred" to blend and hide the transition.

After this was completed, the work on the background began. The illustration of the background consisted of two trees, a gate and tiles. This was accomplished on the computer, using the mouse to draw specific shapes, then using various tools and techniques to create specific color and lighting patterns. Final touches included enhancement of the foreground and the addition of jewelry to the model using these same techniques.

Once the image was complete, it was output to 4x5 film with a digital film writer from which a 16x20-inch enlargement was made.

DEAN COLLINS

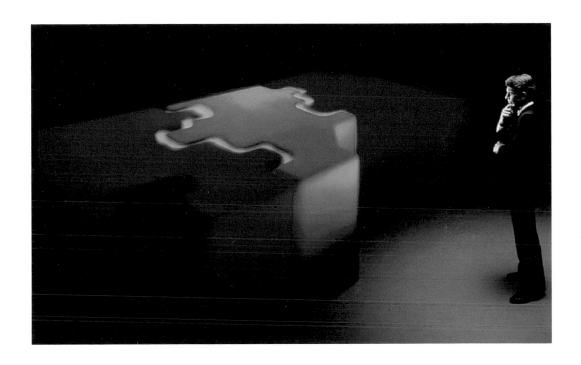

A M E R I C A

For over a decade, Dean Collins has educated photographers around the world with his informative and entertaining lectures, videos and publications. Dean's education and research in the science of photography has led to his development of numerous theories and techniques. Recent efforts have enabled him to combine his knowledge of photography and interface it with the emerging technology of digital imaging.

DEAN COLLINS

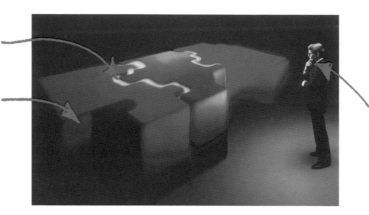

Glow caused by strobes under cubes & a diffusion filter over the lens.

Each cube exposed on a separate sheet of film. Colors generated on camera.

Model front lit to emulate light coming from cubes.

PHOTO NAME: Contemplation.

PHOTOGRAPHER: Dean Collins.
Collins and Associates, San Diego, California. U.S.A.

ASSIGNMENT: As part of a sales brochure that was introducing NCR's new parallel processor, the image needed to say two things: Choices and Problem Solving. The type that accompanied this page read, "NCR recognizes that you may be faced with islands of information that do not interact. The NCR 3600 provides an open platform with the power and scalability to bridge these gaps."

FILM: 4x5 Kodak Ektachrome Professional, EPP 100, rated at 80 ISO.

Exposures:	Shot #1	Yellow Glow	f/45 - bulb exposure 8 strobe flashes
	Shot #2	Piece A	f/45 - bulb exposure 8 strobe flashes
	Shot #3	Piece B	f/45 - bulb exposure 8 strobe flashes
	Shot #4	Piece C	f/45 - bulb exposure 8 strobe flashes
	Shot #5	Man	f/45 - bulb exposure 8 strobe flashes

CLIENT: NCR.

ART DIRECTOR: Dennis Scmeltzer.

CAMERA: Sinar P2 4x5.

LENS: 90mm Schneider.

ABOUT THE SHOT: The final image is the result of five different 4x5 transparencies that were individually scanned and then digitally combined on an Apple Macintosh II FX.

PRE-PRODUCTION: Specific instructions, in regard to the color, shape, and texture of the three puzzle pieces, were given to a model maker. The completed puzzle measured 12 feet in length, 5.5 feet in width, and 3 feet in height. The cubes, made of a light white plaster,

were sanded down to have a smooth surface. The pieces were fitted together so that the connecting gap could be varied to allow the desired amount of light to pass between them.

The model was cast by the production manager, art director, and client. They were looking for a conservative and sophisticated corporate male.

SETUP: The setup was prepared in two steps. First, the cove (800 square feet) was painted dark grey to allow the light to fade to black quickly in the shadow areas. Two sawhorses were then placed parallel, eight feet apart from eachother in the middle of the cove. Next, two 8 foot, 2x4 inch boards, were placed so that they ran from one sawhorse to the other, one on each side. This created a rectangular support frame. A 4x8 foot sheet of 1/2 inch frosted plexiglass was then positioned on top of the frame. A skirt made of black felt material ran around the outside of the frame work. This skirt extended from the floor to the top of the plexiglass. Finally, two Broncolor strobe heads without any parabolic reflectors were put on floor stands and slid under the fabric. They were positioned in the center, and one third in from either end of the box. When completed this structure resembled a giant lightbox. (Fig. 1)

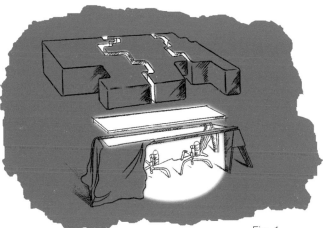

The second step was to place the puzzle pieces ontop of the plexiglass. This allowed the gaps between the pieces to be illuminated from below.

A 4x5 Sinar P2 view camera with a 90mm lens was placed on a Foba studio stand and set up 15 feet away from the set. The camera height measured 5 feet 4 and 1/2 inches from the floor to the camera's monorail. Two camera movements, a 6° tilt and 6° swing on the front standard, were necessary to carry the plane of focus both across the top and along the front of the puzzle.

Fig. 1

SHOT #1; THE YELLOW GLOW: With the entire room dark, the two strobes enclosed in the light table were set on full power and turned on to illuminate the frosted plexiglass. Two filters were placed on the rear element of the lens, two layers of Roscolux #11 Straw to add the yellow color and a Gepe glass slide mount for diffusion. From the camera's view point the effect was a bright glowing strip which defined the separations between the cubes. The client requested the glow to have a brightness of 36%, or one stop brighter than 18%. To determine the exposure of this area, a spot meter reading was taken for several points of the crack to ensure that the reading would render an even exposure. The ISO of the meter was adjusted to take into account the one stop loss of light for the filters. This reflective reading, f22 at 1/60, placed an 18% value on this image area. To carry focus throughout the image, the camera aperture was set at f/45. Because f/45 is two stops closed down from f/22, the exposure needed to be increased three stops to bring the image to the desired 36% value. (At f/45 the metered value was 4.5%, so an increase of three stops would bring the value to 36%.) To obtain the correct exposure, the shutter was set to bulb and the strobes were manually fired eight times.

The yellow glow was the only thing exposed on this sheet of film.

SHOTS #2, #3, #4; THE PUZZLE: A single strobe head with a 9-inch reflector was attached to a boom arm and positioned 6 feet directly above puzzle piece A. Black felt was placed over cubes B and C. The yellow filters were removed from the camera and replaced with a Roscolux Medium Red #27. A reflective light meter was again used to determine the exposure. The reading of the top center of the cube was f/22 at 1/60. Like the previous

exposure, the client and art director requested a reflective value of 36%. The same exposure calculations for the yellow glow applied here. The camera was set at f/45 and the shutter on bulb. With the strobe modeling lights off, and the camera open, the strobes were manually fired eight times to render the glowing color on the cube.

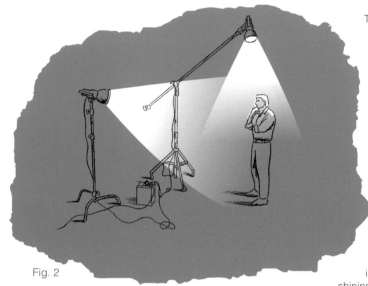

Fig. 2

This procedure was repeated to expose each cube on a separate sheet of film, each time moving the strobe over the top of the next cube and masking out the other cubed with black felt. Also, the color of the filter inside the camera was changed. (Roscolux Primary Blue #80 for cube B and Light Red #26 for cube C.) The final result was three sheets of 4 x 5 film with only one piece of the puzzle exposed on each one.

SHOT #5; THE MAN:

The man was lit by two separate light sources. The first was with a strobe with a 9-inch reflector on a boom arm shining directly down onto the model. This light created both a hair light, as well as the circle of grey on the floor. The second strobe, also with a 9-inch reflector was positioned on a light stand 10 feet in front and to the right of the model. A spot grid was added to funnel the light onto his face and hands. (Fig.2)

Here the exposure was determined by using an incident light meter with the dome pointed at the light in front of the model. The power of the strobe pack was adjusted until it read f/45 at 1/60. No filtration was used for this image.

Before the film was shot, the felt was removed from the puzzle. In the final exposure of the man there was a hint of detail in the cubes; this was used as a point of reference when the images were merged in the computer.

INTO THE COMPUTER: All five 4 x 5 chromes were individually scanned on a high-end scanner at 350 dots per inch, (dpi). The scans were loaded at low resolution into Adobe Photoshop on a Macintosh.

The image of the blue center cube was used as the base photo because of its central location in the image. It became the foundation for the build-up. All of the other images were added to the base to create the final shot. Next, masks were created in the computer to cut out the other cubes and the glow. These cut image parts were "pasted"* onto the base photo. After each image was "pasted" onto the shot, the bottom layers were "revealed"* to expose the other cubes and glow.

Using the puzzle as a point of reference it was easy to paste the man into the set. The floor areas were "faded"* to merge the black areas together where the bottoms of the cubes ran into the grey floor.

Once the assemblage was completed, color separation films, generated directly from the computer, created the final printed piece.

Paste, fade and reveal are terms associated with Adobe Photoshop.

BERNARD VAN ELSEN

A U S T R A L I A

In 1968, Bernard Van Elsen established himself in an unused warehouse in Adelaide, Australia, specifically to provide the best car photography in the country. The rest is legend. His lighting skill, inventiveness and innovation have set many standards which have won him awards in all areas of advertising and corporate photography.

BERNARD VAN ELSEN

Reflection off the cove ceiling.

Highlight reflection of cove wall.

8x10 background chrome electronically stripped in.

Horizon line created by black fabric.

Studio floor propped to resemble outdoors.

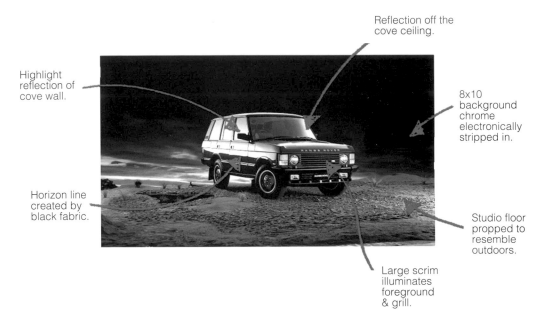

Large scrim illuminates foreground & grill.

PHOTO NAME: Range Rover.

PHOTOGRAPHER: Bernard Van Elsen. Van Elsen Photographics, Kent Town, South Australia. Australia.

ASSIGNMENT: The shot was to show the Range Rover in an environment resembling the Australian outback. A studio shot was requested to ensure that the lighting on the truck could be strictly controlled. The final image was to appear on a double page spread in a magazine. No guidelines in relation to type were given.

FILM: 4x5 Kodak Ektachrome Professional 64T, rated at 64 ISO. 8x10 Kodak Ektachrome Professional, EPP 100, rated at 100 ISO.

EXPOSURES: Main image, 10 seconds at f32. Background image, 30 seconds at f32.

CLIENT: D.M.B. & B. Weeks Morris Osborn.

ART DIRECTOR: Richard Osborn.

CAMERA: Sinar 4x5.

LENS: 150mm Schneider.

SHOOT TIME: 3 days.

ABOUT THE SHOT: The truck, along with the set, were photographed in a studio cove with a black background. The background, an 8x10 location shot taken at sunrise, was electronically stripped into the original. The retouching and stripping was completed on Facelabs Quantel "Bigfoot" Graphic Paintbox system, then output to a high resolution Quilt transparency.

THE SETUP: The first part of the production was to create the set. The idea was to create an environment that would closely resemble the outdoors. Several truck loads of dirt were brought in from the outback and dumped in the studio, spread out, and then flattened with rollers. Next, the dirt was sculpted to resemble the chapped surface of the desert floor. The art director then selected areas for the shrubs to be planted and the pond to be dug out. A taxidermist supplied the lizard which was added for fun.

A Sinar 8x10 view camera was set up for positioning and the truck was driven in from the rear of the set. Assistants then detailed the truck, removing dirt from the tires and looking for any imperfections.

A large piece of black fabric on a support frame was then stretched across the entire background of the set to ensure that the film would not be exposed behind the truck. Next, a scrim with two 1K lights behind it was positioned just off the right side of the camera (the front of the set); this illuminated the grill and headlights of the Rover. Two more 1K lights were placed on floor stands to the left and positioned so the light bounced off the inside of the cove. A smaller piece of black fabric was then placed between these 1K lights and the Rover. This long, narrow fabric created the horizon line reflected on the side of the truck. (The dark reflection is the black fabric; the white reflection is the light bouncing into the cove wall and ceiling.)

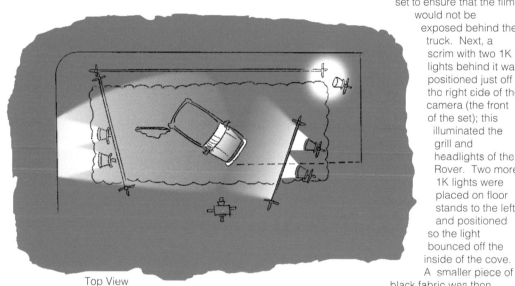

Top View

One final light, a 2K was added to give shape to the front windshield and hood; it was positioned at the right rear of the set. The 2K was tilted up so the light would bounce off of the coved ceiling. The best reflection was obtained by looking through the camera as an assistant made minor adjustments to the reflecting angle of the 2K. Bounce light worked well in this environment to create a soft transfer of light from the highlight to shadow areas in the glass and chrome.

To emulate the color of the setting sun, various densities of warm colored Lee gels were blended with the tungsten lights, and an 82A and 10 magenta (filters or gels) were added to the camera lens.

METERING THE LIGHT: Working with tungsten lights, it was easy to determine how the film would register. With the meter ISO set at 40 to compensate for the filter, an ambient reading was taken. A Polaroid, shot at 10 seconds at f32, was used to make slight adjustments to both the lighting and the set. Several Polaroids were taken before the art director gave the o.k. and final film was exposed.

SHOT 2; THE SUNSET: A location with an open skyline was necessary to get an 8x10 image of the clouds. Several exposures were taken using various filters to give the art director a variety of chromes from which to choose.

Front View

DEAN COLLINS

A M E R I C A

For over a decade, Dean Collins has educated photographers around the world with his informative and entertaining lectures, videos and publications. Dean's education and research in the science of photography has led to his development of numerous theories and techniques. Recent efforts have enabled him to combine his knowledge of photography and interface it with the emerging technology of digital imaging.

Out-of-focus background taken outside.

Strobe from behind to edge-light woman, emulating outdoor sun.

True tone of model determined by an incident meter reading of large panel in studio.

Blur created in Photoshop.

PHOTO NAME: Rained Out?

PHOTOGRAPHER: Dean Collins, Collins and Associates, San Diego, California. USA.

ASSIGNMENT: This image was produced as part of an educational lecture to increase awareness about computer imaging to the photographic community. The lecture sponsored by Kodak's Center for Creative Imaging, Apple Computers, Supermac, Ken Hansen Imaging, Leaf Systems, Inc., and Adobe Software travels both domestically and internationally.

The purpose behind this particular image was to illustrate the potential that computers can have in aiding a photographic studio; in this case, how a rainy day didn't result in the loss of a day's work and paying out cancellation fees.

FILM: 35mm Kodak Ektachrome EPP, 100 ISO rated at 80 ISO.

CAMERA: Canon EOS1, 35mm.

LENS: Canon 200mm, f2.

SCANNER: Kodak RFS 2035, 35mm, 1000 dpi.

HARDWARE: Macintosh Quadra 700, 20 megabytes of RAM. Syquest 44 megabyte storage drive. Monitor: Supermac, Supermatch 20T.

SOFTWARE: Adobe Photoshop, 2.0.

ABOUT THE SHOT: This image is the result of combining two 35mm slides into a single image–one shot of the background and the other of the woman.

SHOT 1; THE OUTDOOR BACKGROUND: The first image, the out-of-focus background, was taken out the front door of our studio on a small walking path. An assistant stood on the path and the camera was focused on him. An incident meter reading was taken with the dome of the meter pointed at the sun to ensure the shadow would not affect the reading. Once the exposure and focus point were locked into the camera, the assistant stepped out and a few slides were exposed.

These shots, along with several other location backgrounds slides, are kept in our filing system. Most of the backgrounds were shot at historical locations in San Diego where photographers are not allowed to use tripods because they mark up the clay floors. The background files contain a series of both in and out-of-focus images.

SHOT 2; THE WOMAN: The image of the woman was taken in the studio and lit to emulate outdoor sunlight. A red sweep was draped behind the model at the rear of the set. This background was selected to act as a color key for a mask which would later be created in the computer.

The lighting consisted of two strobe heads. The first head was placed off to the right of the camera at the front of the set. This head illuminated a 6x6 foot Lightform panel with a translucent fabric. This large source created soft diffused light on the model, the same light quality that you would find outdoors from light bouncing off of white walls. The second strobe was placed behind the model, opposite the first strobe, at the rear of the set. This head acted as the sun, creating a rim of light on the model. Finally, another 6x6 foot panel was placed to the left front of the set. This panel was covered with a white reflective surface and added fill light to the shadow areas. (Fig. 1)

Fig. 1

METERING THE LIGHT: An incident meter was placed next to the woman's face with the dome pointed towards the illuminated panel on the right. This meter reading, f4 at 1/60, placed the proper exposure for the model's true tonality, or diffused value. Next, a second reading was taken with the dome pointed towards the raw light, which was rim lighting the model. This reading, f5.6 at 1/60, was taken to ensure that the rim light would be overexposed from the main light by only one stop. A one stop ratio created a realistic outdoor look without the highlights getting too hot.

INTO THE COMPUTER: Once the film was E-6 processed, the two images were loaded into the slide carrier of a Kodak RFS 2035 35mm film scanner linked to a Macintosh Quadra 700. To determine what resolution (dots per inch, dpi) to scan the image, it was necessary to know the size of the final printed image and at what halftone screen frequency the image would be printed. This would save time once the image is scanned because the larger the scan in dots per inch, the larger the file, and the more memory (random access memory and storage memory) that is being used.

In this case the final image size would be 4x5 inches and was being printed at 175 half tone lpi, similar to the printing and image size of a small catalog. The formula we use for determining the scan resolution is known as the Lawler Factor: 1.25 x final halftone density x % increase of reproduction = scan dots per inch. Therefore, our formula was , 1.25 x 175 (halftone lines) x 4 (400% increase in size) = 875 scan dots per inch. Because the Kodak scanner has four default settings, 250 dpi, 500 dpi, 1000 dpi, and 2000 dpi, the setting of 1000 dpi was selected for the scans. Each image was cropped in the scanner

Shot 1

preview window to allow the work to be done on the smallest file possible. Each slide file was 4 megabytes in size (4 million bytes).

Once the images were scanned, they were imported into the Adobe Photoshop program. First, the image of the woman was manipulated. By using a series of techniques, the red background was selected, and dropped out of the image, leaving only image of the model (without the red background). Next, the background file was opened, and the image of the model was pasted onto the out-of-focus landscape.

The final image, stored on a Syquest disk, was taken to a service bureau and output to separation films for printing. Additionally, the same file was output as a 35mm slide for projection by an Agfa Forte Matrix film recorder at 4000 lines per inch.

Shot 2

STEVE KRONGARD

A M E R I C A

STEVE KRONGARD

Sky shot from New Mexico dropped into masked area.

Original shot of houses taken in Cape Cod.

Manipulated image flipped on itself to give mirrored effect.

PHOTO NAME: Untitled.

PHOTOGRAPHER: Steve Krongard, New York, New York. U.S.A.

ASSIGNMENT: This image was created during a workshop at Kodak's Center for Creative Imaging in Camden, Maine.

FILM: Shot #1: The Houses, 35mm Kodak, Kodachrome 25, rated at 25 ISO.

Shot #2: The Sky, 35mm Kodak, Kodachrome 64, rated at 64 ISO.

CAMERA: Nikon F3.

LENS: 20mm & 85mm.

HARDWARE: Macintosh IIfx.

SOFTWARE: Adobe Photoshop.

ABOUT THE SHOT: This image is the result of two 35mm slides which were combined on an Apple Computer using Adobe Photoshop software.

SHOT #1, THE HOUSES: The initial shot of the houses, taken in Cape Cod, was an appealing image although aspects of it were lacking. A 20mm lens, used to exaggerate the perspective, distorted the foreground which took away from the graphics of the buildings. The sky offered a rich blue color, but again was only average, not lending much interest to the image. Kodachrome 25 was the film of choice because it offered fine grain and long term stability. (Shot 1)

SHOT #2, THE SKY: The second component of the final assemblage was taken in New Mexico. At the time the camera was loaded with Kodachrome 64. The camera was hand held during the 1/30th of a second exposure to record a bracketed series of images of the sky, just after the sun had set. (Shot 2)

INTO THE COMPUTER: A few weeks before the workshop, the images were sent ahead to be scanned and stored. Each image was about 2.5 megabytes in size.

The first image to be manipulated was the houses. They were separated from their backgrounds by creating a mask. Next, this masked area was flipped giving the image symmetry. A fresh file was then

Shot 1

created to store the new image – Saving the image during various phases of the manipulation process is a good habit to develop because it allows you to backtrack if a mistake is made or a change is desired.

Shot 2

The image of the sky was then brought to the screen, and flipped in the same fashion as the houses. Again this new element was saved as an independent file. Now saved, the flipped sky was brought into the image of the houses as it was pasted behind the masked area. A soft edged mask was used so the merging of the two images would appear natural. The final step was to add a little warmth in color to the houses, so they would appear to have been photographed at the same time of day as the clouds.

Before the image was taken for a 35mm slide output, the sharpen tool was used on the entire image to ensure the highest quality would be obtained from the image setter. The sharpen filter in Adobe Photoshop is an electronic technique for enhancing edge definition in an image. With an effect similar to improved focus, the sharpen technique compares the pixels in an image with adjacent pixels, and enhances their contrast where edges or significant value changes occur.

Variations on sharpen exist; some will sharpen an entire image, increasing contrast between all pixels, while others sharpen only the edges, and then only when a certain contrast threshold is reached.

Sharpening electronic images is usually a good idea, as it tends to enhance an image's natural contrast, and sharpening compensates in part for the wear and tear that scanning and halftone reproduction have on the original images.

JAMES A. SUGAR

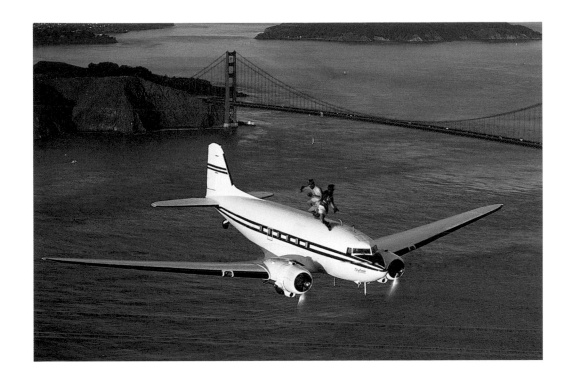

A M E R I C A

For over 20 years, Jim Sugar has worked as a contract photographer for National Geographic. His assignments, which have taken him all over the world, enabled Jim to earn the Magazine Photographer of the Year Award from the National Press Photographers' Association. He has also received numerous White House News Photographers' Association awards and World Press photo contests.

JAMES A. SUGAR

North tower of bridge repainted.

Horizon line straightened.

Identification numbers of DC-3 removed.

Men shot in studio are lit similarly to environment and "scaled" to size using Photoshop.

PHOTO NAME: Surfing San Francisco Bay.

PHOTOGRAPHER: James A. Sugar, Mill Valley, California. U.S.A.

ASSIGNMENT: This image was produced in part for Digital Imaging 92, a lecture involving me, Dean Collins and Brian Lawler. The lecture was created to increase the awareness of the coming of the digital age in photography.

The concept for this image was to show how a photojournalist could use a Macintosh computer running Adobe Photoshop to combine an existing stock photograph with a carefully crafted studio shot to produce a final image that satisfied the client's requirements.

FILM: Kodachrome Professional 64 ISO, rated at 64.

CAMERA: Nikon F3.

LENSES: Shot #1: Nikkor 80-200mm zoom f4.5.

Shot #2: Nikkor 35mm f2.

SCANNER: Leaf 45 at 200 dpi.

HARDWARE: Macintosh Quadra 700, 20mb RAM, SuperMac Thundercard, Apple 21" monitor.

SOFTWARE: Adobe Photoshop 2.0.

ABOUT THE SHOT: The final image combines two 35mm slides into a single image: one image of a vintage DC-3 aircraft flying above the Golden Gate Bridge and the second a studio image of the "surfers".

SHOT #1, THE AIRPLANE: The original photograph of the plane was shot on assignment for National Geographic Magazine as part of a story on the San Francisco Bay. The major obstacles of this shoot came in the preproduction. Locating and obtaining permission to photograph the DC-3 and finding a plane to shoot from were the first steps. The shoot plane needed to have a removable rear door and the ability to fly at the same speed as the DC-3. Next the pilots' schedules were coordinated and permission

Shot 1

was obtained from Air Traffic Control. It was then a matter of waiting for the perfect weather, not always easy in San Francisco.

On the day of the shoot an assistant and I boarded the plane with five Nikon F3 bodies. I wore a head set to communicate with the pilot of the photo plane, a Piper T-tail Lance. By keeping eye contact with the pilots of the DC-3, I used hand signals to make small changes in the DC-3's position. Otherwise, the DC-3 flew in formation off the Lance.

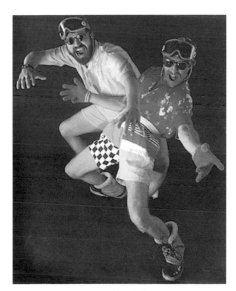

Shot 2

There was only a 15 to 20 second window during each pass where both the plane and the bridge were in perfect position. Maintaining a safe distance between planes while composing the plane and bridge in the viewfinder was a real test. As minor adjustments were made in the composition of each pass, some 24-36 images were recorded.

SHOT #2, THE SURFERS: I photographed the two surfers in the studio, emulating the same lighting and camera angle used to record the plane. A slide of the DC-3 was projected just opposite the set so I could match the position of the model's hands, feet, and bodies with the angle of the plane's fuselage. A dark background was selected to contrast the model's bright clothes and to enable the men to be easily separated from the background later using Photoshop's "Magic Wand".

The lighting consisted of four strobe heads. The main light, a strobe fired through a translucent umbrella, offered a quality of light similar to the outdoor

sun. A softbox was then set opposite the main to add fill light to the shadows, reducing the scene contrast range. The other two strobes, positioned to the rear and on either side of the set, rim-lit the subjects, separating them from the background. (Fig. 1)

INTO THE COMPUTER: After editing the film for the best frame from both shoots, I scanned the 35mm slides into a Macintosh Quadra 700 computer using a Leaf 45 scanner. The image was scanned at 200 dots per inch, Since the final output for publication would be approximately 4x5 inches in size, the file size was 2.3 Megabytes.

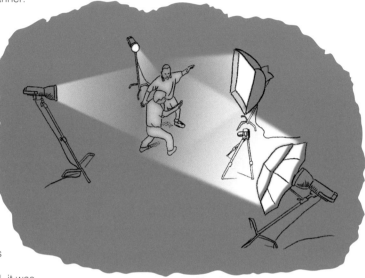

The image of the plane was the first to be brought up on the monitor. Using the cropping tool, the horizon of the image was straightened. Next, the logos on the side of the plane were removed and the north tower of the Golden Gate Bridge was repainted in. The weather was grey on the day of the shoot. Once this image was finalized, it was saved to be used later. Next, the surfers were

Fig. 1

brought up on the screen, isolated from the background using the magic wand, and "copied" onto the computer's "clipboard". The image of the saved plane was brought back to the screen. The "paste" command was then selected to place a copy of the men, from the clipboard, onto the image of the plane. Since the men were proportionally larger than the plane and did not appear real, the pasted image was reduced in size by using the "scale" selection. Once the surfers reached a believable size, their position on the plane was adjusted, and the completed image was saved.

DAN LIM

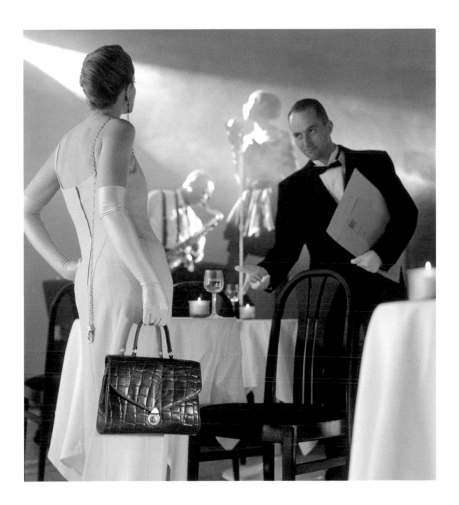

C A N A D A

Dan Lim's photography career began in 1980, in San Francisco, CA, as an apprentice for various still life and fashion photographers. His natural tendency has always been to photograph people. In between commercial assignments, Dan spends many hours in his Toronto studio, testing new concepts and ideas to keep his portfolio a continual surprise for art directors.

Spot grids are used to highlight models on the stage. Fog machine helps to create ambience.

Rear wall of studio painted dark-grey.

Waiter lit by bounce light from strobes.

Purse is selected in the computer and the rest of the image is converted to black & white.

PHOTO NAME: Untitled.

PHOTOGRAPHER: Dan Lim, Dan Lim Photography, Toronto, Ontario. Canada.

ASSIGNMENT: To create an upscale image for an international bag company to be used in packaging, catalogue, display ads and point of purchase displays.

FILM: Kodak Ektachrome 100X Professional, (EPZ). 100 ISO rated at 100.

EXPOSURE: 1/60 second @ f/4.5.

CLIENT: Bree International.

ART DIRECTOR: Alex Wittholz, Helios Design.

STYLIST: Lynn Spence.

SHOOT TIME: One and one-half days.

CAMERA: Mamiya RZ 67.

LENS: Mamiya, 180mm f/4.5.

COMPUTER SYSTEM: Kodak Premier.

ASSIGNMENT: My client, Bree International, is an upscale international bag company with stores in Europe, North America and Asia. This image comes from a campaign which I was selected to shoot for both my strength in lighting and graphic composition, as well as my ability to work with people on camera. Because I shoot a lot of fashion, I am used to recording fluid body movements and positions. This helps to keep images from appearing contrived.

The image was to be used in packaging, catalogs, magazine advertisements and point of purchase displays. No guidelines in relation to text were given.

PREPRODUCTION: This shot required a lot of time and preparation. At a creative meeting, the art director, stylist and I decided on which props and what wardrobe would be used. I was given the freedom to select the talent for the shoot.

THE SETUP: A dramatic yet simple set was constructed for the shot. The stage, where the talent would appear to be performing, was not terribly difficult to build. The trick, however, was to build it at the right height in order to suit the desired camera angle. Two assistants were used to help construct the set and stage.

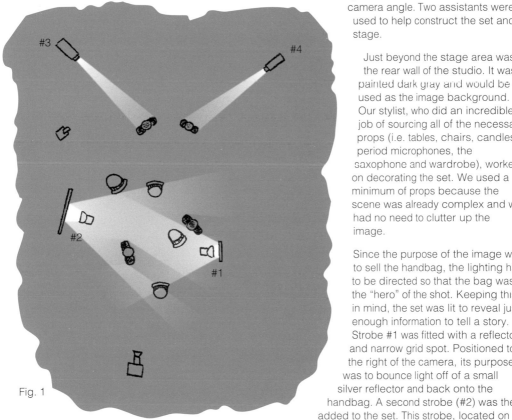

Fig. 1

Just beyond the stage area was the rear wall of the studio. It was painted dark gray and would be used as the image background. Our stylist, who did an incredible job of sourcing all of the necessary props (i.e. tables, chairs, candles, period microphones, the saxophone and wardrobe), worked on decorating the set. We used a minimum of props because the scene was already complex and we had no need to clutter up the image.

Since the purpose of the image was to sell the handbag, the lighting had to be directed so that the bag was the "hero" of the shot. Keeping this in mind, the set was lit to reveal just enough information to tell a story. Strobe #1 was fitted with a reflector and narrow grid spot. Positioned to the right of the camera, its purpose was to bounce light off of a small silver reflector and back onto the handbag. A second strobe (#2) was then added to the set. This strobe, located on the left of set, was directed away from the set toward a large 4 x 8 foot sheet of white reflector board. This created a soft "bounce" light across the set, providing the room's ambience.

The singer and saxophone player were rim lit by two strobes with spot attachments. These heads (#3 and #4) were located high above the set and placed on either side at the rear wall of the studio. To add a hint of fill light to the front of the stage, a fill card was positioned to the left of the sax player to reflect light from strobe #4. A barndoor attachment on this strobe head helped to shield some of the light from striking the singer. A smoke machine was also used to blow smoke to the rear of set, helping to add realism to the scene. (See Fig. 1)

METERING THE LIGHT: An incident light meter was used to determine the exposure. A reading of strobe #1 read f/5.6 at $^1/_{60}$. Because this was the mainlight of the set, the camera was set at this reading. A meter reading of the woman read f/4.5, one-half stop under the mainlight. This was just enough of a reduction in exposure to make the handbag "pop" off of the model. For this same reason, a reading of f/4 on the waiter was appropriate.

The backlight reading of spotlights was adjusted until strobe #3 read f/16, and strobe #4 read f/8.5. This would create the desired rim lighting effect for the stage.

EXPOSING THE FILM: Polaroids were first shot to check exposure, focus and composition. The final film shot was Kodak EPZ professional. I chose this film because of its accurate color rendition and film latitude, especially in showing shadow details.

INTO THE COMPUTER: Once the film was processed and the final transparency selected, the film was taken to be manipulated. Using Kodak's Premier Workstation, the image was scanned, retouched, manipulated and then output back to film. The process of dropping out to black and white all of the elements of the image, except the handbag, was simple. In the computer program a path was carefully drawn around the handbag. This area of the image was then saved and the rest of the image was converted to gray scale. This manipulated file was then saved and output as a color transparency.

DEAN COLLINS

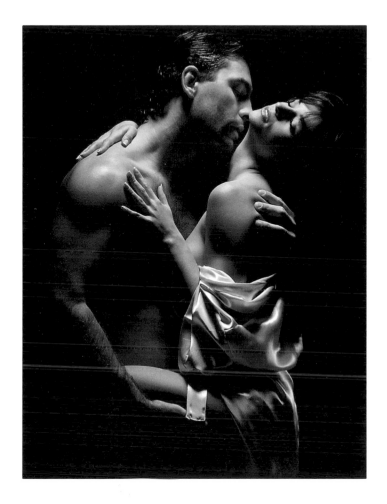

A M E R I C A

For over a decade, Dean Collins has educated photographers around the world with his informative and entertaining lectures, videos and publications. Dean's education and research in the science of photography has led to his development of numerous theories and techniques. Recent efforts have enabled him to combine his knowledge of photography and interface it with the emerging technology of digital imaging.

DEAN COLLINS

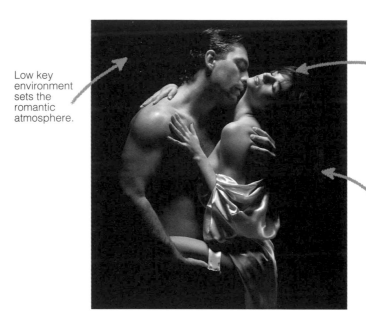

Low key environment sets the romantic atmosphere.

Models lit from above with semi-specular light source.

Mirror used to add definition to woman's hair.

PHOTO NAME: Untitled

PHOTOGRAPHER: Dean Collins, Collins and Associates, San Diego, California. U.S.A.

ASSIGNMENT: Our studio was hired to develop images for a new product which would be introduced on both a national and international level. The product, Nepegen, was first being introduced to a small number of sales distributors in the United States and Asia. Our job was to create a series of images which would be visually appealing and appropriate for both cultures and their markets. In the end, the project would encompass our studio's photographic, design and prepress facilities.

FILM: Kodak Ektachrome Professional Plus (EPP). ISO 100 Rated at 80.

CLIENT: Foslip of California.

CAMERA: Hasselblad 2000 FCW.

LENS: Hasselblad 180mm.

PREPRODUCTION: The client and marketing director held a series of casting calls for talent. Selection of models at this point was critical because they planned to use the same people for all of their print and television advertising.

SETUP: Because the shoot would take place first thing in the morning, the set was constructed the prior evening. A black seamless paper, which hung at the back of the set, was selected as background on which colored text could easily be reversed. Above the set, a Broncolor strobe head with a 16-inch dish was placed on a boom. (See Fig.1) This semi-specular light source would create deep shadowing on the models, defining their figures and creating the desired mood. Once the Hasselblad with a 180mm lens was attached to the Foba studio stand, a black flag was placed between the camera and the light source to prevent lens flair.

METERING THE LIGHT: When the talent and make-up artist arrived, we had a brief meeting to discuss the details of the three shots we needed to complete. While the make-up was being completed, we calculated our exposure and loaded the film backs. The exposure was determined by using a combination of both incident and reflective readings.

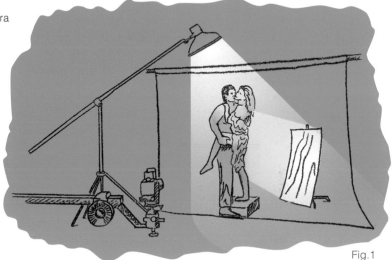

Fig.1

First, an incident meter reading was taken of the light dish from head height, with the dome of the meter aimed at the light source. This reading, f8 and 1/2, set the diffused value or true tone for the flesh tone. Next, a reflective spot meter was used to read the black background. To ensure that the background would reproduce black, it was necessary that the reading be four stops darker than the camera setting, f2 at 1/60. (Photographic black is four stops darker that 18% grey.)

When the models took their places on the set, it was necessary for the woman to stand on a small apple box to be at the desired height. After a Polaroid was shot to check exposure and composition, a small plexiglass mirror was added behind and to the right of the woman. This mirror bounced light from the main source into her hair, adding just enough detail to make it separate from the dark background. (See Fig.1)

EXPOSING THE FILM: After the client approved the final Polaroid, six rolls of EPP120 were shot, each with slightly different poses and expressions. In this type of situation you have to shoot a lot of film. It can be uncomfortable for everyone, especially in a case like this where the models were complete strangers. It takes a few rolls for the models to relax and act a bit more natural. As the photographer, it is your job to make everyone at ease and set the mood on the set. If the models don't feel comfortable, it is going to show up on the film.

INTO THE COMPUTER: Once the exposure and density on the first roll developed, the balance of the film was processed. The client then came back to the studio to select the hero image. Next, John Shireling of Medius Prepress, and Gary Burns of Burns Design (both incorporated within Dean's studio), took over to complete the remainder of the project. The shot was scanned into the Photoshop program on a Macintosh Quadra 900 with a Leaf 45 Scanner at 300 dots per inch (dpi). This scan rate was chosen to ensure that the image would hold detail when enlarged to 8x10 inches. If an image is not scanned at the proper rate, it can lead to problems. If resolution is too low, pixels will show in the image. If resolution is too high, it will result in a large file that greatly slows

down the process and adds cost to output. An unsharp mask filter was applied to the image in the computer and provided us with the sharpest scan possible with our system. Now in Photoshop, the image was retouched. Small fly away hair and imperfections in the skin were removed at the art director's discretion, and slight warming was added to the overall color balance. When complete, the 10 megabyte image file was imported in Quark XPress (a graphics program) and output directly from the computer on a XL7700 thermal printer. These original thermal prints were used in the introductory sales kits the client was sending to Asia.

JEFF WIANT

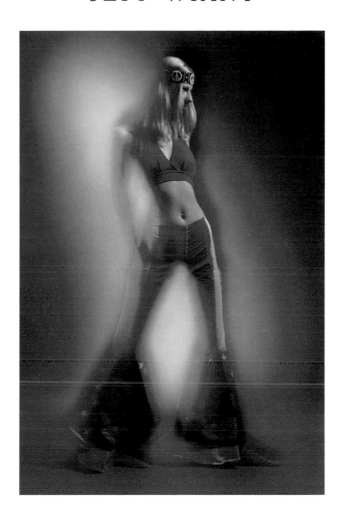

A M E R I C A

Jeff's love for photography drove him to pursue a formal education from Brooks Institute of Photography. Upon graduation Jeff studied under Dean Collins for several years. His work can be seen editorially in San Diego and nationally. Jeff resides within San Diego and works throughout the world.

JEFF WIANT

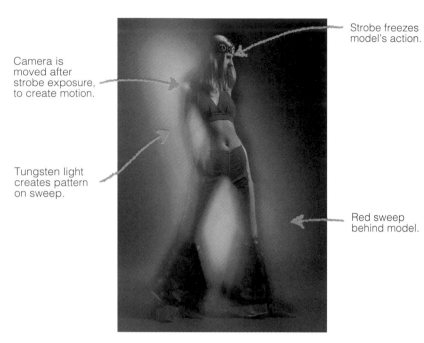

Strobe freezes
model's action.

Camera is
moved after
strobe exposure,
to create motion.

Tungsten light
creates pattern
on sweep.

Red sweep
behind model.

PHOTO NAME: Untitled.

PHOTOGRAPHER: Jeff Wiant, Jeff Wiant Photography, San Diego, California. U.S.A.

ASSIGNMENT: Hip Equip Designs, a fashion design company, hired me to shoot some "psychedelic feeling images from the 60's" to showcase their clothing for advertising. I was given total creative liberty in producing the images.

FILM: Kodak Ektachrome 100X professional EPZ. 100 ISO rated at 80 ISO.

CAMERA: Canon EOS 1.

LENS: 85mm, f/1.2 L.

ABOUT THE SHOT: This image was recorded on daylight balanced film, using an eight second exposure, combining flash and tungsten lighting. The flash was triggered at the beginning of the exposure, recording a properly exposed frozen image of the model. During the remainder of the exposure, tungsten lighting added warm, ghost-like images while the photographer shook the camera and the model held still.

THE SET-UP: With the red, white and blue colors of the clothing in mind, I selected a red seamless background which was draped out about 12 feet onto the studio floor. The model would stand nearly 10 feet from the back of the background to ensure it would appear out-of-focus when shot with an aperture of f/11. A 1K (1000 watt) tungsten lamp with a focusable fresnel lens and barndoors illuminated the red paper from the right side of the

set. The barndoors and lens of the light were set so a narrow path of concentrated light struck the background while a small portion of the light spilled onto the back of the model.

A Broncolor 20-inch Softlight dish was attached to a strobe head and placed eight feet up on a light stand, shining down onto the model, just out of the camera's view on the left of the set. A P-22 Lightform Panel, 3x6-feet in size, was positioned opposite this source to reflect light into the shadow and to reveal some detail in the clothing. (Fig. 1) In this case, the P-22 panel was covered with gold reflective material. A black flag was used between the Softlight dish and the camera to avoid the possibility of lens flare. I always flag my lens as much as possible to ensure that the greatest color saturation will be obtained. (NOTE: The black flag is not illustrated in Fig. 1.)

METERING THE LIGHT: An incident meter was used to determine the exposure. I first used the meter's ambient setting to read the tungsten light striking the center of the background. This reading was f/22 and $2/3$ at an exposure time of 8 seconds. Having used this shooting technique several times before, I knew that 8 seconds would work well for the effect I was trying to achieve. Next, the flash exposure of the Softlight was metered, being sure to aim the dome of the meter toward the light so the shadow would not be averaged into the reading. I adjusted the power of the strobe pack until a reading of f/11 was obtained. This reading, which was set on the camera, gave me a 2 and $2/3$ stop overexposure on the background. By overexposing the background this far I would achieve a white patch of light in the center of the background, while the remainder of the seamless would appear red as the light fell off. This bright spot of light added dimension to the image while offering enough contrast in tonality to be sure the model would separate from the background.

Fig. 1

EXPOSING THE FILM: The camera was placed on a tripod with a ball head. The ball head allows me to freely move the camera in any direction as the exposure is being made. The image was recorded as follows: First, with the strobe modeling light off and the background light on, the strobe is fired from the camera as the shutter is triggered. This freezes the model and she remains in the same position for the entire exposure. Remember that the image is being recorded on Kodak 100X, which is a daylight balanced film. Because the strobe is also daylight balanced, this area of the image appears neutral and true in color. The instant after the strobe is triggered is when I begin to shake the camera from side to side, not stopping during the 8 second tungsten exposure. Because the tungsten source is a different color temperature than the film, a warm color shift appears in the areas affected by this exposure. At the end of each shot the modeling light of the strobe is turned on and the image is recomposed for another attempt.

The amount and direction in which the camera is moved during the exposure will affect the look of the final image. In order to satisfy both myself and my clients, I have done a great deal of testing.

133

DAVE & MARK MONTIZAMBERT

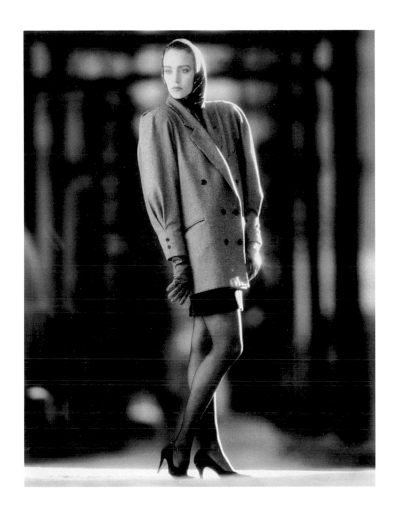

C A N A D A

Canadian photographers Dave & Mark Montizambert operate their own studio in Vancouver, B.C., Canada. Students of Dean Collins, both are active photo-educators who teach, lecture and write. Dave and Mark shoot on a national level in both Canada and the United States.

DAVE & MARK MONTIZAMBERT

Subject's diffused value determined by incident meter reading with dome pointed at light panel.

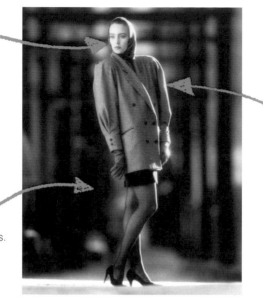

Edge light created by strobes.

Background compression created with 300mm, f2.8 lens.

PHOTO NAME: Untitled.

PHOTOGRAPHERS: Dave and Mark Montizambert.
Montizambert Photography, Vancouver, British Columbia. Canada.

ASSIGNMENT: Boulevard Magazine, a local publication, requested a bi-monthly photographic article to be both shot and written by a photographer. The article had to appeal to amateur and professional photographers, as well as those with little or no photographic experience. The article explained the relationship between lenses and their effects on perspective. The idea was to offer different methods of creating the compressed feeling obtained by a long lens, as shown in the final image, which was shot with a 300mm f2.8.

FILM: 35mm Kodak T-Max 100, rated at 80 ISO.

EXPOSURE: 1/60 at f2.8.

CLIENT: Boulevarde Magazine.

ART DIRECTOR: None.

CAMERA: Nikon 801 (8008).

LENS: 300mm f2.8.

THE SETUP: The shot took place in an alley directly out the back door of the studio. The alley offered several options as backgrounds; a group of telephone poles proved to be the most appealing in the final film. Because traffic kept interrupting the`shoot, the placement of the model and all of the equipment were marked on the pavement with chalk, to allow for quick removal and placement.

A 35mm camera with a 300mm f2.8 lens was set up on a home made "boardpod". The "boardpod," a 1x2 foot piece of plywood with a ball type tripod head mounted to it, was used so the camera would sit just above the ground. The model was positioned 46 feet from the camera. The cropping through the lens was a little more than the full length of the model. With the camera focused on the model and the aperture at f2.8, the poles were blown out of focus. This created the striped pattern in the background.

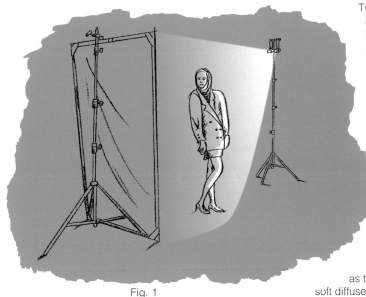

Two Metz CT60 flash units were attached side by side on a lightstand. These strobes were placed behind and to the right of the model at an axis of 45°. The distance at this axis was 15 feet. Next, a P22 Lightform panel (a collapsible 3x6 foot plastic frame) with a white reflective fabric, was placed three feet to the left and slightly in front of the model. This set emulated the sun passing behind the model which created a strong edge light helping to separate her from the background. The panel, which picked up the light from the strobes, acted as the main light and created the soft diffused light on the front of the model. (Fig. 1)

Fig. 1

METERING THE LIGHT: An incident meter was used to determine the final exposure. Black tulle, which created a light loss of 1/3 of a stop, was stretched across the front element of the lens to slightly diffuse the image. The tulle, which came from a florist, also reduce the contrast of the image. This helped to avoid major dot gain* when the image went to print.

The dome of the meter was pointed at the panel to place the exposure for the subjects diffused value or true tonality. The strobe power was adjusted until the meter read 1/60 at f2.8, which matched the ambient daylight reading, balancing the two exposures.

Dot gain is a term used for the contrast gain areas in a printed piece. It is most apparent in the black and shadow areas. A printed image is made up of thousands of tiny dots placed next to each other on top of paper. Whiter areas with subtle detail are made up of fewer dots that are spread apart, while dark areas, such as the scarf in this image, are made up of many dots placed closely together. As the ink is placed onto the page, it is absorbed into the paper and spreads. Because little space exists between the dots in the dark areas, the spacing is blocked up, thus creating a loss in detail and a gain in contrast.

The amount of gain is affected by the presses, inks, and papers being used. It is always a good idea to ask your client how your image is going to be printed in order to compensate in the original. In this case the image was running on a sheet fed, web press on paper near the quality of newsprint.

WHAT IF YOU DON'T HAVE A 300mm LENS? Here's the trick, which was the focus of the article. Put the longest lens you have on your camera and take a shot at the same aperture and distance as described above. Don't worry about the model being too small in the view finder. After the film is processed, enlarge the middle portion of the image, so it is the

same as the full length shot that was taken with the 300mm. If you compared the two shots you would see no change in perspective. However, differences would be apparent in grain and depth of field. The grain is larger because you have enlarged only a small section of the negative. This is why a film with fine grain was selected for the shot; the depth of field is greater with a shorter focal length because the aperture, even at the same setting, is smaller.

INTO THE DARKROOM: In a two-reel canister, the film was processed for 6 and 1/2 minutes in D-76 developer, mixed normal, and at 68°. The agitation cycle was 4 hand rotations every minute. Prints were made on Kodak Poly Contrast III RC paper with a #2 filter and processed in Dektol, mixed at the recommended 1:1 ratio.

105mm f2.8 lens, camera to model 46 ft.

50mm f2.8 lens, camera to model 10 ft.

DEAN COLLINS

A M E R I C A

For over a decade, Dean Collins has educated photographers around the world with his informative and entertaining lectures, videos and publications. Dean's education and research in the science of photography has led to his development of numerous theories and techniques. Recent efforts have enabled him to combine his knowledge of photography and interface it with the emerging technology of digital imaging.

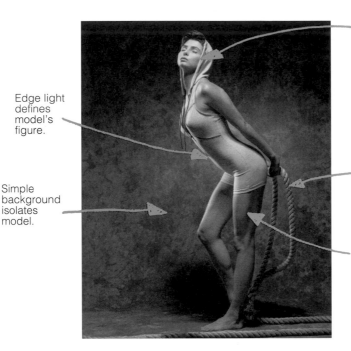

Large specular light source offers good definition in clothes and facial features.

Edge light defines model's figure.

Rope used as a simple prop and design element.

Simple background isolates model.

Black and white contrast range suitable for final press.

PHOTO NAME: Savauge.

PHOTOGRAPHER: Dean Collins, Collins and Associates, San Diego, California. U.S.A.

ASSIGNMENT: Savauge Sportswear, a local company, came to our studio looking for a series of creative black and white photographs that would showcase their clothes while emphasizing the shape of a woman's body. The images would be used for posters, promotional cards, and small hang tags that would be attached to the clothes in retail stores.

FILM: 120 Kodak T-Max 100 ISO, rated at 80 ISO.

CLIENT: Savauge Sportswear.

ART DIRECTOR: Simon Southwood.

CAMERA: Hasselblad 2000FCW.

LENS: Hasselblad 150mm f4.

THE SETUP: To begin the shoot we set up one Broncolor Opus A4 power pack and two strobe heads. One of the heads, which acted as an edge light, was placed behind and off to the left, rear of the set. A spot grid directed this source to the woman's torso, emphasizing her figure. Next, the main light, a strobe head with a 20-inch reflector, was placed on a boom arm just above and in front to the model. A scrim was placed between the model and the main light to control the intensity and light fall-off on the subject's head and shoulders. This lighting set-up was selected because the small sources of light created a hard edge transfer from the subject's diffused value to the shadow area which gave good dimension and definition to the model's figure. (Fig. 1) A series of black flags place between the lights and the camera were used to control lens flair.

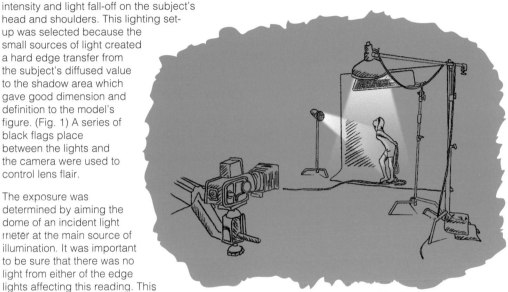

The exposure was determined by aiming the dome of an incident light meter at the main source of illumination. It was important to be sure that there was no light from either of the edge lights affecting this reading. This reading of f11 at 1/60 set the

Fig. 1

subject's diffused value or true tonality. A Polaroid 664 was then taken to check the exposure and composition. After making a few minor adjustments the film was exposed.

The film was processed through a Jobo ATL3 processor with T-Max developer. The final print was made 15% less than normal contrast to account for the contrast gain of the final press. The following procedure was used to standardize our studio darkroom.

BLACK AND WHITE STANDARDIZATION: The objective of this test is to produce a negative that will print the diffused value (true tone) of the primary subject, with the D-min (unexposed film) producing D-max (pure black) on a #2 grade paper. Highlight and shadow information are subjective principles. For each B&W image recorded, the photographer must assess the scene, and then expose the film accordingly to produce the best negative possible for that particular situation.

Manufacturers offer photographers with an International Standard (ISO), a starting point or suggestion on how to rate your film. Due to inaccuracies in the calibration of photographic equipment and darkroom chemistry, you may find that your ISO rating should be slightly different than the manufacturer's. Therefore, for every new type of film that we shoot, the following test is completed.

Three test rolls of film are shot, one with a +1 exposure (one stop overexposed, which is underdeveloped), one with a normal "0" rating, and one with a -1 exposure (one stop underexposed, which is overdeveloped). This information will provide a reliable standard to accurately and consistently produce the best negative possible for any given situation.

To create your own test rolls, follow this procedure: 1) Select a simple subject matter that offers a full contrast range from lights to darks. If necessary, light the subject with a single strobe light to produce visible shadow areas on the subject. Utilizing a strobe will alleviate the need to deal with shutter speeds. 2) Using an incident light meter with the dome of the meter

facing the light source, take a meter reading with the meter set at the recommended ISO, in this case 100. For the purpose of this exercise, say that the meter reading is 1/60 second at f8. Next, using three identical rolls of ISO 100 B&W film, expose each roll of film the same way, using 1/60 second at f8 as a mid-point, and bracket by 1/3 stop increments. 3) Expose the first frame at an ISO rating of 400, or f16, and continue to expose each frame at a 1/3 lower ISO rating, ending at ISO 32, or f4 1/3. A total of 12 frames will be shot with f8 landing in the middle of the roll. Try to begin with a meter reading that provides an aperture setting somewhere near the middle of the aperture ring; this will allow you to bracket in each direction. 4) Now, develop the 3 rolls together using fresh chemistry. Using the manufacturer's suggested development time as your guideline, remove the first roll of film when 80% of the proper development time is reached (a pull), remove the second roll at normal development time, and remove the third roll after 140% of normal time (a push). Proceed with the standard stop bath, fix, rinse, and dry for each roll of film. Be sure to mark each roll as to its specific development time.

PRINT STANDARDIZATION: Theoretically, the proper printing time for a B&W negative is the minimum time for D-min to reach D-max. In other words, prior to printing, you must determine the minimum time needed for the negative (unexposed film, D-min), to print absolute black (D-max). To properly determine this printing time, use a piece of developed, unexposed B&W negative for your test. 1) Use a #2 grade paper (or a #2 polycontrast filter) as the basis for the experiment. Insert the unexposed negative into the film holder, set the enlarger lens to the middle of the f-stop range, and adjust the enlarger to cover an 8x10 printing area. 2) Set the timer to 1 second and create a test print revealing 12 sections across the paper, exposing 1 second each time. Develop this paper normally to reveal a series of stripes, ranging from black to white. (Fig. 2) Examine the stripes as they advance from grey to black. Find the point at which you can no longer distinguish between stripes of black. This first black represents your D-min; it should be between 5 and 8 seconds to allow for any dodging or burning that may be needed. For the purpose of this exercise say that our D-min time is 5 seconds. 3) Once you have produced a successful test print and identified your D-min time, remove the film holder and negative from the enlarger and take an incident meter reading of the light striking the easel. (Fig 3) This will provide you with a luminance value for the enlarger. For this exercise, our meter was set to ISO 100 at 1 second. These numbers are arbitrary, you may select any ISO and shutter speed. Regardless of the setting, the resulting aperture reading from your meter will now act as your standard luminance value for all B&W printing for the particular film you are standardizing. Our meter reading was 1 second at f4.2.

An incident meter reading is necessary to create a standard luminance value for your enlarger. The lens aperture is irrelevant if the enlarger is moved up or down. The closer the enlarger head is moved toward the easel, the greater the intensity of light from the enlarger, and vise-versa.

The use of an enlarger luminance value will eliminate the need for a new test sheet each time the enlarger is moved. By establishing a luminance value through the use of a meter, each time the enlarger is moved up or down you need only to:

Fig. 2

- remove the negative holder.

- take a new incident meter reading above the easel.

- adjust the lens aperture until the same f-stop reading from your test is reached.

CONTACT PRINTS: To produce a contact print, simply adjust the printer head to the desired height and coverage, take an incident meter reading and adjust the iris to produce the same f-stop determined in the test. (Ours was f4.2)

With the enlarger now set, place your exposed negatives on top of a piece of #2 grade paper, set your timer to your D-max time (5 seconds), and make a contact print. Repeat this process for each of the three rolls, taking note of which was pulled, normal and pushed.

Once the contact prints are dry, select a frame on each roll that is the most acceptable - one in which the diffused highlight (true tone) of the main subject is accurately represented on the contact print. Then determine what ISO the film was rated at for that frame. You now have an accurate ISO rating and development time for increased contrast (+1), normal development, and decreased contrast (-1) for your 100 ISO black and white film.

Fig. 3

JOHN STREET

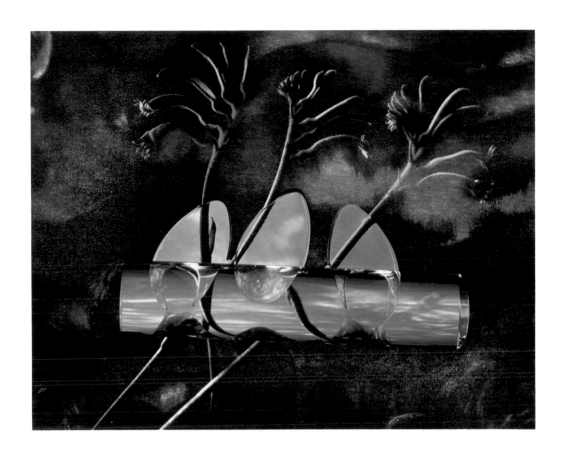

A U S T R A L I A

John Street hocked his first camera to buy himself out of the Royal Navy in 1960. Two
hears later, in London, a client paid £10,000 for a series of 10 pictures taken with a cheap
plastic camera. His mentor in parting advised, "Study Rembrandt's lighting." Resulting from
this john's philosophy is 'simple things shot beautifully'. Since 1978, John has won
numerous Australian Awards. He shoots in a beautiful garden studio in Melbourne, Australia.

JOHN STREET

Flowers lit with fiber-optic lighting system.

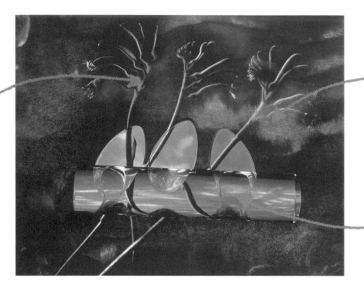

Scarf is moved to top shelf and lit from below in second exposure.

Acrylic shapes lit from strip light below the set.

PHOTO NAME: (Zenrim Poem)
In the landscape of spring there is neither
high nor low; The flowering branches
grow naturally, some long some short.

PHOTOGRAPHER: John Street, John Street Studio, Melbourne. Australia.

ASSIGNMENT: This is one of twelve photographs taken for Detail Printing's 1993 calendar. The calendar size was 20x30 inches and about 2000 copies were printed. The guidelines for the project were very open: "use color to show off our printing." This was a rare opportunity to go wherever creativity led.

FILM: Ektachrome 64 Professional (EPR). Size 11x14 sheet 6117. 64 ISO rated at 64.

CLIENT: Detail Printing.

CAMERA: 11x14 View Camera.

LENS: Rodenstock, 480mm.

ABOUT THE SHOT: The concept for this image came from an idea which I had held in mind for some time. "The idea was to use flowers as birds and acrylic as a material form of consciousness, revealing the feeling of escape from the coarser world and the seeking of liberation to a higher level of consciousness."

Polished acrylic pieces, exotic flowers and a silk scarf were recorded with multiple exposures on a single sheet of film combining flash and fiber-optic light-painting. Kodak 11x14 inch film was used, allowing almost life size reproduction of the flowers and precise alignment of masking.

PREPRODUCTION: A series of acrylic shapes were cut and polished by an experienced model maker, each having specific optical properties. Each object would either magnify, diminish, distort or reflect portions of the image and the light. The hand painted silk scarves were sourced from a fashion designer and the exotic flowers were acquired from multiple florists,.

Creative Light Works, the manufacturer of the fiber-optic system I use, custom made two twelve inch lighting probes, allowing me to work in close without disturbing the flowers. This way the image could be painted with light without needing to touch the glass shelves. Each probe had a different attachment. One probe emitted a narrow beam of light while the other had a "wider beam skimmer".

About four weeks of extensive studio experimentation and testing went into the preparation for this shoot. It should be understood that although these images took about twenty minutes to expose, they did not just happen—much creative thinking and experimentation went into the preparation.

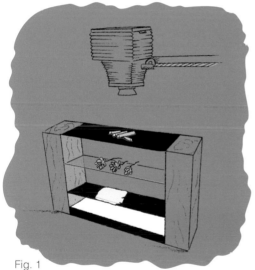

Fig. 1

THE SET-UP: For the entire project, I worked with one very good assistant. I find that two heads are better than one when remembering how many seconds on this and that, and what part of the exposure is next.

To begin the set construction for this shoot, an 11x14 view camera was assembled. The camera was fitted with a Sinar Digital Shutter and a 480mm Rodenstock lens. A color correction filter (05 Magenta) was placed in front of the lens and remained for the whole exposure. The camera was secured to a studio stand and positioned in a vertical orientation, with the set directly below. Between the camera lens and table, an electronic shutter was independently mounted. This exterior shutter would be used to eliminate light contamination between exposures.

To meet the various shooting needs of the different images for this assignment, a flexible multi-shelf "table" was constructed. This table allowed numerous shelves of transparent glass or plexiglass to be inserted, as needed, with variable spacing. The objects which were to be photographed would rest on these shelves with the camera looking down through the shelves. The table frame and hardware were (obviously) outside of the camera's view.

For this particular image, the table was set-up as follows: Strobe #1, a strip light, was first positioned at the base of the table facing the camera, illuminating the shelves above. Over this background light, a sheet of 1/2 C.T. Blue filter was taped. This filter is a weak blue in color. Placed directly over the strip light was Shelf C, a piece of opal Perplex (i.e. Plexiglass) with a matte. The other shelves, #A and #B, were both made of transparent glass and placed into the table's frame. (See Fig.1)

Next, a silk scarf chosen for its rich palette was placed on top of Shelf C. A black opaque cardboard mask was cut to block out any light from passing beyond the area around the scarf. The entire shelf was now either masked or covered by the scarf. Only the scarf was visible from camera.

Just above the scarf, the flowers were arranged on Shelf B. The camera was adjusted so the plane-of-focus fell onto the flowers and the silk scarf on the lower shelf was out-of-focus. (See Fig. 1)

The top shelf, #A, would hold the acrylic shapes. Before the shapes were placed on the glass, a black card was cut to completely cover the shelf. Once the shapes were placed appropriately, their positions were carefully traced onto the black card and then cut out. This generated an exact template to make a mask needed for the exposure. Both sections of the mask, the entire board which covered the shelf and the small cut-out would be needed for the exposure. Next, the black card mask was returned to its position on Shelf A and the acrylics repositioned into the cut out areas. Now the acrylics were directly on the glass of the shelf and could be lit from below. The small cut-out section of the mask (the shape of the acrylics) was set aside.

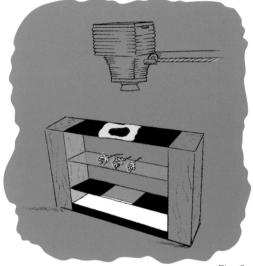

METERING THE LIGHT: The set was now complete, and a series of exposure tests needed to be completed. The exposure for the image would be made up of three different exposure segments. For the first segment, an exposure of the acrylics is made from below with the mask in position around the shapes. The strip light was then fired three times, creating an exposure through the scarf and through the acrylic shapes. For the second segment, the mask pieces were switched; the mask of the outside of the acrylic is removed and the mask of the acrylics is set on top of the the the acrylic shapes. In addition, the scarf is moved from Shelf C up to Shelf A, where it is gently draped over the top of the masked area. Again the strip light from below is fired, this time only twice,

Fig. 2

exposing the backlit scarf. Because they were under the mask, the acrylics were not exposed during this segment. Finally, the scarf and all masks were removed. The third segment of the exposure took place, utilizing both attachments of the fiber-optic probe to paint with light. The 12" probe was used to expose the finger-like parts of the flower and the skimmer was used to light the stems. (See Fig. 3) Each flower took about 5 minutes to expose. The varying degree of exposure on the flowers accounted for how much they either merged or were covered by the scarf. (The brightly exposed areas of the flowers merged through the background, and the darker, underexposed areas remained covered by the texture of the scarf.)

The initial exposure was based off of a reflective meter reading taken of the scarf on Shelf C. This first reading, f/64 at 1/60 second, would render the scarf at an 18% tonality. Because this tonality would be too dark, the strip light would be fired three times, thus increasing the brightness of the scarf.

I developed a special film back to replace the 11x14 ground glass to shoot Polaroids for proofing the image. This back utilized two removable acrylic spacers and one 8x10 Polaroid film cartridge.This system allows the 8x10 Polaroid film cartridge to be registered in three different positions (See Fig. 4), so an 8x10 instant image can be shot of the right, center or left portions of the image. These Polaroids can then be matched together so the entire film area can be viewed.

EXPOSING THE FILM: With the 11x14 format, film choice is rather limited. Kodak's Ektachrome 6117 was chosen for its fine grain, classic sharpness and very rich palette.

The camera's digital shutter was set to Bulb at f/64, and would be opened only once, remaining open for the duration of the exposure. The independent electronic shutter was

used to keep the film from being exposed while the masks were switched and the scarf was moved. The use of an exterior electronic shutter avoided camera movement between exposures. Also, I was allowed to program the time this shutter would remain open, assuring me of highly accurate, repeatable exposure times.

Again, here is the sequence in which the image was recorded:

EXPOSURE #1: For the first exposure, the large mask was in place on the top shelf, blocking all light except that which passes through the acrylic pieces. The ambient lighting in the studio was turned off. The camera's digital shutter was opened. The independent electronic shutter was opened, and strip light #1 was fired three times at full power to lighten the dark scarf.Then the independent electronic shutter was closed. (Fig. 1)

EXPOSURE #2: The set was changed as follows: First, the large black mask was very carefully removed. Care had to be taken so that the acrylic pieces were not disturbed between exposures. Next, the smaller blank cut out from the larger mask earlier was placed on top of the acrylic pieces. This exactly covered the acrylic pieces and would minimize light contamination, thus preserving the color saturation of the film area just exposed. Finally, the silk scarf was removed from the lower shelf and carefully draped over the entire top shelf, completely covering the top shelf and acrylic pieces. The independent electronic shutter was then opened, the strip light was fired twice and the shutter was closed. (Fig. 2)

EXPOSURE #3: The flowers were lit using the fiber-optic light system with the silk scarf and mask now removed. I directed the steady hand of my assistant while I stood by the camera. The 12-inch probe attachment is used to paint the finger-like parts of the flowers. The skimmer attachment is added for a broader beam of light to light the stems of the flowers. Each flower is painted for approximately five minutes at f/64. Finally, the camera's shutter is closed, ending the exposure.

LOOKING BACK: As mentioned, the concept for these images came from ideas held in mind. After a couple of shots, these ideas were all thrown out, as they became too limiting – creating the very restrictions which limit creativity. From this point the pictures and ideas simply flowed and happened, for the most part rather quickly. Everything just came together quite naturally. One of the pictures was born from listening to Mozart, others just arose from the flowers or the silk scarves. As craftsmen, the release of all preconceived ideas and techniques is an excellent way of enjoying photography!

Fig. 3 11x14 Polaroid proffing stystem.

Skimmer

Fig. 4

12-inch Probe

HOLLY WARBURTON

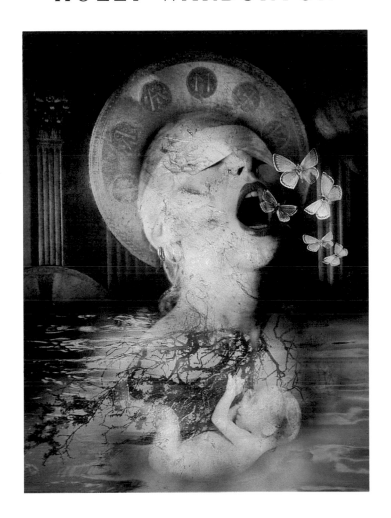

E N G L A N D

HOLLY WARBURTON

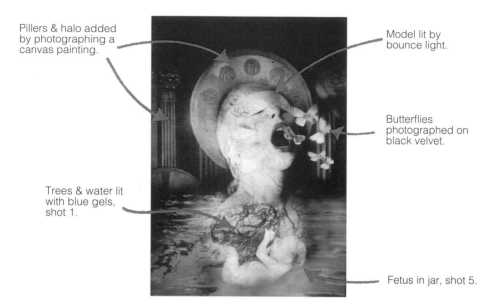

Pillers & halo added by photographing a canvas painting.

Model lit by bounce light.

Butterflies photographed on black velvet.

Trees & water lit with blue gels, shot 1.

Fetus in jar, shot 5.

PHOTO NAME: Screaming Butterflie

PHOTOGRAPHER: Holly Warburton. Sandee Ashton Associates, London. England.

ASSIGNMENT: This image came about as part of an audio-visual exhibition at the Museum of Modern Art in Oxford, U.K. At the same time the programs were being produced, prints were made for an exhibit at Pat Rays Gallery, Yokohama, Japan. The exhibit print sizes were 20x24 inches.

FILM: 4x5 Kodak 64T Tungsten Professional, 64 ISO, rated at 64 ISO.

EXPOSURES: Not Recorded.

ART DIRECTOR: None.

CAMERA: Sinar 4x5.

LENS: 150mm.

ABOUT THE SHOT: This image is the result of five exposures placed on a single sheet of 4x5 film. All images were taken in the studio and various techniques were used to merge the images together.

SHOOTING: SHOT #1, WATER AND TREE: The first image consisted of a tank of water and tree branches. The tank of water, placed in the middle of the studio, was back lit by 4 Arri (tungsten) lights covered with dark blue gels. A few branches from a tree were added to the set, behind the tank.

A spot meter reading was taken to get a basic exposure, and then Polaroids were shot until the desired exposure was reached. The water and branches took up a small area at the bottom of the image. This area was marked on the ground glass to control the positioning of the other images. Before the film was shot, the tank of water was rocked to create rippling on the surface.

The areas behind the tank were covered with black fabric to keep them from being exposed.

SHOT #2, FEMALE HEAD:

A live model was used to create the image of the screaming head. The 4x5 camera was moved to a model sitting in front of a black background, then her head position was traced on the ground glass. Her chest area was draped with black to avoid exposure on this area, allowing this and the previous images to merge.

She was lit by one tungsten light bounced off white polyboard, which created a soft light quality. A spot meter reading was taken of her flesh tone and then a series of Polaroid test shots helped to determine the proper exposure.

The final image revealed the model with traces of the tree branches throughout her neck and face.

SHOT #3; THE HALO AND PILLAR: This section of the image assemblage was a painted background. The canvas painting was selectively lit with a tungsten light that was covered with a green gel, and then lined up with the tracing of the model's head on the ground glass of the camera. The painting was carefully positioned so the halo didn't overlap the model's head.

SHOT #4; THE BUTTERFLIES: The butterflies were laid out on top of a black fabric and shot from above. A few exposures were made with the camera at different heights, giving the illusion of several butterflies fluttering in the air. The butterflies were positioned in the image based on an estimation from both Polaroids and the ground glass tracings. Again, this set was lit with tungsten lights.

SHOT #5; BABY: An actual fetus, acquired from a museum, was used for this component of the photograph. Contained within a glass jar backed with black velvet, the fetus was lit from the sides with tungsten lights reflected off white polyboard. The baby was aligned in the ground glass so that it would be exposed at the bottom of the frame.

FINAL MANIPULATION: The final E-6 processed image was taken to a lab and a Cibachome print was made. The print was manipulated with dyes and paints, adding to the surrealism to the image.

JILL ENFIELD

A M E R I C A

Jill Enfield started photography by going to workshops around the country, finally attending NYU and receiving a BFA. Primarily an architecture and landscape photographer, Enfield began painting her photographs with oils in 1985, working to keep a dreamlike affect without significantly altering reality. "I work intuitively and the actual meaning of the image is open to interpretation by the viewer."

Low camera angle with wide lens offers dramatic perspective.

Sweeping clouds exaggerated by infrared film.

Infrared film records green plant life as white, allowing foliage to be easily hand painted.

Final photographic print is hand painted with colored oils.

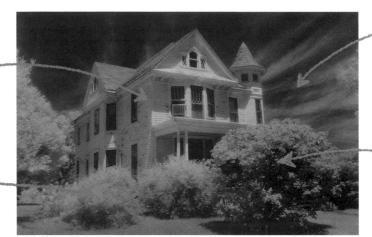

PHOTO NAME: Untitled.

PHOTOGRAPHER: Jill Enfield, Jill Enfield Photography, New York City, New York. U.S.A.

ASSIGNMENT: This was a self-assigned project that I was able to complete with the aid of a Kodak grant. I found myself very interested in photographing the architecture and landscape along the Mississippi River, and wanted to shoot the entire length of the river to compare the vast differences between the north and south.

The resulting images were to be used for many purposes including, hopefully, a book, editorial magazine stories, greeting cards, stock images and portfolio pieces.

FILM: Kodak Black and White High Speed Infrared Film (HIE). Recommended 50 ISO with a #25 red filter, rated at ISO 200 with a #25 Red Filter. NOTE: This film is sensitive to approximately 900 nanometers and must be handled, stored and processed with extreme care, in total darkness. A film changing bag is necessary on location.

CAMERA: Nikon FE2.

LENS: Nikkor 35mm.

PREPRODUCTION: Before leaving for the shoot, I tried to get as much leg work done as possible. Research was done at the historical society, public library and through personal referrals. My assistant and I spent time on the phone and in the library compiling information about important landmarks in the regions we would be visiting. The Mississippi River is over 2,500 miles long, so deciding ahead of time which towns we would stop in and which we would pass up helped estimate the route for the five-week journey.

Although I often work alone, for the purposes of this assignment I chose to work with one assistant. This would help to maximize my shooting time, not having to deal with the details of traveling. In addition, it would be necessary to carefully document each roll of film in a notebook, keep detailed notes on exact subject matter, locations, addresses, phone numbers; an assistant was critical for my post-production research.

ABOUT THE SHOT: This image is a single exposure recorded on black and white infrared film. It was printed on fiber-based paper and then hand painted.

THE SETUP: All of my work was recorded on 35mm black and white infrared film. This negative film would give me the opportunity to both print and hand tint my work later. I chose the 35mm format over 4x5 (infrared is not available in 120mm format) because of its versatility and flexibility.

Once we arrived at the location, I walked around the house to determine which angle would be of most interest. Because the bushes around the house were situated in such a way that a straight-on shot was boring, I chose an angle slightly from the side. The combination of a 35mm lens and a low camera angle helped to accentuate the lines of the house, enhancing the impact of the image. The dramatic cloud formation, which was barely visible to the human eye, was exaggerated by the infrared film sensitivity and red filtration.

METERING THE LIGHT: Using the camera's reflective light meter, I took center weighted readings of the highlight, midtone and shadow areas. Based on these readings and past experience, the best exposure was determined and a series of images were taken. Because infrared film has an extremely sensitive and delicate emulsion, I always shoot several frames of the same subject to ensure the success of an assignment.

INTO THE DARKROOM: The film was developed according to Kodak's recommendations: D-76 developer straight for 10 minutes at 70 degrees Fahrenheit; a 30 second stop bath with Kodak's Indicator Stop Bath; and fixed in Rapid Fixer without hardener for 5 minutes. I then rinsed the film in water for 30 seconds, treated it with the Hypo Clearing agent for 1-2 minutes, then washed for 5 minutes at 65-75 degrees Fahrenheit. In order to minimize drying marks, the film was treated with Photo-Flo solution before drying. The film was then hung to dry in a dust-free environment.

The most time consuming step came after the contact sheets were made: deciding what to print. I went through the contact prints several times and marked the images that caught my eye. They were then stored for about a week until I reviewed them once more, again marking the most interesting frames. The images which were marked most often after several reviews were printed.

The first printing session was an editing process as well. All of the selected images were printed quickly onto resin-coated paper. At this point I was not concerned with producing a great print, but enlarging all of the images to an 8x10-inch size for review. The most interesting images from this edit were then printed on Kodak Ektalure G fiber based paper. Ektalure G is a heavy, graded, warm tone paper which offers beautiful results when hand tinted.

I began printing with Dektol paper developer, prepared 1:2. This first print had too much contrast and needed to be lightened. By adding Selectol Soft, 1:1, to the Dektol, the contrast of the paper can be controlled. If I go too far and need more contrast, I "spike" the developer by adding more Dektol. After making this first print, I studied the negatives of the other shots and chose those with similar densities to print at the same time. The prints were washed in an archival washer for at least one hour and then dried, face down, on screens.

HAND PAINTING: My decisions of what areas of an image to paint are purely intuitive. Some prints look great just as black and whites, while others need color in order to create a certain mood. I try to recreate the feeling of the area from memory and personal interpretation.

For hand tinting I use oil paints (any brand) and colored pencils. These are applied directly onto the paper (Note: Remember that the paper was fixed without the hardener added) using cotton, toothpicks and cotton swabs for brushes. The oil paints are very forgiving and can be removed easily with turpanoid if a mistake is made. After repeated application, the turpanoid will affect the paper emulsion and disable further application of color to the affected areas. Many photographers will spray the final painted print with a clear matt spray to avoid smudging.

RENÉ SULTRA

F R A N C E

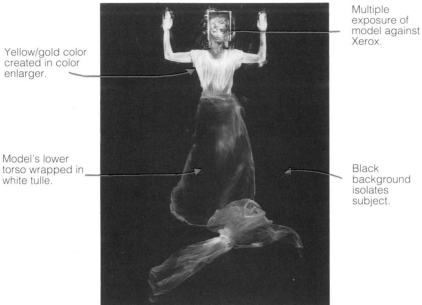

Multiple exposure of model against Xerox.

Yellow/gold color created in color enlarger.

Model's lower torso wrapped in white tulle.

Black background isolates subject.

PHOTO NAME: Untitled.

PHOTOGRAPHER: René Sultra, Toulouse. France.

ASSIGNMENT: Personal Research.

FILM: 35mm, Kodak T-Max 400 ISO, rated at 400 ISO.

PAPER: Kodak Ektacolor Ultra F, filtration 25 yellow, 70 magenta, 0 cyan.

CAMERA: Leica M4 (2).

LENS: 50mm.

THE SETUP: A large sheet of black plastic was draped along the back wall of the studio and onto the floor. Two large Xerox copies of photographs taken by Harry Burton during the discovery of Tout Ahkh Amon, were joined together to make a life sized image of the mummy. This image was taped to the black background directly behind where the model would stand. The two figures, the woman and the mummy would be brought together during the exposure to create a single human shape.

"I wanted to use the photographic process to record an image which would draw a link between present time (the woman) and the past (the image of the mummy); a representation of the return of "Ka", the moment when the soul returns to a mummy, giving the preserved corpse eternal life. (Mummification is how the human body is protected against the destructive power of time.)"

The set was lit by one small handheld tungsten lamp. This lamp was used to selectively paint in areas of exposure that were desired. Marie, the model, who was wrapped in white tulle, took her place on the set and the camera was focused on her. This would allow the background to be slightly soft and offer a better merging of the two images. The exposure was recorded in two parts. During the first step, Marie waited on the side of the set. To begin the exposure, the room lights were turned off, leaving the set in total darkness. Once the camera shutter was opened, the lamp was turned on as it was moved to illuminate selected areas of the Xerox prints. The lamp was kept out of the camera view so the bulb would expose a trail of light. Next, while the lamp was turned off briefly, Marie took her place on the set. Once she was positioned in front of the Xerox, the lamp was again turned on and specific areas of her body were illuminated. (Fig. 1) The time for each exposure was between 5 and 10 seconds.

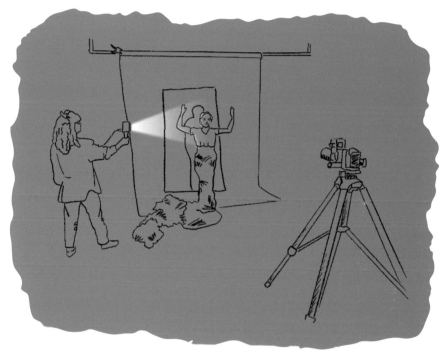

Fig. 1

MAKING THE PRINT: The negative from the normally processed T-Max film was placed into a color enlarger. The color of the enlarger was set to 25 yellow, 70 magenta and 0 cyan. This combination gave the print an extreme yellow "gold" cast. The color paper, Kodak Ektacolor Ultra F, was processed RA4 as recommended.

EDWARD GAJDEL

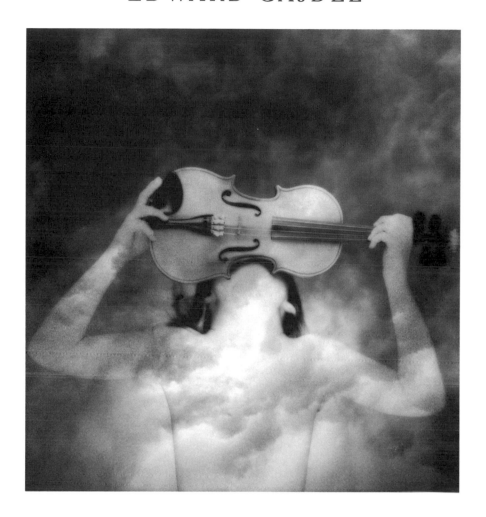

C A N A D A

Inspired by the great masters, European born Edward Gajdel's passions lay with his black and white work. One of Canada's leading photographers, Gajdel pursues his craft with a passion, sincerity and honesty that only further enhances his exquisite and poignant images. His sensitivity toward his subjects is outweighed only by his creative visual capacity which is based on simplicity.

EDWARD GADJEL

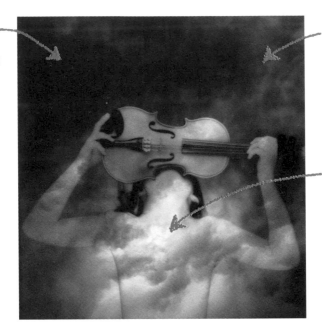

Dark portrait background allows clouds to be blended with shot #1.

Second image of clouds added in the darkroom.

Large softbox and umbrella used to illuminate boy.

PHOTO NAME: Voice Of An Angel.

PHOTOGRAPHER: Edward Gadjel, Edward Gadjel Photography, Toronto, Ontario. Canada.

ASSIGNMENT: The circumstance which brought this image to life was the sudden and tragic death of a Canadian design legend, Scott Taylor. As a tribute to his life's accomplishments, "The Scott Taylor Memorial Art Auction" was formed to raise funds for cancer research. Based on a symbolic theme of "Angels," the many photographers and illustrators who have known and worked with Scott were invited to donate original works for auction. I wanted my image to represent my greatest respect and gratitude for Scott, as he was instrumental in launching my career as a photographer. I wanted to really push myself stylistically.

FILM: Kodak T-Max 100 Professional (TMX). 100 ISO rated at 100. Kodak Tri-X Pan 400 (TX). 400 ISO rated at 400.

CAMERA: Hasselblad with 80mm lens (shot #1). Leica M6, 35mm (shot #2).

ABOUT THE SHOT: This image is the result of two separate black and white negatives being printed together on a single sheet of photographic paper.

PREPRODUCTION: My biggest dilemma with this project was finalizing a concept. It was extremely difficult to come up with a concept that could possibly say all the things I wanted. For the longest time I had no clue about how I would approach this challenge. Finally, the

pressure of a deadline had forced me to begin somewhere, anywhere. I just had to begin. What happened beyond this point was an unusual set of events that, in retrospect, seem quite miraculous. I started searching for ideas in my own files, hoping that I would come across an image that would appropriately express my feelings. The photograph had to represent a certain purity, an innocence, a thirst for living and a mystery of the unknown. I did not find a single image which encapsulated my thoughts, but in the process I found several images that expressed my feelings in part. After further thought, I ended up with two negatives: one, an overexposed test print of a young child holding a violin over his head, the other a 35mm shot of some amazing storm clouds.

SHOT #1 SETUP: The image of the child holding the violin was shot as a test for an ad several months prior. A large dark canvas backdrop on two 9-foot light stands with a crossbar was used as a sweep to provide a continuous background for the image. It was illuminated by a 125-watt second (w/s) strobe head with a grid. (Fig. 1)

The child was front-lit by two separate light sources, a large 72-inch silver umbrella and a large soft box. Two strobe heads with a joint output of 1000 w/s were used to bounce light into the umbrella, located at the center of the set and above the camera. The soft box, located at the center of the set and below the camera, was illuminated by a single 750 w/s strobe head. (Fig. 2) This lighting setup, typical in beauty photography, created creamy white, glowing skin tones.

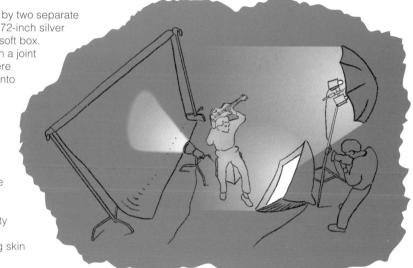

Fig. 1

The camera was hand held to allow me freedom and spontaneity to follow the subject quickly

METERING THE LIGHT, (SHOT #1): After the exposure was determined with an incident flash meter, a series of Polaroids was shot to fine-tune the image and determine the desired exposure. My exposure was approximately 1/125 second at f/16, nearly three stops over the normal exposure. This, unknowingly, was crucial in the later merging of the two images.

THE SETUP, (SHOT #2): The photograph of the clouds was created outside using a 35mm Leica M6 camera. Using the camera's built-in reflective meter to set my exposure, I exposed several images throughout the day as the cloud formations changed.

INTO THE DARKROOM: This is where the miracle took place. Although I love to print and regard printing as an art, I usually refrain from multiple printing as it demands too much time and patience. Working with only one enlarger, I chose to begin with the negative of the child. I first focused the image onto a white sheet of paper and then traced the figure of the child. This would allow me to determine the best area on which to expose the clouds. Setting this focusing paper aside, I made a test exposure on photographic paper. To protect the latent image from light contamination between prints, the photographic paper was placed back into a paper safe.

Next, the 35mm negative of the clouds was placed into the enlarger, replacing the negative of the child. Using the focusing paper with my tracing, I attempted to determine the best position for the child to come through the clouds. A naturally light area near the bottom center, around the chest of the child, looked like a good starting point.

Without any burning or dodging, I made at test print of the two combined images which came out beautifully. I could not believe it. Immediately, a second print was made, making only slight changes in image placement and darkening the overall print by exposure time. I continued trying to fine-tune the prints by burning and dodging specific areas. The results were simply bad in comparison to the two original unaltered prints. After selenium toning the grade two paper, I chose the darker print for framing.

I was witness to a miracle in my darkroom and vowed never to try to duplicate this image again. The project, which took nearly a month to complete, was received with praise and, incidentally, fetched the highest price at the auction.

RICHARD PETRY

A M E R I C A

Final art piece copied onto 8x10 film with even lighting.

Checker pattern painted onto print.

Toy boats and small props tell the story of the image.

PHOTO NAME: Stormy Seas.

PHOTOGRAPHER: Richard Petry, Columbus, Ohio. U.S.A.

ASSIGNMENT: This image is a one-of-a-kind fine art piece that was sold to a private collector. "Stormy Seas" deals with order and chaos, movement, layering, wind, color, water, sailing, knots and a few other issues.

FILM: 8x10 Kodak VPS 100 ISO, rated at 100 ISO.

CAMERA: Calumet 8x10.

LENS: Sinar Symmar-S 360mm.

ABOUT THE SHOT: The unique look of this image is created by combining both photographic and painting processes.

THE SETUP: Two silver umbrellas, one on either side of the set, were used to flat light the image. Each umbrella was set at a 45° angle off to the side of the set. This eliminated most of the shadows on the set. It was necessary to use 4800 watt seconds of power to shoot at f45. The platform and original size of the set being copied was 20x24 inches. (Fig. 1) There was one stop of bellows compensation when the 8x10 camera was focused this close.

Creating the set was the most difficult part of the shoot. Pieces of paper and glass, along with toy boats, flowers, and other objects were placed flat onto the white background. The design and meaning of the image hinged on the styling of each object and its position within the image.

(Fig. 1)

Once the props were in position, an incident light meter was used to establish the exposure of the set. With the meter flat and the dome facing up, readings were taken across the entire image to ensure the set was evenly illuminated. Once the exposure was even from side to side, the strobe packs were adjusted until the exposure read f45 to ensure depth of field. No filtration was used.

Because a print would be made for the second stage of the shoot, negative film was used to ensure the largest tonal range could be recorded. The negative film was C-41 processed, and a 40x70 inch custom print was made on Kodak Ektacolor Plus paper. The print was then covered with frisket, a clear film used to make masks when painting with an airbrush. The frisket, which has a sticky surface, was carefully cut around selected objects in the print. This mask allowed the white background of the print to be painted. These background areas are then painted with acrylic using an airbrush. It is with this technique that the small checker boards and some shadows were created. The combination of the photograph and the airbrushed paint gives an illusion of depth to the image.

The print is then mounted into a frame which has been painted as well to complement the image. The entire project took about 40 hours to complete, with the majority of time spent on building the set and then painting the print.

JOHN SEXTON

A M E R I C A

Respected photographer, master printmaker and workshop instructor, John Sexton prefers photographing the quiet message of our natural environment, responding most often to small pieces of the whole. From soft fog in a pine forest to the elegant detail of a corn lily, his images are distinguished by a tonal delicacy, formal elegance and sense of mystery that convey a love of light.

JOHN SEXTON

Spot meter and zone system used to determine exposure.

Negative brushed with selenium toner to intensify cliffs in final print.

Small aperture creates burst effect on lights.

Long converging lines lead viewer into the image.

PHOTO NAME: Hoover Dam at Night.

PHOTOGRAPHER: John Sexton, John Sexton Photographer, Carmel Valley, California. U.S.A..

ASSIGNMENT: This image is part of a current personal project entitled "Places of Power," an attempt to photographically reveal the aesthetic beauty in man-made, utilitarian objects which represent high technology. Currently, the following subjects are part of the "Places of Power" projects: Ancient Anaszi Ruins, Power Plants, Hoover Dam and The Space Shuttle. The aesthetic interest of these subjects is largely due to the fact that "form follows function." A book of these photographs is planned for publication.

FILM: Kodak T-Max 100 Professional, (TMX) 100 ISO rated at 40.

EXPOSURE: 7 minutes @ f/11.

CAMERA: Linhoff 4x5 MasterTechnika.

LENS: 75mm, Nikkor-SW.

PREPRODUCTION: Prior to visiting Hoover Dam, I contacted the authorities to obtain permission for access to the photo site. Permission was granted on the condition that I would be escorted by a U.S. Bureau of Reclamation police officer. Working alone, I scheduled the photograph to be taken in the early evening, allowing set up time and an exposure of the lights while some ambient sky light still existed.

ABOUT THE SHOT: This photograph is a single long exposure using only available light for its illumination. The shadow detail of the cliffs was extracted through darkroom manipulation.

THE SETUP: I arrived at the scheduled rendezvous site where I was to meet my escort officer with plenty of time to spare. Unfortunately, the officer was delayed and arrived long after our anticipated time of departure. With the light falling fast, we arrived at the site and I began to set up my camera. I used a 4x5 view camera and a 75mm lens, a perspective which would allow me to record the entire face of the dam as well as some foreground elements. I added a slight front rise to the camera's lens board to include the upper portion of the dam without inducing any convergence in perspective. In addition, a slight forward tilt of the lens board was made to carry the desired depth of field. By the time the camera was set, it was almost completely dark.

With the lights around the dam on, I was faced with recording an extremely high contrast situation. To determine the exposure, I used a Pentax 1 degree digital spotmeter and the Zone System. The exposure would take seven minutes with an aperture of f/11. A large aperture was selected because the ambient light from the sky was diminishing quickly, and that light, along with bounce light from the face of the dam, were the only illumination on the cliffs surrounding the dam. Because of the length of the exposure, it was necessary to compensate for the effective loss of the film's speed due to reciprocity.

For T-Max 100, I normally rate the film at an Exposure Index (EI) of 64. This high contrast situation, however, called for an EI of 40. This rating would provide an overexposure on the film which would be corrected by underdevelopment, providing the best negative possible. (I have conducted several film speed tests under various lighting conditions to find an approximate Zone 1 or white with detail density on the negative. This is the equivalent of a densitometer reading of .10 or above when reading the negatives film base plus fog or D-min.)

No filtration or multiple exposure techniques were used.

INTO THE DARKROOM: The film was developed using a compensating development procedure to underdevelop the film. This was achieved by using Kodak T-Max RS Developer diluted 1:15 (normal dilution is 1:4) for ten minutes at 75 degrees (F). By reducing agitation, 10 seconds every 2 minutes, the highlights were mildly developed while the shadows received nearly full development.

Once the film was dried, a first test print was made and reviewed. I decided that the shadow areas of the cliffs would need to be intensified. This was achieved by using Kodak Rapid Selenium Toner (diluted 1:1 with working strength Kodak Hypo Clearing Agent for 10 minutes) on selected areas of the negative. After the negative was re-soaked in water, the desired areas to be enhanced were covered with a photo wipe. This would prevent "bleeding" of the Selenium Toner into the surrounding areas. The intensification solution was applied to the emulsion side of the negative with a cotton swab. (Working on a light box will allow you to more easily see your negative and which areas of you are affecting.) Since there was such a small amount of silver density in these areas, there was only a slight amount of intensification needed.

Because the resulting negatives still had considerable contrast, some printing manipulation would be needed. In addition to normal dodging and burning (lightening and darkening local areas of the print), I also "flashed" selected areas of the print. "Flashing" is a printing technique where non-image or white light is "flashed" onto the paper to reduce the intensity of specific areas. The amount of light that is applied to these areas is so small that without additional exposure on the paper, the "flashed" areas are actually invisible. On this print, the spotlights which were shining directly into the camera lens on the right, as well as the door to the interior of the building, were "flashed" through a hand cut mask. Although this technique can be done using only one enlarger, I prefer to use a second enlarger to "flash" the non-image light. This eliminates the need for the negative carrier to be removed from the enlarger for the "flashing." Once the paper is "flashed" through the mask, it is registered into the easel for proper positioning. This technique, along with burning, can bring subtle detail to the highlight areas of the image.

ANNEMARIE & PETER SCHUDEL

S W I T Z E R L A N D

The team of Annemarie & Peter Schudel specializes in advertising photography in their studio in Zurich, Switzerland. Much of their work deals with food, photography for packaging, for cans, frozen food, chocolates and biscuits. Both exhibit and publish their artistic photography, often done on their own. Totally engaged photographers, they say photography takes the place of children in their life.

Simple props add to the image's story.

Carefully styled food is shot immediately.

Box light at table level, lights the set.

Type is added to original image in duping process.

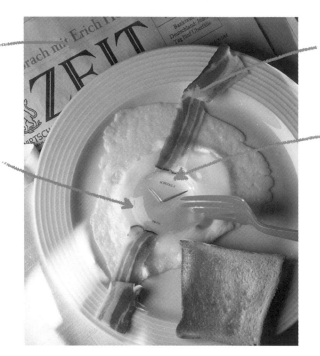

PHOTO NAME: Egg & Bacon Watch.

PHOTOGRAPHER: Annemarie and Peter Schudel, Foto A. & P. Schudel, Zurich, Switzerland.

ASSIGNMENT: We were asked to produce a photograph to be used for the cover of a Swiss magazine, *Idee*. This honor is given to a different photographer each month. In this way, it has become a platform for self-promotion in our country. We were told that this month's issue would deal with watches. We wanted to approach this in a somewhat abstract manner because we work with several different watch manufacturers and did not want to give an advantage to any single brand. Type did not influence the layout.

FILM: Kodak Ektachrome Duplicating Film.

CLIENT: *Idee* Magazine.

CAMERA: Sinar, 4x5.

LENS: Schneider, 300mm.

ABOUT THE SHOT: This photograph is a single exposure food photograph, that was later sandwiched with a piece of litho film containing type and copied onto 4x5 duplicating film.

PREPRODUCTION: The most difficult thing about this assignment was definitely the conceptual planning. We worked long and hard, reworking many ideas before we realized this was the one symbolic idea that really grabbed us. A sketch was then made of the layout to plan the image's design completely.

THE SETUP: Using a table top as a working surface, the lighting and props were set into position. A Broncolor Pulso 2 power pack and Broncolor Boxlight were used for lighting. The Boxlight, a small contained box with an opaque plexiglass front, is a very efficient light source which emits even, diffused lighting. It was placed on the table on the left side of the set (See Fig. 1) Opposite this source, a small mirror was added to the set to add fill light to the shadows.

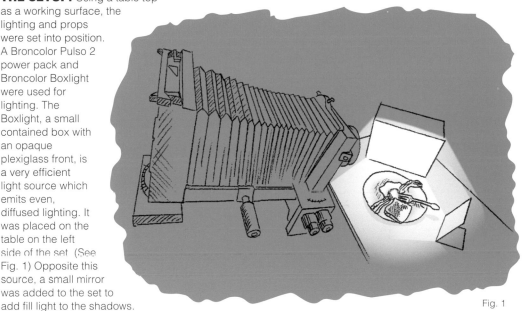

Fig. 1

A daily newspaper as well as the plate and fork were added to further enhance the image's story and help with the overall design.

METERING THE LIGHT: Using a hand-held flash meter, an incident reading was taken to determine the proper exposure.

EXPOSING THE FILM: To begin with, we tested the photograph using "stand-in" food, shot on Polaroid film. This allowed us to rehearse the steps which would be necessary to record the image. One major problem that occurred was that the eggs began to wrinkle as they cooled. To solve this problem, as with most food photography, it was necessary to shoot the film the moment the food was put into place.

While another batch of bacon and eggs was being prepared, the camera was loaded with film, ready for the final exposure.

Once the shot was completed, we had an idea which would further help the promotion aspect of the photograph. Since every watch should display name of its maker with pride, we decided to add the type "Schudels Swiss" to the image. This was accomplished by reproducing the words onto on litho film at the appropriate size. The litho film was then sandwiched over the final image (so that it appeared to be on the watch's face) and then both pieces of film were copied onto Kodak duplicating film, creating the final composited image.

ANNEMARIE & PETER SCHUDEL

After the magazine had been published, *Nikon News* contacted us seeking permission to use the photograph in one of their articles about advertising photography. Overall, the shoot and the image were a tremendous success.

PENINA

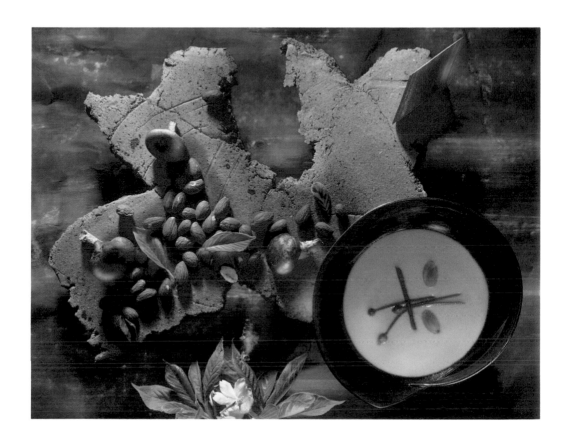

A M E R I C A

Born in New York City and educated at the School of Visual Arts and The New School for Social Research, Penina lives and works in San Francisco. Penina has a book of her personal work called Polo, and numerous awards from Graphis. Her work is represented in the design collection of the Library of Congress and the National Sporting Library in Washington, D.C.

Large, soft light source is used to light the set.

Background is lit from below table.

Light painting technique is used to create warm highlights.

PHOTO NAME: Almond Soup.

PHOTOGRAPHER: Penina, Penina Photographer, San Francisco, California. U.S.A.

ASSIGNMENT: My assignment was to create an image for the *The San Francisco Chronicle Sunday Image Magazine.* I was selected for the job because of my unique style of shooting food. No type would effect the composition of the image.

FILM: Kodak Ektachrome 100 Plus Professional 4x5, (EPP). ISO 100 rated at 100.

CLIENT: *The San Francisco Chronicle.*

CAMERA: Sinar P, 4x5.

LENS: Schneider,165mm.

ABOUT THE SHOT: This image is a single exposure, lit with both flash and additional light painting through the use of a fiber optic wand.

PREPRODUCTION: Prior to the actual shoot, a stylist was selected to assist in the set design and prop selection.

THE SETUP: We began by constructing a small working platform on two sawhorses. A piece of frosted Plexiglass, placed across the sawhorses, offered not only a stable surface but also one which could be illuminated from below. A piece of hand painted purple material was placed on top of the Plexiglass to be used as the background for the image.

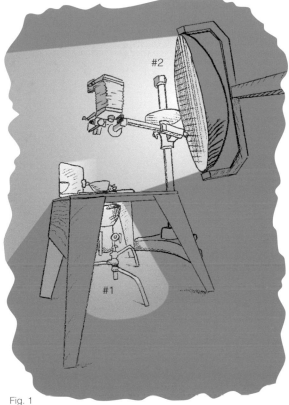

Fig. 1

The lighting from below the set was accomplished by placing a strobe head (#1) beneath the table, just under the Plexiglass. Because the Plexiglass and the purple fabric were both translucent, a single burst from the strobe lit up the fabric, giving it a glowing quality. A piece of black material was secured around the Plexiglass to contain any stray light and keep it from contaminating the set during the exposure.

The stylist and I worked to style the props. The time-consuming part of this, like any food shoot, was the nit-picking placement of every little detail. The top of the set was lit by a large Northlight (#2) with a grid attachment. (See Fig. 1) This 3-foot round light source generated light with a very soft quality. Its purpose here was to add subtle detail to the shadow areas. The highlights would later be added by "light painting." A small mirror placed opposite the Northlight added fill light to the right side of the set.

The "light painting" was done with a small fiber-optic light source, allowing me to create unique highlighting throughout the image. By holding the fiber-optic close to selected areas of the image for several seconds, while keeping the source in motion, beautiful non-directional highlights can be created.

METERING THE LIGHT: Most people find it hard to believe that I do not use a light meter when shooting. I determine my exposure by first viewing the set through my fingers, which I cup and hold up to my eyes, as if looking through a lupe. I can then "feel" the lighting and have a good sense of what exposure will be needed for the depth-of-field I desire. I do, however, shoot Polaroid film to verify this exposure. Using this technique, it was determined that the proper exposure for an aperture of f/45 was two pops from the strobe at full power.

EXPOSING THE FILM: Because I would be using multiple flashes from the strobes and painting with light, it was necessary for the studio to be in complete darkness. This would allow me to set the camera shutter on "bulb," leaving the lens open for as long as needed.

Once the lens was opened the strobes were manually fired twice. Next, I approached the set with the fiber-optic light and began to "paint" the set. Because my fiber-optic system is not daylight balanced at 5500 degrees Kelvin, it tends to create a warm color shift when using it in conjunction with daylight balanced film. In this case, I desired the warm color of the light

and did not make an effort to color correct this source. To help with the timing of the light painting, I utilize an audio metronome to keep track of how many seconds each area of the image is lit. Each painted area of the set was lit for a five second period. (See Dissection #1) for the areas affected by the light painting.) Once all exposures were recorded, the camera's shutter was closed and the image was complete.

Light painting system used for several seconds in each position to create warm highlights.

Light temperature is not color corrected, creating warm color balance.

Bowl and soup highlights painted with light.

Dissection 1.

PENINA

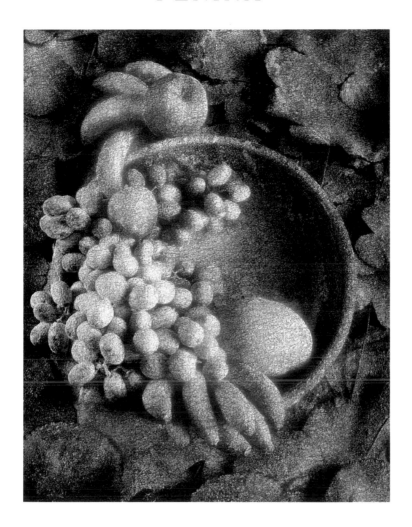

A M E R I C A

Born in New York City and educated at the School of Visual Arts and The New School for Social Research, Penina lives and works in San Francisco. Penina has a book of her personal work called Polo, and numerous awards from Graphis. Her work is represented in the design collection of the Library of Congress and the National Sporting Library in Washington, D.C.

Northlight with strobe casts diffused light across entire image.

Lightpainting adds warm highlights to image.

Tissue paper, placed in film holder creates pattern over entire image

Set dusted with light coat of white flour.

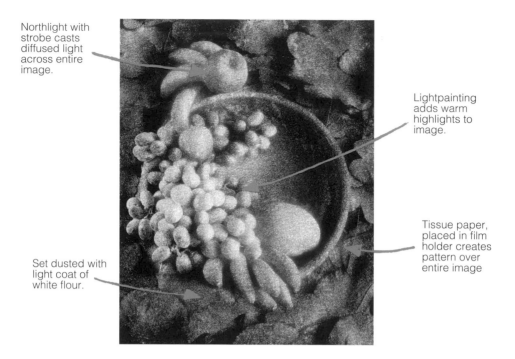

PHOTO NAME: Fruit.

PHOTOGRAPHER: Penina, San Francisco, California. U.S.A.

ASSIGNMENT: This image was produced for a self promotion advertisement in a photographic source book. The image was to appeal to designers and art directors who purchase fine art photography.

FILM: 4X5 Ektachrome 100 Plus, ISO 100 rated at 100.

CAMERA: Sinar P, 4x5.

LENS: Schneider 165mm.

THE SETUP: Pushing the limits of creativity is always a challenge, and experimenting with new techniques is essential to create work different than anything you have ever seen. For this image a bowl, several pieces of fruit, and some leaves were placed on a table and carefully styled. The shapes worked well for this image because they were easily recognizable, even with the texture that would be placed on the image.

The camera was positioned directly above the set so that the lens and film planes were parallel to the table top. A Northlight, a large contained 3x4 light source, was the main light. This light, fixed with a grid attachment to control the lighting direction, was positioned to the right of the camera,

just above the table. Three power packs, two at 5000 watt seconds (ws) and one at 2400 ws, powered six Balcar heads inside the Northlight. The light was turned slightly so the origin of light came from the upper right of the image. A small white card, positioned just opposite the main light on the table, added some fill light to the set revealing detail to the shadow area. (Fig. 1)

The second light source was a Mini Mole, a small Mole Richardson tungsten light source. It was used as a light painting device to create highlights. To balance the tungsten light source to the daylight balanced film, it would be necessary to add an 80A (Blue) filter to the light. However, a warm color shift was desired on the highlights, so the Mini Mole was not filtered. The strobe exposure was underexposed by 1/2 stop to accentuate the light painting . The exposure for the light painting was based on experimental testing and experience.

The final step was to dust the entire set with a light coat of white flour. A series of Polaroids were shot to evaluate the lighting and design. At this point the pattern seen on the final image was not apparent.

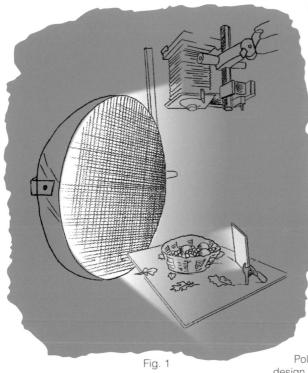

Fig. 1

Once the desired exposure was found, the film holders were loaded, each one with a piece of tissue placed in front of the film. (Fig. 2) Because the tissue was directly on the film plane, the image was recorded unaltered wherever there was a gap in the fibrous tissue. At the same time the image was recorded, the pattern of the tissue was contact printed onto the film. Because the tissue was not entirely translucent, the resulting contact image revealed a black mask of the tissue's pattern. In this case, there was no exposure compensation added for the tissue.

Fig. 2

SAVINI & RÜFENACHT

S W I T Z E R L A N D

Publicity photography requires good communications and teamwork. Dennis Savini and Irene Rufenacht exemplify that. Irene is a multi-functional organizer while Dennis has a sound basis in the widest range of the aspects of professional photography. This lets them go beyond the conventional perspective and create the unexpected, producing photographs that speak a language of their own.

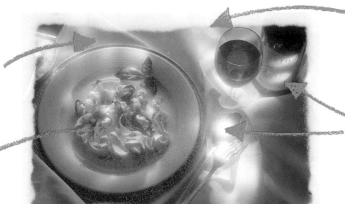

Base
exposure from
large diffusion
panel.

Food stylist
prepares food
to perfection.

Airbrush mask
frames image.

Highlights
painted in with
Hosemaster.

PHOTO NAME: Tagliatelle Vongole.

PHOTOGRAPHERS: Dennis Savini and Iréne Rüfenacht, Savini & Rüfenacht Photography, Zurich. Switzerland.

ASSIGNMENT: This image was produced for the Swiss Association of Chefs and Hotel Proprietor. It was one of eleven images which opened each chapter of a professional table service book. The final image was 12x16 inches and did not include any text.

FILM: 4x5 Kodak Ektachrome duping film 6121.

CLIENT: The Swiss Association of Chefs and Hotel Proprietor.

ART DIRECTOR: Heinz von Arx.

COOK: Isabelle Dirr.

CAMERA: Sinar P2, 4x5.

LENS: 300mm.

THE SETUP: This shot was to convey the feeling of sitting in an Italian pergola with the sun shining through the leaves of the surrounding trees. The lighting setup that was used to accomplish this was very simple. It consisted of two lighting devices, a single strobe head and a Hosemaster fiberoptic lighting system. (For more information on the Hosemaster System please refer to Still Life, "Alvados" by Aaron Jones.) The strobe would add fill light to entire image, revealing some shadow detail, and the Hosemaster would highlight specific areas the art director requested.

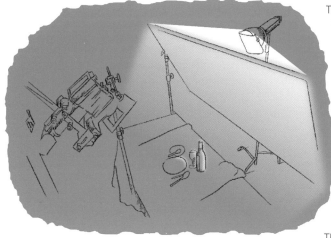

Fig. 1

The strobe was located to the rear of the set and was covered with a blue Lee gel. The gel gave the shadows a cooler color balance, exaggerating the warmth of the highlights. A diffusion scrim placed between this light and the set diffused the hard light quality of the raw strobe, creating soft light across the entire set. This soft quality of light revealed detail in the shadows and made the image appear fairly flat.(Fig. 1) It was after this initial exposure that the Hosemaster was used to create highlights, adding life and depth to the image. No flags or fill cards were used.

The metering was made as simple as possible through the use of a Sinar system consisting of their digital shutter and meter. The system allows reflective meter readings to be taken directly off the film plane. In this case, a shadow reading of an area with a tonal value of 18% was taken, rendering an exposure setting of f22 1/3. An area with a tonal value of 18% was selected because the

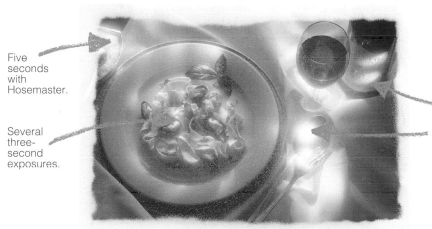

Five seconds with Hosemaster.

Five seconds on bottle and background.

Several three-second exposures.

Ten seconds on fork and spoon with diffusion filter over the lens.

Dissection 2, Light painting with Hosemaster.

reflective meter would give an exposure setting to make that area of the image 18%. The digital shutter aperture was then set to f22 1/3. The exposure was made by first triggering the strobe at the beginning of the exposure, and then leaving the set in darkness while the light painting took place. The exposure times for the light painting were fairly short and simple. (See dissection 2 for details.) Every image which was painted was slightly different, offering the art director several choices.

INTO THE DARKROOM: The final step was to create a mask to dupe the image. An airbrushing tool was used to paint a window onto a sheet of cleared 4x5 film. This mask was sandwiched together with the original chrome, and a contact image of the film was made.

KATHRYN HOLLINRAKE

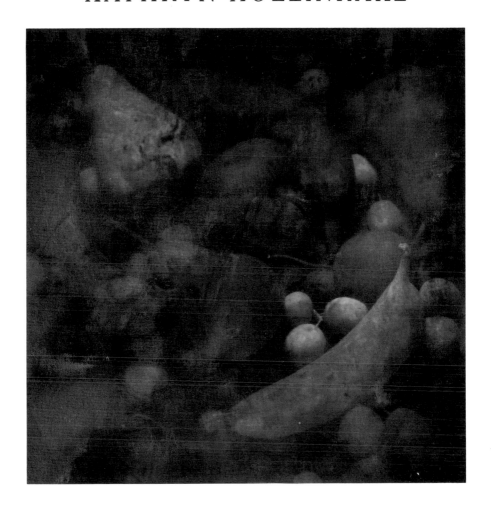

C A N A D A

Kathryn Hollinrake chose photography "because I thought it would be faster than drawing." At Ryerson in Toronto, she "took the wrong program - Photographic Technology - and got the wrong job - T.S.R. for Kodak Canada." Hollinrake later opened a studio with photographer Jason Thomas Morris and continues to "hurtle with ever increasing speed toward fame and fortune in Canada!"

KATHRYN HOLLINRAKE

Camera is focused on the screen for the second exposure.

Fruit is painted before the shoot and carefully styled.

Camera is focused through the screen to the fruit for the first exposure.

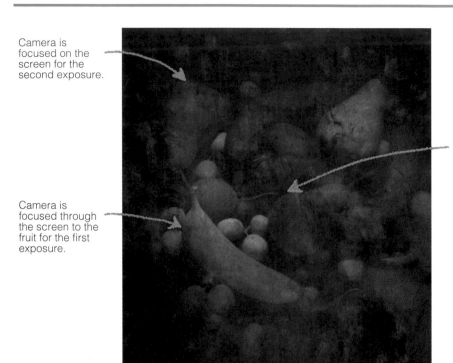

PHOTO NAME: Painted Fruit.

PHOTOGRAPHER: Kathyrn Hollinrake, Toronto, Ontario. Canada.

ASSIGNMENT: "Painted Fruit" was created to be entered in a Kodak/Hasselblad photo contest. The contest required that the image be shot on Kodak Ektar 120mm film, which was entering the professional market at the time. Knowing that the judges of the contest would be interested in color saturation, I chose a combination of various fruits and paint as my subject matter.

CLIENT: Self Study.

FILM: Negative: Kodak, Ektar 25 Professional (PHR). 25 ISO rated at 25. Transparency: Kodak Ektachrome 64 Professional (EPR). 64 ISO rated at both 50 and 64 ISO.

CAMERA: Hasselblad.

LENS: Hasselblad, 120mm.

PREPRODUCTION: I greatly enjoyed putting this project together and having the creative freedom to express my personal vision. Having decided that fruit would be a key component of the image, I traveled to a wealthy neighborhood in town where a variety of quality fruit was easily accessible. Fruits of various shapes, colors and sizes were selected to offer me some flexibility and interest in the image's composition.

The first step toward creating the painted look of the image was to hand paint each piece of fruit, as well as the paper background (which was large enough to cover a table top). In this case I used water-based gouaches that would show the rough brush strokes, adding texture and depth to the image. A piece of sheer fabric screen, which would later be placed between the fruit and the camera, was selectively painted as well.

THE SETUP: Although I often work with assistants, I chose to work alone, giving me a quiet and private environment in which to work.

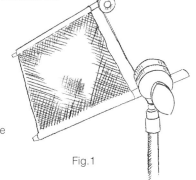

I began by setting up a small table on which the background and fruit would later be set. Above this table, the painted fabric was suspended by C-stands at a slightly downward angle. (Fig. 1) The idea was to have the camera focused "through" the fabric for one exposure, and "on" the fabric for the other. The lens that enabled me to change this focus and also compress the perspective of the image was a 120mm. This double exposure technique would give the image the "painted" feeling I was trying to obtain.

Fig.1

Two Broncolor P4 strobe heads, fixed with wide grids, were placed on the left of the set. (Fig. 2) One of the heads, just above the table, was aimed slightly downward to side-light the fruit. This heavy side lighting created shadowing on the fruit and their painted surfaces. To reveal some detail in the shadows, a silver fill card was placed on the right of the table-top, just out of frame. The second light was aimed to skim across the top of the fabric, showing the screen's texture. Each strobe head was controlled by a separate power pack, enabling their power and triggering to be independently controlled.

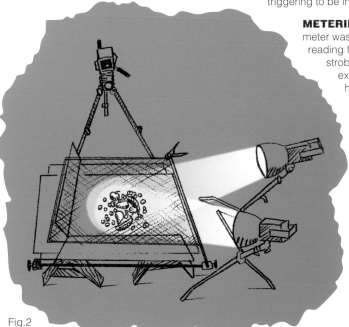

METERING THE LIGHT: An incident meter was used to take an exposure reading for each light. The power of the strobe packs was adjusted until both exposures were equal. The honeycomb grids were key, directing the light to a concentrated area so one exposure would not affect the other. The first exposure to be made was of the fruit, with the camera focused on the fruit. During this exposure, only the light striking the fruit was fired. Once this first exposure was made, the camera was adjusted, in the dark, so the focus was now on the screen. At this point the second strobe was fired, the lens was closed and the merging of the two images was complete.

Fig.2

TIM WHITEHOUSE

A M E R I C A

Taught by peers and employers, Tim Whitehouse worked in catalog studios in the 70's, using 4X5, 8X10 and 11X14 cameras, tungsten lights and huge strobe systems. His myriad experiences have taken Whitehouse from national portrait chains to two-person commercial studios, from advertising, wedding and portrait photography to the staff of a large aerospace company, and, ultimately, to digital imaging education.

Colored strobe burst emulates sunset.

Model of aircraft carrier.

Pilot lit by a portable strobe in cockpit.

Models lit with P22 panel.

Small strobes created wing lights.

Fog machine adds realism to the set.

Runway is watered down.

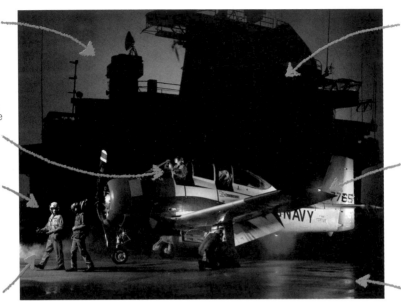

PHOTO NAME: T-28 Aircraft, Carrier Operation.

PHOTOGRAPHER: Tim Whitehouse, Tim Whitehouse Photography, San Diego, California. U.S.A.

ASSIGNMENT: I was to create a high quality photograph of a historic Navy T-28 Trainer on the flight deck of a carrier. The image would be used for an aerospace related trade publication as well as for a large print for office decor. Type did not influence the layout, and I was given full art direction of the image.

FILM: Kodak Vericolor 400 Professional (VPH). 400 ISO rated 400.

CLIENT: San Diego Aerospace Museum.

CAMERA: Sinar, 4x5.

LENS: Goerz Dagor 210mm., Schneider 90mm Super Angulon.

ABOUT THE SHOT: This image was created by printing two separate film negatives onto a single sheet of photographic paper.

SHOOT TIME: 6 Hours Shot #1. 2 Hours Shot #2.

PREPRODUCTION: To make certain that the image would be as authentic as possible, an assistant researched the clothing and headgear appropriate for the shot. We were able to borrow the needed items from the Museum's archives. Four assistants, who could also stand in as models, were scheduled to work on the shoot. The fifth man in the shot was the tractor driver who towed the aircraft onto the set. The location, Gillespie Field in El Cajon, California, was secured by the Museum.

THE SETUP: SHOT #1: The first of the two images created was the Navy T-28 training plane on location. The shoot began at sunset and lasted into the darkness of night. This allowed ample setup time with the intention of shooting in total darkness. A black sky was critical to the merging of the images later in the darkroom.

I chose to use a 4x5 camera because of the high image quality desired in the final enlarged prints. The camera position allowed plenty of open area above the plane so the aircraft carrier image could later be added. Because this aircraft is very stocky in form, a 210mm lens was selected to realistically represent its size. The camera angle was selected with the viewer in mind, offering the perspective of a person being "on deck" a carrier. The angle also featured important components of the plane which would not be visible from extreme high or low angles. A front lens swing of five degrees was added to adjust the focus parallel to the plane.

Fig. 1

A 3x6-foot, P22 Lightform Panel was covered with a translucent fabric and lit from behind by strobe #1. The strobe head behind the panel was positioned to evenly illuminate the entire fabric, providing the softest light possible. This source would illuminate the two models in front of the plane as well as the fuselage, nose, doors and leading wing edge of the plane. (See Fig. 1) A second strobe (#2) with a reflector and coarse spot grid was placed to the right of the camera, lighting the vertical stabilizer. The Navy logo was illuminated similarly by another strobe (#3) with a spot grid.

To eliminate the need for long exposure of the red signal lights, two small portable strobes were mounted to the plane. These small sources were covered with a red gel material and aimed directly at the camera. These sources are labeled in the lighting diagram as #4 and #5.

Hidden behind the nearest main wheel, another battery-powered strobe (#6) was added to the set. It was positioned so the light would bounce off of the wing's white undersurface to light the crewman, wheel and fuselage.

Strobe #7 was placed near the cockpit and pointed down at the white upper surface of the wing to create a soft up-wash of light near the emerging pilot. However, the main source on

197

the pilot was another battery powered head (#8) which was actually in the cockpit. Strobe #1, at the plane's nose, was triggered by the camera. All other heads were set on "slaves" which allowed them to fire simultaneously.

Once the lighting was in place, one assistant watered down the pavement surrounding the plane while another prepared the fog machine. The fog machine added the hint of environment to the aircraft (steam catapults are used to provide thrust for planes as they take off).

METERING THE LIGHT: SHOT #1: The exposure was determined through a series of incident and reflective light meter readings. The incident meter was set on aperture priority to obtain a reading of f/22 and 1/2, which experience dictated would be enough to carry focus through the image. A shutter speed of 1/250 eliminated any ambient light on the airstrip which could affect exposure and color balance. Each strobe head was independently metered to obtain this reading, each time with the dome pointed toward the source.

Knowing that a reflective meter gives an exposure reading which will make any object 18% in value and that white with detail (72%) is two stops above 18%, reflective spot meter readings were taken along the white areas of the fuselage. By obtaining a constant reading of $1/250$ at f/11 and $1/2$, two stops below the set exposure of $1/250$ at f/22 and 1/2, it was guaranteed that the white areas of the plane would appear white. A series of Polaroids helped in fine-tuning the image before the final film was exposed.

EXPOSING THE FILM: SHOT #1: Kodak VPH 400 film was selected due to the depth of field needed with the limited available strobe power. Several sheets of film were exposed with the models altering their positions slightly throughout the shoot. Once the shoot was complete, a clear piece of acetate was taped to the ground glass, and a tracing of the plane's position was made. This was critical to the composition of shot #2.

THE SETUP (SHOT #2): The second shot took place at the San Diego Maritime Museum where there was access to a seven-foot detailed model of an aircraft carrier. The model was pulled from its case and set on a stand, allowing a small set to be constructed. A black backdrop was hung along the back of the set. One

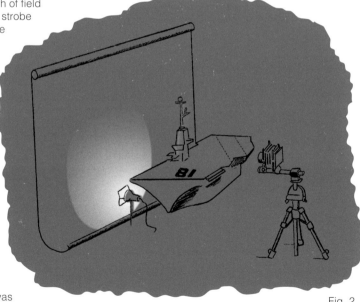

Fig. 2

strobe head, with a six-inch reflector covered with an amber gel, was placed against the background (Fig 2). This burst of light created the feeling of a bright evening sky at sunset and silhouetted the carrier. With the acetate tracing of the plane on the ground glass, the camera was moved into position to properly place the carrier. A 90mm Schneider Super Angulon lens helped to exaggerate the flight command structure of the model.

EXPOSING THE FILM (SHOT #2): After determining the exposure with an incident meter, a Polaroid was shot to check the focus and composition. Because the negative from this shot would be printed together with the negative from shot #1, a series of exposures were bracketed in one stop increments to provide a choice of densities.

INTO THE DARKROOM: This step would include selecting a best negative from each shot, positioning them together in a negative carrier and printing them in a color enlarger. When using this printing technique, you must make sure that the two negatives have the same density and will print correctly when given the same exposure time. To determine the printing time and best negative combination, the negative with the best composition from shot #1 was selected. This negative was printed alone and dried completely, being careful to write down the print time, aperture and color balance. Next, three negatives from shot #2 were individually printed at the same time, aperture and color balance as shot #1. Once these prints were dried, the negative which matched the first print was selected. (It is important to compare tonal densities with dried prints rather than wet ones to achieve accurate results.)

These two negatives were then sandwiched together, emulsion-to-base, in order for the alpha-numeric characters to print correctly, and placed in the enlarger. The first composite print had a slight red color shift. This was corrected with extra cyan filtration for the final print.

In the end, I thought the sky looked a bit contrived, but people really seem to like this image anyway, perhaps due to the emotions conjured up by the emotions of this era.

ALBERT NORMANDIN

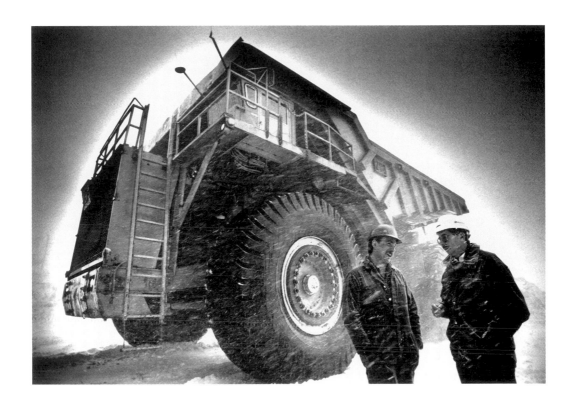

C A N A D A

Born and raised in Vancouver, B.C., Canada, Albert Normandin went from building race cars to printing equipment. He bought a one-way ticket to New York City to work for Jay Maisel, and three and one-half years later returned to Vancouver. Normandin works as a location photographer and his assignments range from Annual Reports, Advertising and Fashion to Coal Mining.

ALBERT NORMANDIN

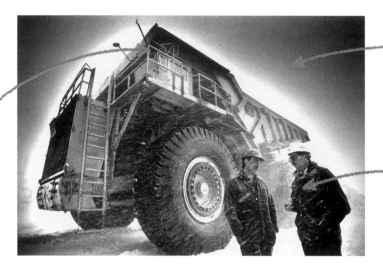

Wide angle lens gives image dramatic perspective.

Bright sky burned down in darkroom.

Incident meter reading of men used to determine exposure.

PHOTO NAME: "Men In Snowstorm,"
Rocky Mountains, B.C. Canada.

PHOTOGRAPHER: Albert Normandin, Albert Normandin Photography, Coquitlam, British Columbia. Canada.

ASSIGNMENT: My job was to create a series of images to be used for an annual report. I was selected over other photographers because of my strong black and white people images and my ability to work quickly in difficult situations. This image was not used in the annual report because the client felt it showed adverse working conditions and settled for a less controversial image shot indoors. The image, which I have used for self promotion, has been one of my most successful.

FILM: Kodak T-Max 400 Professional (TMY). 400 ISO rated at 400.

CLIENT: Westar Mines.

CAMERA: Nikon,35mm.

LENS: Nikkor, 20mm.

SETUP: Upon arriving at the shoot location, we set-up and recorded the photograph scheduled on our itinerary. As we were leaving the building, a large garage door to the shop was opened. It was then that I saw a huge truck, barely visible through the white haze of a snow storm. This image came to my mind immediately, and I suggested that we try this shot.

I elected to use a Nikon 35mm camera, allowing me to work very quickly in the harsh elements. I chose to use only available lighting, and would use the ongoing snowstorm as a source of fill light, revealing information in the shadow areas. By using a 20mm lens from a low camera angle, I was able to emphasize and exaggerate the massive size of the truck as it towered over the men. Because the snow was quickly sticking to my lens and the models were freezing, I had only a few moments to shoot.

METERING THE LIGHT: An incident light meter was used to determine exposure of the men, being that their exposure was the most critical. The meter's ASA was set to 400, matching the speed of the T-Max 400 film.

INTO THE DARKROOM: Once the film was processed, a contact sheet was made to get a quick glance at the image composition and exposure. Due to the falling snow, the sky area of the image was exceptionally white and appeared to be overexposed. By burning in this area of the image, I was able to create a halo above the truck, grading the upper portion of the image. I found this manipulated print to be more pleasing as it forced the attention of the viewer to the center of the image.

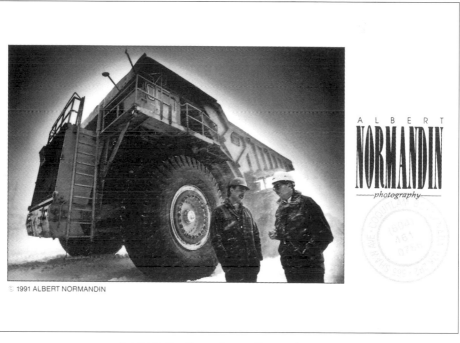

© 1991 ALBERT NORMANDIN

Example of self-promtion mailing card.

TIM MANTOANI

A M E R I C A

Tim has been working closely with Dean Collins since he graduated from Brooks Institute in 1991. An accomplished photographer and writer, his articles and images have appeared around the world. His current portrait study of professional athletes illustrates his strong technical and creative talents. He is based out of San Diego, California.

"No Fear" logo is attached to lightsource, backwards, to reflect appropriately in Ivan's eyes.

Exposure determined by probe reading of skin tone.

Low lighting adds drama to the image.

PHOTO NAME: In The Eyes Of The Ironman.

PHOTOGRAPHER: Tim Mantoani, Collins and Associates, San Diego, California. U.S.A.

ASSIGNMENT: My client, No Fear, arranged a photo shoot with Ivan "The Ironman" Stewart, a legend in off-road racing. Their guidelines were simple, "We need to do a really cool shot!" So, with all the freedom in the world, I went to work.

FILM: Kodak Ektachrome 100 Plus Professional (EPP). 100 ISO rated at 64.

CLIENT: No Fear.

CAMERA: Sinar P2, 4x5.

LENS: Schneider 300mm.

ABOUT THE SHOT: I knew that I wanted to do a close-up shot of Ivan with the words "No Fear" appearing in his eyes. This would accomplish two of my objectives. First, in order to see the words in his eyes, the client would have to use the image big; a poster or full-page ad. Second, I wanted an image that would create a bit of a buzz around their business - "Who did that shot?"

PREPRODUCTION: I began by taking a small die-cut stick of the "No Fear" logo and placing it onto the glass of a super-slide glass slide mount. The slide was placed in a 35mm projector and projected onto a black piece of seamless paper so the words covered an area about six feet in length. Carefully tracing the outline of the projected image, a large version of the logo was created on the paper. (See Fig. 1) The words were then individually cut out of the paper. Next, the letters were covered with a spray-mount photo adhesive and applied to an 8x10-foot piece of clear plastic.

THE SETUP: A large "mondo flat," or diffusion silk, which would be used as the mainlight, was attached to a 10-foot bar and suspended four feet above the ground by C-stands. This made the area of the flat which would be lit 4x10-feet in size. The "mondo flat" is made of the same diffusion fabric used in large lightboxes designed for lighting automobiles. The "No Fear" logo was next positioned onto the front of the flat. (See Fig. 2) Correctly positioning the logo, so it would reflect in-focus into Ivan's eyes, required consideration of a few factors involving the physics of light.

I knew that specular highlight is simply a mirrored reflection of the source of illumination. Because the reflection was to be "mirrored," it was necessary

Fig. 1

to flip the logo so it read backwards on the light source, therefore reflecting it properly in his eyes. I also knew that the sharpness of the specular highlight would be affected by five separate factors. These factors include the surface efficiency of the object, the camera f-stop, the incident distance, the reflective distance and the motion of the the light source.

Surface efficiency means the texture of the surface. For example, a highly polished ball is a very efficient surface and will produce a focused return of light, while a matte surface will disperse the light striking it and will produce a less defined reflection of the specular. In this case, the area of the image I was concerned with (Ivan's eyes) would, like a highly polished ball, return a defined image. The camera f-stop was another factor to consider. Because lens aperture corresponds to depth-of-field, and the camera was focused on Ivan, the specular reflection would be out-of-focus at a large aperture. Knowing this, I increased the power of the strobe packs until a meter reading of f45 was achieved for maximum depth-of-field.

The incident distance (the distance of the light source to the object) and the reflective distance (the distance from the object to the camera) also played important roles. The distance from the light source to the object determines the level of definition that will be revealed in the specular highlight. The closer the light source is placed to the object, the more defined the specular will become. Here the light source was about three feet away from Ivan to achieve the sharpest specular highlight possible. The reflective distance also affected the specular highlight because depth-of-field decreases as the distance between the camera and the subject decreases. In other words, as the camera gets closer to a subject, the depth-of-field will diminish, and the specular

highlights on the object will become less defined. With the camera only four feet away from the subject, shooting at the maximum aperture of f45 was needed.

By adding motion to the light source, with a tungsten or multiple flash exposure, the definition of the specular can also be affected. This, however, did not play a role in this single exposure flash image.

To evenly light the 4x10-foot flat, and to achieve a meter reading of f45, four Broncolor power packs and four strobe heads were used. Each strobe had its own pack and each pack was set at full power. The heads were each fitted with a nine- inch reflector and positioned evenly behind the flat, one foot above the ground. (See Fig. 2)

A Sinar P2 was the camera of choice because I knew that I wanted the client to be able to use the image at a large size and still retain high quality. A 300mm lens, used at a distance of four feet, gave both the focus and perspective desired. Focused at such a close distance, there was considerable bellows compensation needed.

METERING THE LIGHT:
To determine the bellows compensation, the exposure and the filter compensation for the 81D warming filter added to the camera, a Broncolor reflective probe was used. The

Fig. 2

probe system is a reflective metering system which reads light off of the film plane. Because the light is read through the camera, the bellows and filter compensations are calculated in the reading. To determine the exposure, I set the aperture on f45 and took a reflective reading off of Ivan's forehead. This reading of + 1.5 told me that the area which I was reading was one and one-half stops above "0" or 18% grey. Since Caucasian skin is near 36% in value, one stop above 18%, I was theoretically overexposing his skin tone by one-half stop. I, however, like to overexpose my skin tone a bit, and therefore I used this reading for my exposure.

A Type 59 Polaroid was shot of an assistant, prior to Ivan's arrival, to check composition, exposure and focus. Once Ivan arrived, another Polaroid was quickly shot and then a series of 12 images was recorded.

In the end, the clients were very happy with the image and used it for the cover of their catalog and a large print for the company's conference room.

JOHN HEWESTON

A U S T R A L I A

Diffusion filter reduces importance of the background.

The camera is tilted, adding spontaneity to the image.

Bride pops out of booth and interacts with photographer.

Unique prop is used to add to the interest of the image.

PHOTO NAME: Untitled.

PHOTOGRAPHER: John Hewitson, Picture Man, New South Wales. Australia.

ASSIGNMENT: This photograph is an out take from a wedding assignment. We were selected by the client because our studio had just won seven awards at The Australian Institute of Professional Photography Awards.

FILM: Kodak Vericolor III Professional Type S (VPS). 160 ISO rate at 160.

CAMERA: Hasselblad 500CX.

LENS: 80mm.

THE SETUP: The shoot took place prior to the wedding at the location where the reception would be held. The location provided a variety of backgrounds offering several shooting possibilities. An old phone booth, however, offered the most interest and color. It was selected to add uniqueness to the image. Small twigs and a little dust were cleaned off the booth to avoid being distractions.

Provided with an overcast day for shooting, it would be necessary to use a reflector to create some contrast on the bride. A gold reflector was selected to bounce warm light onto the bride, adding fill light to the eye sockets and creating more contrast in the image. (See Fig.1)

Although we chose to hand-hold the camera, in most cases to keep up a fast-pace with all the wedding events, this image was recorded with the camera on a tripod for stability and precise composition. We were shooting with a Hasselblad 500cx with an 80mm lens. A diffusion filter had been left on the lens, accidentally, and it looked so good we used it for the photo. The filter helped to blur the background, forcing attention onto the bride.

EXPOSING THE FILM: A hand-held incident meter was used to quickly determine the exposure, and the bride was asked to stand inside the booth. When we were ready to capture the image, we asked the bride to "burst" out of the telephone booth and shout, "I'm engaged!" This interaction between bride and photographer gave the image the spontaneity for which our studio is known. It is difficult to get good shots when you go to strange locations and need to photograph people you do not know. Our staff of photographers thrives on using this technique to capture that little extra that our competition does not.

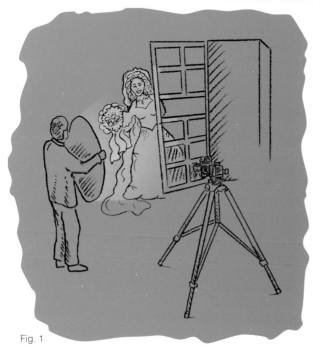

Fig. 1

Three shots were recorded to offer the client a variety of expressions. We try not to shoot too many frames per shot because processing costs can get too high. When putting together wedding albums, we often show images such as this in a sequence. In some cases, a sequence of images can tell more of a story than just a single photo. The result is that the client is pleased, you boost sales and everyone is happy!

AARON JONES

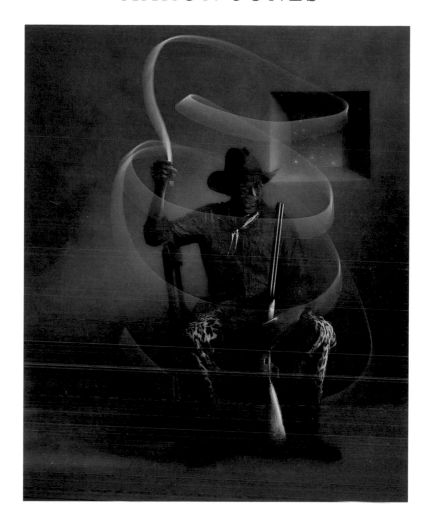

A M E R I C A

At 36, Aaron Jones sold his woodworking business in Oregon to pursue a career in photojournalism. Moving quickly into advertising photography, with no commercial experience, Jones began to shoot advertisements for Boeing 747. Relocated in Santa Fe, New Mexico, the self-taught Jones is noted for special lighting techniques and the painterly style he's applied to still life, sets, people photography and motion picture film.

AARON JONES

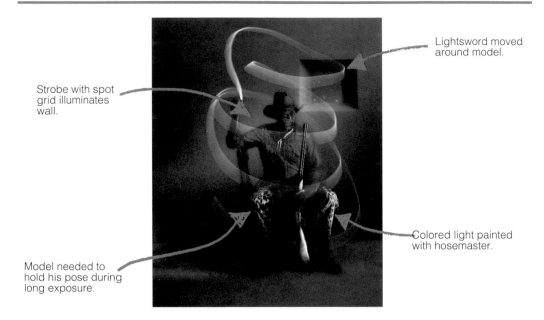

Lightsword moved around model.

Strobe with spot grid illuminates wall.

Model needed to hold his pose during long exposure.

Colored light painted with hosemaster.

PHOTO NAME: COWBOY

PHOTOGRAPHER: Aaron Jones. Aaron Jones Photography, Hosemaster - Aaron Jones, Inc., Santa Fe, New Mexico. U.S.A.

FILM: Kodak Ektachrome Professional, EPP 100, rated at 100 ISO.

EXPOSURE: f/32, Bulb.

CAMERA: 8x10 Toyo.

LENS: 360mm, Schneider.

THE SETUP: A background, painted to resemble a starry night, hung at the back of the set. This was lit by two strobe heads, each positioned at a 45°axis. (The same lighting configuration most commonly used when doing copy work.) Directly in front of the background stood a false wall with a window. A circle of light on the wall behind the model was created by another strobe head fixed with a spot grid attachment, positioned on the set's right. Two additional strobe heads were placed on lightstands, one on each side, at the front of the set. These heads, pointed directly up to the ceiling, added fill light to the entire set.

After the 8x10 view camera was set up, a chair placed exactly where the model would sit. The chair was important because the "cowboy" would have to remain still during the long exposure.

The final step prior to shooting was to prepare the Hosemaster. The Hosemaster is a fiberoptic lighting device which allows the photographer to paint light into specific area of the image. A daylight (5500 Kelvin) light source, contained in the main unit, is carried through a narrow fiberoptic cable. The flexible cable is hand held and it allows for precise illumination

of desired areas of the image. Various attachments, which can project both different patterns and qualities of light, can be fixed on to the cable's end. This offers several choices in creativity. In this case, an 8-inch Lightsword attachment, which resembles a small fluorescent tube with a 1 1/2-inch width, was attached to the Hosemaster. Red and amber gels were then cut and placed over the Lightsword.

The Hosemaster system contains an exterior shutter/filter system for the camera as well. The shutter has a window that can manually be opened and closed from controls at the end of the fiberoptic cable. This removes any chance of camera movement and simplifies the process of producing this type of image. The filter holder, attached to the back of the shutter, is also controlled from the fiberoptic cable. When the shutter switch is held down, the filter frame flips up, covering the shutter window with a chosen filter.

SHOOTING: The Hosemaster shutter was put into place with the window in the closed position. Final touches were added to the model's costume and he took his position. He was directed into a relaxed pose that could be held for several minutes and lights were turned off, leaving the studio in total darkness. The darkslide was next pulled out, and the camera shutter was opened. The Hosemaster shutter (HS) was opened, the strobes fired, and the shutter was closed. (An incident meter reading had been taken earlier for the strobes. This exposure reading was underexposed by two stops, allowing some detail to be revealed in the shadow areas of the final image.)

Next, the "light rope" was created by placing the 8-inch Lightsword into the model's open hand, opening the HS, pulling the Lightsword out and swirling it around him. It was essential to keep the light source pointed towards the camera at all times to register a complete path of light. Once the path was painted, the HS was closed.

The Lightsword was then taken off and replaced with a small snoot. Again the HS was opened. Blue and red gels were placed over the light at different times while the final exposures were made, painting colored light onto the cowboy. Both the camera shutter and Hosemaster Shutter were closed, completing the image.

The film was processed on site with a Jobo ATL-3 Autolab processing unit and Kodak E-6 one shot chemistry.

Hosemaster and Lightsword are registered trademarks of Aaron Jones, Inc.

Lightsword

GEOFF BROWN

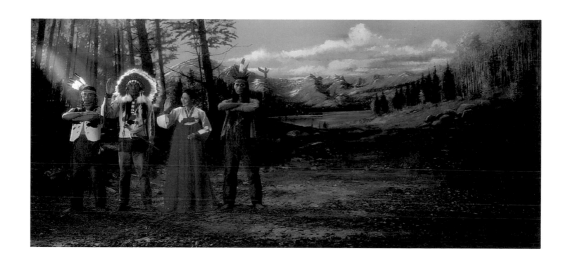

A U S T R A L I A

Using borrowed equipment to photograph his friends surfing began Geoff Brown's interest in photography. A 21st birthday gift of a Miranda Sensorex 11f sparked his obsession. After being a wedding shooter on weekends, Brown moved to London for two years to learn advertising photography. Since his return to Australia, he has worked on major accounts and won several awards.

Edge-light illuminates feathers,
separating subjects from background.

10x30 scrim
adds fill light
to the entire
set.

Light rays
emphasized
by spot
grid on
background.

Subjects' diffused value
(true tone) determined by
incident reading of 10x10
scrim.

Leaves & ferns
add realism.

PHOTO NAME: Untitled.

PHOTOGRAPHER: Geoff Brown. Moonline No 2 - Geoff Brown
Photography, Sydney. Australia.

ASSIGNMENT: This image was to be used as a magazine advertisment
that would increase the awareness of Korean Airlines Worldwide Network.
No guidelines in relation to type were given.

FILM: 5x7 Kodak Ektachrome Professional, EPP 100, rated at 100 ISO.

EXPOSURES: f/22 at 1/60.

CLIENT: Korean Air Lines - 1992 Destination Campaign.

ART DIRECTOR: Kevin Geeves.

CAMERA: Sinar P 5x7.

LENS: 150mm Rodenstock.

PRE-PRODUCTION: Pre-production was key in producing this image. Strict directions needed to be
followed in regards to the models and their specific costumes. Finding the models was a definite
challenge; the Korean stewardess, who we later found out didn't speak much English, needed to be flown
in from Korea the day before the shoot.

Several backgrounds were considered before the proper one for the shot was located. This
background was chosen because it most appropriately defined the environment and time
that the image was to capture.

SETUP: The first item to be constructed was a 10x30 diffusion scrim that was suspended from the roof and hung 11 feet above the floor. Three strobe heads, evenly spaced apart above the scrim, were positioned facing up away from the fabric. These heads were fired straight up into the studio's silver ceiling where the light bounced down onto the diffusion fabric and evenly illuminated the set.

The background, also 30 feet in length, was supported behind the set and then rolled out under the giant scrim. To add realism to the environment being created, dried leaves and a few plants were added.

A Sinar 5x7 view camera and 150mm lens was positioned so that as much of the set as possible would be included on the ground glass. The camera's height was about chest level, and all of the camera's positions remained at zero.

Next, a 10x10 foot diffusion scrim was placed near the corner of the right side of the set. A 3x3 foot softbox, located just behind the scrim, illuminated this large panel which lit the front of

Top View

the set. This large light source created a soft light quality which gave detail in the shadow areas of the models. A black flag was placed between the lightbox and camera to eliminate the possibility of lens flair. On the set's left side, another strobe head, positioned facing away from the set, reflected light off of two white boards and returned soft fill light into the image area.

Three additional flash heads were positioned on the right, rear side of the set. Grid spot attachments were added to two of these strobe heads to direct the path of light to a small area. One of these heads added a rim light to the foliage at the rear of the set and the other enhanced the light path which was painted on the background canvas. The third and final light, closest to the camera, rim lit the models from behind. This source conveyed the feeling of sunlight passing through the trees. Barn doors added to the reflector of this light directed the path of the light and shaded unwanted light from spilling onto the background.

The combination of both these soft and hard light sources helped to create a forest-like ambiance. The large overhead scrim, bounce light at the left, and 10x10 panel in the front added soft, ambient fill light to the set. In nature, this light would be created by light bouncing off of the atmosphere and down onto the earth. The lights on the right-hand side, gave the image the depth and definition that the sun would reveal.

SHOOTING: The exposure, f22 at 1/60, was determined by several tests generated on Polaroid film. Once the art director was content with the image, the aperture was closed 1/3 and the film was shot. (A test proved that with this Polaroid and E-6 film combination, that a reduction of 1/3 stop of light yielded the best final chrome.) To ensure that the skin tones of the models would reproduce properly, Kodak Ektachrome Plus film was used.

Several exposures were taken to offer the client and art director a choice of expressions and poses.

EDWARD GAJDEL

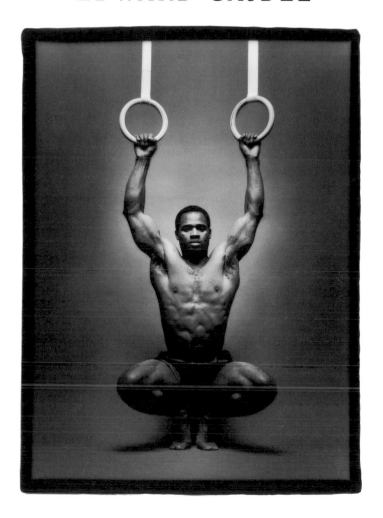

C A N A D A

Inspired by the great masters, European born Edward Gajdel's passions lay with his black and white work. One of Canada's leading photographers, Gajdel pursues his craft with a passion, sincerity and honesty that only further enhances his exquisite and poignant images. His sensitivity toward his subjects is outweighed only by his creative visual capacity which is based on simplicity.

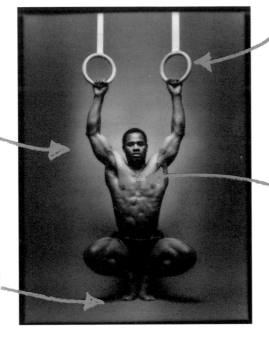

Rings add to the story and offer a simple design element.

Grey seamless background hides gymnasium.

Large umbrella from above defines shape of subject's body.

Shadows are simple and don't compete with subject.

PHOTO NAME: Curtis Hibbert

PHOTOGRAPHER: Edward Gajdel, Edward Gajdel Photography, Toronto, Ontario. Canada.

ASSIGNMENT: This image was produced for The Globe and Mail's *Destinations* Magazine. The objective was to produce a series of images of Canada's top Olympic contenders, where the images would run as a pull-out supplement in the publication. There would be a total of four athletes to photograph, and one of the images would be selected for the cover. The publication size was 8x10¾ inches. Major consideration was given to the layout of the cover type while the shoot was in progress.

FILM: 120mm Kodak, Tri-X TXP, 320 ISO rated at 200 ISO.

CLIENT: The Globe and Mail's *Destinations* Magazine.

ART DIRECTOR: Karen Simpson.

CAMERA: Medium Format.

LENS: 135mm, F5.6.

THE SETUP: The shoot took place on location in a gymnasium due to Curtis' hectic training schedule. The rings added a graphic component to the image, helping to support both the design and drama of the photograph.

A charcoal grey seamless sweep was selected as a background and hung at the rear of the set. The grey seamless provided minimal fill light and allowed light to gradually fall off across the set. It also was not distracting and made Curtis the total focus of the image.

The lighting consisted of only one strobe head and a large 6-foot, silver umbrella. The umbrella, which was suspended above the center of the set, created strong contrast light on the subject and yet a soft shadow on the background. This light best defined Curtis' sculpted body and the subtle details of his features. Simplicity in the setup was a prime consideration due to the location and time constraints. (Fig. 1)

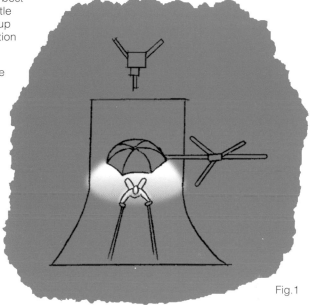

SHOOTING: To get the fullest tonal range exposed on film, taking into consideration both the flesh tone of the subject and the lighting, the Tri-X film which Kodak rates at 320 ISO, was rated at 200 ISO. This overexposure would later be compensated for by pulling the processing time slightly. Shooting black and white film allows incredible control, and every setup should be analyzed to achieve the optimum results.

An incident light meter was used to determine the exposure. There was no exposure compensation necessary for bellows or filter. The reading, f22 at 1/125, helped to ensure depth of field and sharpness. Because the set limited the movements he could perform, simple graphic shapes in his posing were selected to

Fig.1

emphasize the power and muscularity of his body. Curtis picked out his favorite music to play during the shoot to help him relax and to make the shoot fun for everyone.

The shoot took about of two hours, with 1 1/2 hours of setup and 40 minutes of shooting. Considering the limitations given to time and location, this image was a huge success and was the uncontested cover image.

INTO THE DARKROOM: The film was processed at 70° in D-76 developer for 8 minutes. A cold light enlarger was used to print the negative to pull the greatest range from the film. During portions of the enlarger exposure a Nikon soft filter #1 was placed of the lens, slightly diffusing the dark areas of the image. The background around Curtis was printed down to make him the thrust of the image, bringing the viewer's eye immediately to him.

The final print was made on normal grade glossy Forte paper and partially selenium toned.

JUDY LAWNE

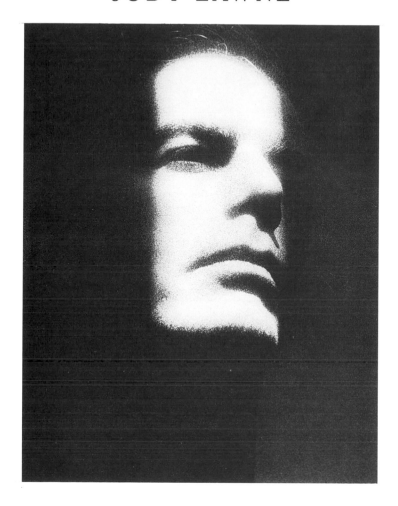

A M E R I C A

After being a model, T.V. Commercial actress and producer, Judy Lawne began to follow her true love - photography. After several years of assisting, Lawne started her own commercial work, focused on fashion, celebrities, movie specials and book jackets. Her Portraits of Dance, an ongoing work, has been presented in several galleries and as a coffee table book.

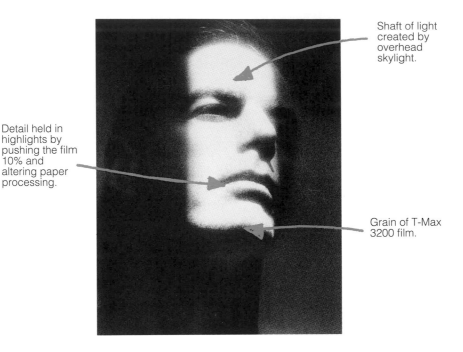

Shaft of light created by overhead skylight.

Detail held in highlights by pushing the film 10% and altering paper processing.

Grain of T-Max 3200 film.

PHOTO NAME: Portraits of Dance.

PHOTOGRAPHER: Judy Lawne, Los Angeles, California. U.S.A.

ASSIGNMENT: Next to photography, dance is one of my great passions although I know little about it technically. Meeting Terrence, the man I photographed, was my first break into learning more. Terrence was perfect for my project, "Portraits of Dance". He is not only a great dancer, but a teacher of ballet. For the shoot he performed an excerpt from Orpheus. "Portraits of Dance" was a self-study project, with the images to be used in my first exhibition.

FILM: 35mm Kodak T-Max 3200, rated at 3200 ISO.

DEVELOPER: T-Max Developer (normal processing plus 10%).

CAMERA: Nikon 8008.

LENS: Nikkor 35-135mm.

THE SETUP: The shoot took place in a studio with outdoor ambient light entering the room through a door, side window, and overhead skylight. The skylight, 4x4 feet in size, was changed to a 2x4 feet by inserting a 2x4 foot piece of foamcore into the light, covering half the source. (Had the skylight not been available, a 4x4 foot Plum reflector with a incandescent light would have been used. Strobe might have interfered with the emotion I was trying to capture.) The modified skylight helped to direct the light onto his face, leaving the rest of his body in shadow. (Fig.1) This shadowing of the body was emphasized by Terrence's black leotard as well.

I had come into the studio on several occasions to ensure the light for the 1:00 shoot would be appropriate. With an incident light meter I took two separate exposure readings. The first reading was for the general ambience in the room, being sure not to read the direct light passing through the skylight. Next, a reading of the skylight was taken. The readings showed that the direct light passing through the skylight was 3 stops brighter than the ambience. My camera, set at the ambient exposure, would then record for the shadows and overexpose his face to give the image this dramatic look. The film was pushed 10% in the processing to hold some detail in the highlight areas.

When it was time to shoot, Terrence was directed to dance through the studio and to concentrate on his emotional expression when he reached the skylight. I used a 35-135mm zoom lens to capture a variety of images. This image was taken with the lens zoomed in as Terrence entered the light.

INTO THE DARKROOM: The negative was printed on Kodak Elite paper, grade #3. To help the highlights develop, Dektol developer was mixed at a 2:1 ratio and the print was processed for nearly 3 minutes. Also during the development, the image was pulled from the tray and wiped dry with a wiper blade. A hairdryer, set to high power, was used to blow hot air onto the areas around Terrence's eyes and mouth. When the print was returned to the developer, these areas developed at a faster rate, allowing both the highlights and shadows to have desirable detail.

Fig. 1

DENIS REGGIE

A M E R I C A

Anationally renowned celebrity and society wedding photographer, Denis Reggie is the quintessential pioneer of modern wedding photojournalism. His unique and legendary style results in truly natural wedding photography. Denis artistically documents the essence of the event without the typical posing or prompting, and going beyond the common series of wedding portraits, his photographs are sensitive and spontaneous.

Tilted camera breaks traditional rules of wedding photography.

Expression and mood captures the essence of the wedding day.

Front of set filled with gold reflectors.

Realism of image maintained with small detail imperfections: wrinkled gown and exposed slip.

PHOTO NAME: Untitled.

PHOTOGRAPHER: Denis Reggie, Atlanta, Georgia. U.S.A.

ASSIGNMENT: This photograph was produced for Eastman Kodak to raise support for their Vericolor 400 negative film. The image was to speak to wedding photographers and show a practical application of the ISO 400 film. The image appeared full page in several photographic magazines.

FILM: Kodak Vericolor 400 ISO, rated at 320 ISO.

CLIENT: Eastman Kodak Company.

ART DIRECTOR: Jan Weeks, Rumril Hoyt Agency.

CAMERA: Hasselblad 503cx.

LENS: 180mm f4 cf.

THE SETUP: I record weddings as a journalist, capturing the reality and imperfection that most photographers try to disguise. With this shot, I was walking a fine line, wanting to create an image that broke the rules of traditional wedding photography, yet still appealed to traditional shooters. After all, the objective of the image was to sell film.

The art director and I had arrived at a look for the models and it was just a matter of finding the right ones. We were looking for attractive yet "real" people. I found the bride by chance in Atlanta; she was the daughter of a man I knew who was not only perfect for the job, but a model from a major New York agency. The man was one of almost a dozen models that an agency suggested.

The choice of location was left wide open, with the only limit being set on North America. The Long Vue Estate in New Orleans was chosen because it offered several options for background scenery, and was located close to a wedding I was shooting during the same week.

A balcony on the second level of the house offered a unique vantage point from which to shoot. Overlooking the driveway and courtyard fountain, the angle offered a feeling of distance, as if the people were unaware their photograph was being taken.

I used a Hasselblad camera with a 180mm lens, not worrying about lens compression because both models were fairly tall. A Cullman tripod supported the camera, although several images were taken with the camera being hand held. I wanted the angle of the camera to be off center, breaking the rules of traditional shooting.

The models were made up and their hair styled, but not to perfection. Again, a real life situation was kept in mind. The Vera Wang gown and veil, taken straight out of the box, made the dress appear the same as if it had been worn all day, and a small glimpse of the woman's slip added authenticity to the moment. Final touches on the set included watering down the driveway to darken the bricks, scatterings a few rose peddles on the ground, and adding a few bunches of loosely styled roses.

The 6:00 PM shoot supported the need for an ISO 400 film to freeze action in low light. The sun passing through a canopy of trees behind the models was filled into the set with two gold reflectors. One assistant held a 42 inch reflector on the balcony, while another shaped the light with a 72" reflector from the ground. The meter of the camera's PME prism was adjusted to ISO 200, taking into account that I normally rate the film at 320 ISO, and that the majority of the view finder was filled with white subject matter and the reflective metering system would want to make the general scene 18%.

As the quality of passing light reached its peak, nine rolls of 220 film were exposed at 1/125 of a second at anywhere between f4.5 and f6.3, depending on the sun's intensity. This scene and two others were shot during the 40 minute window when the light was just right.

TRISH PERRIN

A M E R I C A

Trish Perrin's images have been featured internationally for more than a decade. As an educator, Trish has shared her valuable fashion and glamour secrets and techniques with thousands of photographers and photographic students throughout the U.S., Canada, U.K., Australia, and the Asia Pacific. Trish and her husband John operate their studio "On Broadway" in Portland, Oregon and are active consultants for up and coming fashion & glamour studios across America.

TRISH PERIN

Pillars added to accent image design.

Collage is created with gauze and torn images.

Woman phtographed in studio.

PHOTO NAME: Crystal Palace.

PHOTOGRAPHER: Trish K. Perrin, On Broadway Photography, Portland, Oregon. U.S.A.

ASSIGNMENT: The subject is not a professional model, but an everyday person with special dreams and desires for an unusual and creative portrait. A large portion of my business involves offering my clientele this kind of portraiture which can become part of their own collective art.

FILM: Kodak Plus-X Pan Professional (PXP). ISO 125, under exposed 1/2 in camera and pushed 1 stop in development.

EXPOSURE: 1/60 second at f/16.

CAMERA: Mamiya RZ 6x7.

LENS: 180mm, with a Yary black net #3 diffuser behind the lens.

ABOUT THE SHOT: "Euro-style" is what I call this style of photographic art. It has evolved over the years from creating and perfecting a high key, high contrast black and white print which is then hand tinted and formed into a collage. I became interested in several styles of collage art through classes at a local art school. Over time, I began to experiment and incorporate it into my portrait business.

MODEL PREPARATION: The smooth surface and high contrast of her face is created through the application of make-up. First, I apply an opaque under eye concealer. This is applied under her eyes and across her nose to hide dark circles and lines and to create the illusion of a highlight. Next, the entire face is covered with a liquid foundation that matches the client's skin tone. Often a shade of foundation one-half tone lighter than the actual skin tone will be used to increase the image's contrast. Following, a loose translucent powder (which is mixed with baby powder) is used to cover the entire face. This works especially well in the area under the eyes.

Because the expression of the eyes is critical to the success of the image, the eyes are given a lot of consideration. A combination of black and brown pencils, shadows and mascara is used in preparation.

Other touches include contouring the cheek and jaw lines with a pinkish-brown color. Also, I always line the lips with a lip liner pencil to create a fuller, more defined mouth. I have found a dark color, such as wine or a brick red, works well for both the liner and the lipstick. Remember, this is not an everyday cosmetic look; I wanted her to look quite dramatic, but without any hard edges.

For a wardrobe, we selected a gauze which was wrapped around her body. This gauze can be purchased at any fabric store. I prefer the cheaper material because it shreds well. For additional drama, we added a long red wig. Her real hair was very short.

THE SETUP:
Positioned against the camera room wall was a standard 4x8-foot table which raised the subject to camera level. A 4x6-foot plexiglass mirror was then placed on top of the table where the client would recline. A

Fig. 1

long, gray muslin backdrop, with slight black and gray brush strokes, and several pieces of shredded gauze were used to create the set's background. To add interest and directional lines to the image, a series of white pillars was put into position. (See Fig. 1)

From previous experiences, I have a standard formula of lighting, film, development and printing, which yields a high contrast black and white image. Lighting consisted of a wall-mounted 52-inch Larson Starfish which was used as the main light source. The Starfish light was swung out to the center of the room, about six feet from the subject, where it was overhead and just above the camera's view. A 3x4-foot silver mylar reflector was placed just below the table to bounce fill light onto the subject, adding detail to the shadow created by the Starfish. (See Fig. 1)

INTO THE DARKROOM: To create a high contrast image, which works well with this type of tinting process, I send the film to a professional lab and request Kodak D-76 developer. This assures me of consistent results.

Once an image is selected, it is printed on 8x10-inch grade #3 or #4 Kodak Elite or Resin Coated paper. These types of paper seem to take hand-tinting extremely well.

HAND TINTING: Using an art board which is covered with textured white paper as a palette, I begin to mix the dyes into desired colors. The brushes vary in size from "0" to one and one-half inches. The smaller brushes are used to color in detailed areas such as the eyes and lips. I like to work with a drier brush and apply the dyes in several layers in order to safely achieve the colors and density of tone desired. Mistakes, however, can be corrected by applying clear ammonia on a cotton-swab, to lighten or remove the dye. (Note: Be careful not to rub too hard or you can scratch the emulsion.)

BUILDING THE COLLAGE: Starting with the hand-tinted print as a canvas for the collage, shredded gauze, pieces of broken tempered glass, wisps of shredded cotton balls and a torn-up photograph of a different subject's eyes were glued to various areas of the image. I don't necessarily have a system for this process, it simply works by placing things down where they look good and complement, overall, the design of the image. This collage process usually takes me about three or four hours to complete.

Next, the entire piece is taken to a service bureau and copied onto 4x5-inch film. From this film, I print the size my client desires on color photographic paper. Sometimes, dyes may be reapplied to small areas of the final print if needed. In the case where the print is not framed or placed under glass, I have the print laminated with a luster or high-gloss surface.

My photographic art has taken me on a tremendous journey of self-discovery. I always look forward with great anticipation to the next bend in the road. We do gather ideas and information from each other, plus the abundant resources in today's society. I urge everyone to seek and cultivate their own identity and uniqueness... It does exist.

KEN MARCUS

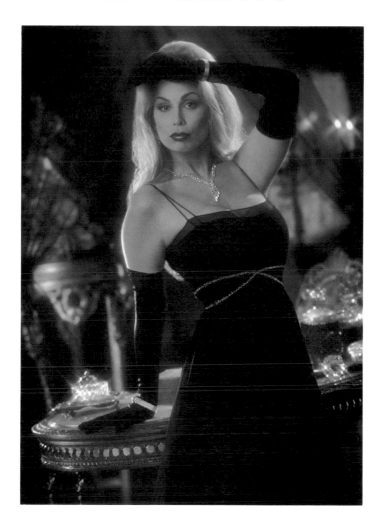

A M E R I C A

Ken Marcus is recognized throughout the world as an outstanding American glamour photographer. Raised in Hollywood, Ken was a student of Ansel Adams for 13 years in Yosemite National Park. He is called upon for seminars, lectures and workshops on the art and techniques of nude and glamour photography. Ken's erotic fine art photographs are exhibited in galleries throughout the U.S. and abroad.

Soft, even lighting on model from large main light.

Sheer black curtains help to add depth to the set.

Black wall at 45° angle reflects studio wall.

Warm edge-lights separate model from background.

Black netting and star filter used over lens.

Strobe under table highlights ornate woodwork.

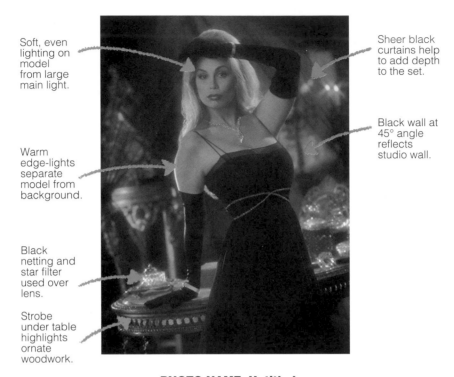

PHOTO NAME: Untitled.

PHOTOGRAPHER: Ken Marcus, Ken Marcus Studio, Hollywood, California. U.S.A.

ASSIGNMENT: This picture was taken for a worldwide endorsement advertising campaign for Canon cameras. Canon requested several photographs, including one which represented the opulent set and lighting style for which I'm mostly known. The two-page would feature multiple pictures on the left page (including one of me) and a single, full-page image on the right.

FILM: Kodak Ektachrome 100X Professional (EPZ). 100 ISO rated at 100. This film was selected for its rich rendition of warm tones.

EXPOSURE: $1/15$ second at f/5.6 .

CLIENT: Canon.

HAIR AND MAKE-UP: Michelle Van der Hule.

ASSISTANTS: Jeffrey Dean & George Sandoval.

CAMERA: Canon EOS 1.

LENS: Canon 80-200mm f/2.8 .

PREPRODUCTION: Prior to the actual shoot, various planning discussions took place, allowing the ideas to evolve in order to meet our final objectives. I was allowed to cast the talent and selected actress Page Olson. Being centrally located in Hollywood, it was fairly simple to acquire the assorted props and furniture needed for the shoot at a local motion picture prop house. We also made arrangements for a make-up artist.

SETUP: My intention was to create a contemporary, yet classic, formal Hollywood portrait, with the overall image having a soft, diffused feeling. Keeping this in mind, the set would be designed to give the viewer an illusion of depth. We would utilize a moveable wall that was covered with a very reflective gold vinyl material. Turned at a 45° angle to the camera, the wall reflected light from the far right side of the set where we placed items of various reflectivity. This created a series of out-of-focus shapes in the background. Draped across the set, in front of the wall, black net curtains were added for additional depth and detail.

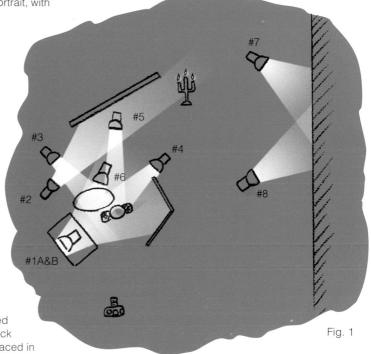

Fig. 1

A Canon EOS 1 with an 80-200mm f/2.8 lens was placed on a tripod for stability and placement. The lens was covered with a homemade diffuser of black netting, and a "star" filter was placed in front of the lens. (NOTE: A variety of "star" filters are available from camera stores; they create the star-bursts of light off of the highly specular areas of the image.) My homemade diffuser was made after several years of testing with different diffusion materials and filters. I find that this black net diffusion still gives the image a "sharp" quality, where many diffusion materials will make this image appear out-of-focus. Because the exposure was based on the camera's through-the-lens (TTL) metering system, no manual compensation was necessary for the filters.

A slight tilt to the camera helped to create a strong and more dynamic composition. The large antique clock, placed camera-left, helped to accentuate the vertical composition.

The lighting consisted of nine strobe heads. The main light (#1), a large homemade 4x8-foot lightbox, would be placed on the right of the set near the model. The lightbox, which contained two strobe heads (#1A&B) to create even illumination, had a white reflective interior and utilized an opaque Rosco diffusion material to disperse the light. Both strobes were aimed facing the rear of the box so the light would bounce off of the white interior walls and bounce through the diffused front. This produced a very soft and flattering quality of light. To add light to the shadow side of the model, two 4x8-foot sheets of white Foamcore board were placed in a V-shape on the right of the set. This wedge of Foamcore would not only reflect light from the main source (#1), but also bounce light from strobe #3, added later to the set.

Another strobe head (#2 with a small reflector and bastard amber colored gel) was added to the set to rim light the clock. The gel was applied to the light in order to add warmth to the color of the set. Next, strobes #3 and #4 were put into place, slightly behind the model and at 45° angles on either side of the set. Aimed at the model, these lights would create rim lighting on both sides of her body, defining her figure and adding dimension to the image. A hairlight (#5) continued this rim lighting effect over her shoulders and added highlights to her hair. (NOTE: Strobes #3-5 all had reflectors with amber gels.)

Under the forward table, a small strobe head (#6) would be set to create highlights on the decorative holes in the ornate woodwork. A grid spot attachment controlled the direction of the light, and another amber gel was used for warmth. The props of gold and cut-glass on this table were arranged for added visual interest and reflective highlights.

The final two strobe heads (#7 and #8) were located on the far right of the set. The sole purpose of these lights was to illuminate a wall and some props on the right side of the studio. This illumination was reflected into the camera by the moveable wall at the rear of the set. This created a series of out-of-focus shapes in the background of the image, giving an illusion of the room being much larger. A lit candelabra was also placed to the right of the reflective wall. Because it was located closer to the moveable wall than the other props, its shape was more defined in the reflection.

METERING THE LIGHT: The soft mood of this photograph required a combination of minimal depth-of-field and a relatively slow shutter speed to properly expose the flames of the candles. An aperture of f/5.6 was selected to ensure focus on the model which created an out-of-focus background. Using an incident light meter, the power of the strobe heads was adjusted to this aperture.

Once the basic exposure was set, a series of Type 669 Polaroids was shot to check the effects of the filters, the composition of the image, exposure and pose. A cropping mask placed over the exposed Polaroid was used for placing the exact composition. Approximately 30 Polaroids were taken throughout the set-up to fine-tune the lighting on the model, props and highlights. Several rolls of 35mm Kodak Ektachrome 100x were exposed to provide several choices for the model's pose and expression. The film was processed normally.

POST-PRODUCTION: After a few editing sessions, the hero image was selected. The image would be scanned and slightly enhanced to provide the client with the most desirable image possible.

The 35mm transparency was scanned on a Dainippon drum scanner and stored on a Syquest disk. The image was then loaded down from disk to Adobe Photoshop where the image was enhanced. Using several Photoshop techniques, luster was added to the model's eyes and lips, her waist was trimmed slightly, and a few specular highlights on the props were darkened. A proof print of the final image was made on a Kodak XL7700 thermal printer direct from the computer file.

SENG HAI

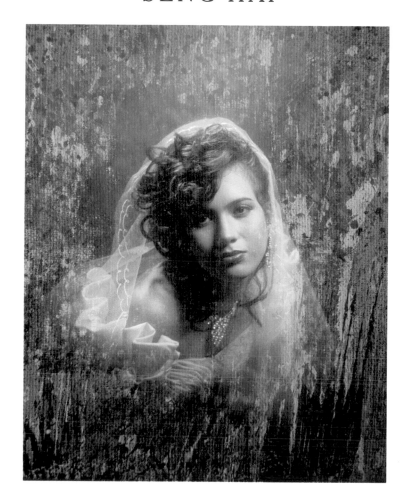

S I N G A P O R E

Seng Hai was just 13 when he began taking photos in his Malaysian hometown. Moving to Singapore in 1974 let him develop as a professional photographer, and between 1983 and 1987, Seng Hai made many trips to Taiwan, always picking up new technologies. By 1988, Seng Hai had initiated wedding photos in Singapore, enhancing the concept with advance photos.

Second exposure merges canvas painting.

Edge lights illuminate veil, separating bride from dark backdrop.

A combination of specular and diffused light sources illuminate the bride.

PHOTO NAME: "Bride With The Purple Background"

PHOTOGRAPHER: Seng Hai, Jalan Sultan. Singapore.

ASSIGNMENT: An.Indonesian company, Prima Color, approached me to produce a series of images to be published for a photography review of a bridal seminar.

FILM: Kodak Ektachrome 100 Plus Professional (EPP), 100 ISO rated at 100.

EXPOSURES: Shot #1: Bride f/8 - $^1/_{125}$ th sec.

Shot #2: Background f/11 - $^1/_{125}$ th sec.

CLIENT: Prima Color.

CAMERA: Medium format.

LENSES: Shot #1: 127mm

Shot #2: 90mm.

SHOOT TIME: $^1/_2$ Hour.

ABOUT THE SHOT: This image was the result of combining two images, one of a bride and one of a canvas painting, onto a single frame of film.

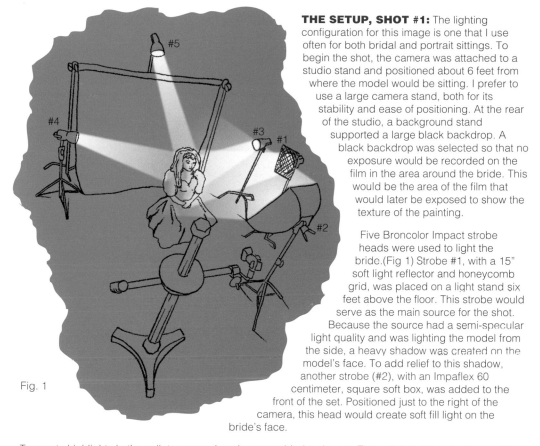

Fig. 1

THE SETUP, SHOT #1: The lighting configuration for this image is one that I use often for both bridal and portrait sittings. To begin the shot, the camera was attached to a studio stand and positioned about 6 feet from where the model would be sitting. I prefer to use a large camera stand, both for its stability and ease of positioning. At the rear of the studio, a background stand supported a large black backdrop. A black backdrop was selected so that no exposure would be recorded on the film in the area around the bride. This would be the area of the film that would later be exposed to show the texture of the painting.

Five Broncolor Impact strobe heads were used to light the bride.(Fig 1) Strobe #1, with a 15" soft light reflector and honeycomb grid, was placed on a light stand six feet above the floor. This strobe would serve as the main source for the shot. Because the source had a semi-specular light quality and was lighting the model from the side, a heavy shadow was created on the model's face. To add relief to this shadow, another strobe (#2), with an Impaflex 60 centimeter, square soft box, was added to the front of the set. Positioned just to the right of the camera, this head would create soft fill light on the bride's face.

To create highlights in the veil, two more heads were added to the set. These lights, #3 and #4, were fitted with standard reflectors and honeycomb grids. Set in symmetrical positions on both sides of the set and slightly behind the subject, these specular light sources gave dimension to the white veil, helping to separate the bride from the dark background. To add to the color scheme of the image, a purple gel was placed over strobe #3. Finally, a fifth strobe (#5) was placed over the top of the background, directly in the center of the set. It was necessary that this source was high enough on a stand and aiming down to avoid it shining directly into the camera lens. The combination of strobes #3-#5 completely separated the bride from the dark background.

THE SETUP, SHOT #2: A small 10x12-inch canvas was stretched flat and stapled to a small wooden frame. The oval shape at the center of the canvas was painted black. This area would mask out the center of the image, allowing the exposure of the bride from shot #1 to be unaffected during the second shot. The area outside of the oval, painted with light purple and white spots, would record over the unexposed black back-ground of shot #1, merging the canvas texture into the image.

With the canvas on a table top and the camera directly overhead, a 60-centimeter softbox was placed at a 45° angle to the canvas. (This is the same softbox used in shot #1.) By side-lighting the canvas, the texture of the paint and canvas ware emphasized. (Fig. 2)

METERING THE LIGHT: For the first shot, an incident meter reading was taken of strobe #1 with the dome of the meter aimed toward the light. This reading, f/8 at $^1/_{125}$, set the true tonality of the bride's skin and was set on the camera. Next, the fill light of strobe #2 was metered. This reading, f/4 at $^1/_{125}$, was two stops down from the camera setting. Additional readings of strobes #3 and #4 read identical to the camera setting, f/8 at $^1/_{125}$. The final meter reading of strobe #5 read one stop over the camera setting, f/11 at $^1/_{125}$. Experience dictated that these ratios would render an exposure appropriate for the image.

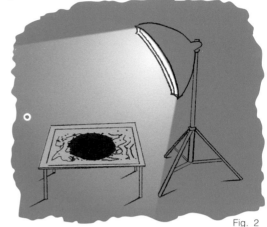

Fig. 2

On the second set, a single incident meter reading was taken from the canvas of the softbox. The canvas was exposed normally at this reading of f/11 at $^1/_{125}$.

EXPOSING THE FILM: With the bride in place on set #1, the first image was recorded with the camera's shutter speed set at $^1/_{125}$ and the 127mm lens stopped down to f/8. A piece of tracing paper was then taped over the matted screen of the viewfinder and the position of the model recorded.

Next, the studio stand was rolled over to the second set and the 127mm lens was replaced with a 90mm. Based on the tracing paper markings, the position of the bride was aligned with the black oval on the canvas. The shutter speed was not changed, but the lens was stopped down to f/11. This exposure was then recorded, merging the two images together.

PHILLIP STEWART CHARIS

A M E R I C A

Phillip Steward Charis, M.Photog.,Cr. F-ASP, is a creative adventurer who has explored one of the most difficult disciplines in the world - formal photographic portraiture that challenges fine-art painting. His life-size portraits bespeak of a long study of classical paintings. The observant eye can discern a touch of Reynolds and a flavor of Sargent in Charis' images.

Background is apparent, yet subtle.

Rembrandt lighting pattern reveals placement of the main light.

Close attention is paid to styling of clothes.

Posing and expression support the mood of the image.

PHOTO NAME: Red Skelton

PHOTOGRAPHER: Phillip Stewart Charis, Charis Inc., San Juan Capistrano, California. U.S.A.

ASSIGNMENT: Red Skelton, a well-known American painter and comedian, came for a portrait sitting of his wife and himself. Throughout the sitting he was constantly entertaining, emphasizing his bubbly personality. After the sitting was completed, I asked if he would pose for a few portraits alone. I wanted to capture the more sad and soulful side of Red Skelton, the feeling conveyed in many of his clown portraits.

FILM: 5x7 Kodak, Vericolor II.

CLIENT: Red Skelton.

CAMERA: 8x10 Ansco view camera with a 5x7 reducing back.

LENS: 12-inch Ektar.

SETUP: My portraits are always taken in the studio; this preserves privacy and allows me to concentrate on the particular feeling I want to capture.

The lighting setup was simple. The main source was a 45-inch Super Silver Umbrella with a Norman strobe set at 200 watt seconds. This light was placed three feet away and to the right of the subject at a 45°angle. The face of the umbrella was aimed slightly more to the camera than it was to the subject.

At the rear of the studio, three silver umbrellas with strobes powered at 200 watt seconds acted as fill lights. These umbrellas, positioned 9-feet above the floor and aimed down at the floor in front of the subject, added even fill to the subject's face and relieved the shadow cast by the main light.

METERING THE LIGHT: A combined meter reading of the main and fill lights read f11. The reading of the main was f8.5 and the reading of the fill, f5.0. This gave a 1:3 ratio which I prefer. The lighting in my studio rarely changes, so I always shoot at f11.

TAKING THE PICTURE: Finding the exact moment to click the shutter is the goal in any portrait. The difference lies in whether you wait for that moment, accelerate the subject to it, or even create it. The trick is to be able to recognize what that moment is, and record it on film. "That's always the question, but the answer is in your eyes and your mind. The problem in any portrait sitting is to relax the subject, to make the protective mask drop so that you can peer in and capture the true essence of the person."

An Ansco 8x10 view camera with a 5x7 reducing back was used to record the image. The 5x7 format has proven to be a good format because not only can we effectively enlarge an image up to 40x60 inches, but 5x7 contact prints are ideal for proofing the images for the client to make their selections. Twelve sheets of film were exposed during this sitting.

FINISHING THE PRINT: When the client returns to the studio to view the proofs, they are offered several choices of how they wish for their portrait to be finished. There are a variety of print finishes and frames available. Once the client has made their selection, the negative is retouched and sent to the lab where the print is made.

When the print is back in the studio the enhancement begins. At times a tie must be straightened, a sleeve narrowed, a jaw line straightened, and the eyes detailed to give new strength and power. The final steps are the signature, a final gloss coat which protects the image and gives it dimension, and then the frame selection. The finished product is truly a work of art.

KIYOMI HAYASHI

J A P A N

KIYOMI HAYASHI

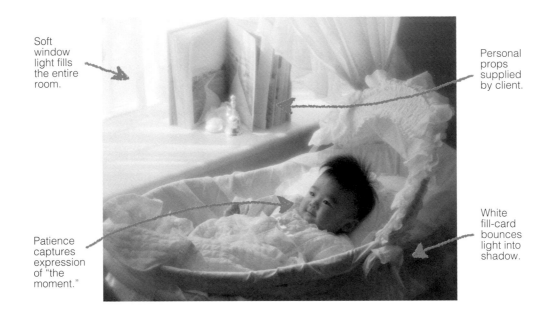

Soft window light fills the entire room.

Personal props supplied by client.

Patience captures expression of "the moment."

White fill-card bounces light into shadow.

PHOTO NAME: Untitled.

PHOTOGRAPHER: Kiyomi Hayashi, Photo Story Hayashi, Tokushima, Tokyo. Japan.

FILM: Kodak PCN Gold. 160 ISO rated at 160.

CAMERA: Medium Format.

LENS: 180mm.

PREPRODUCTION: When a family makes an appointment for a portrait, they are asked to bring in something which can be included in the picture, preferably something they treasure (like a diploma, a toy, etc.). This ties the image to a particular time in the child's life and, by doing so, families are more likely to utilize our services year after year. I like to think about each sitting, going over what I know about the family to make each sitting personalized. For this shot we agreed that the child would look nice cuddled up in a portable basket.

I prefer to use natural light for child portraits. This brings out the soft skin and natural skin tones appropriate for this type of shot. I also find that studio lighting has a tendency to scare children, making it more difficult to create a moment worth recording.

THE SETUP: Prior to a shoot, we anticipate what equipment will be needed and move it close to the set. This allows us to work as quickly as possible when the family arrives. Speed is critical when working with children as they easily lose interest and quickly change moods.

Because of the young age of the subject, there was no real need to hand-hold the camera, as might be the case with a toddler. By having the camera on a tripod, a slower shutter speed could be used as well. A soft focus filter was placed over the 180mm lens to enhance the gentle mood of the image.

The set was lit by soft, ambient light, spilling through three windows and a door. (See Fig. 1) One white bounce card, placed to the right of the camera and close to the subject, added fill light to the front of the baby. This particular bounce card is cut down the middle and taped so that it can hinge, allowing more light control. For this shot, it was closed to about a ninety degree position.

METERING THE LIGHT: I always use an incident meter to determine my exposure settings. The ISO setting of the meter is adjusted to match the speed at which I am rating the film on the camera, in this instance ISO 160. First, a reading was taken with the dome pointing at window A. (Fig. 1) This reading was $1/125$ at f/8. Next, a reading was taken from the baby with the dome pointing at the fill card. The fill card was moved in until the second readings read one stop below that of the window, $1/125$ at f/5.6. In order to ensure an appropriate depth-of-field, this exposure was readjusted to $1/30$ at f/11.

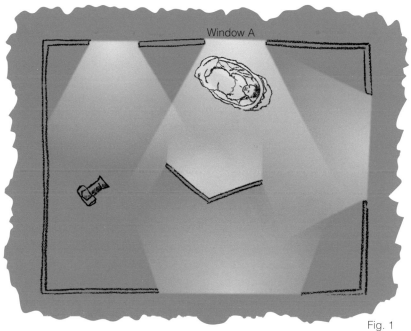

Window A

Fig. 1

At least eight shots were taken to ensure that we would end up with a choice of expressions.

POSTPRODUCTION: After the shoot, the film was sent to a local lab specializing in portrait film processing. After the film was processed, proofs were generated for final print selections. By keeping a record of the processing information, which is recorded on each proof, an accurate rendering can be made on the final print. If needed, skin blemishes, dust or wrinkles are retouched by hand from the image, assuring us that the final portrait is of the highest quality possible. It is my hope that each and every picture I take will become a valued piece of that family's treasure.

LEVINDO CARNEIRO

B R A Z I L

Levindo Carneiro was born in Belem, in the middle of the jungle, where he still finds inspiration for his work. Now he lives in Rio de Janeiro, where he studied Art. Levindo has achieved considerable success in the advertisement field. With his first computer, Levindo began to describe himself not only as a photographer, but also an "image maker."

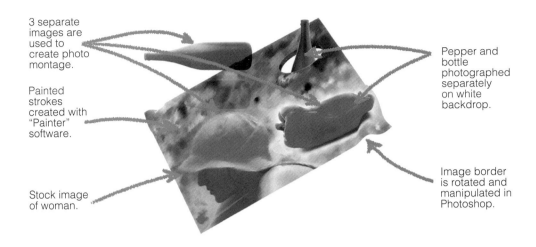

3 separate images are used to create photo montage.

Painted strokes created with "Painter" software.

Stock image of woman.

Pepper and bottle photographed separately on white backdrop.

Image border is rotated and manipulated in Photoshop.

PHOTO NAME: Untitled.

PHOTOGRAPHER: Levindo Carneiro, Rio de Janeiro. Brazil.

FILM: Kodak Ektachrome 100 Plus Professional (EPP). ISO 100 rated at 100.

CLIENT: INTEK.

CAMERA: 35mm, Nikon FM2.

LENS: Nikon, 60mm.

HARDWARE: Apple Macintosh IIfx.

SCANNER: Nikon Cool Scan.

SOFTWARE: Adobe Photoshop 2.5.1. Fractal Design, Painter.

ASSISTANT: Lucia Helena SD.

ABOUT THE SHOT: These images were created in a computer program using existing stock images from both location and studio shoots. The final images, which were written from a digital file back to film, were used in an advertisement for a color separation service bureau, INTEK.

SETUP, THE WOMAN: The photograph of the woman was created on location at an island near the Equator. It was lit with only the beautiful natural lighting of this location. I specifically composed the photograph so that the model's face would be in the shadow of the hat. A large aperture was selected to minimize the distractions in the background.

SETUP, THE BOTTLES AND PEPPERS: The original images of the bottle and the pepper were created in the studio. Each item was photographed separately on a simple table top which was covered with white, seamless background paper. This shooting surface would simplify "dropping-out" the objects when they were transferred into the computer system. (When shooting images with the intention of "dropping out" the background, it is always best to choose a simple, neutral colored background which provides good contrast against the subject being photographed.)

The lighting consisted of a single daylight balanced strobe head which was attached to a studio boom arm and positioned directly above the table facing down. Because the surface of the bottle was highly reflective, the surrounding environment of the studio could be seen reflected in its glass surface. To solve this problem, two large white reflectors were added to the set, one on either side. (See Fig.1) Now, as the light overhead spilled onto the boards, long white highlights were created down the sides of the bottle. This lighting setup remained the same for the shot of the pepper as well.

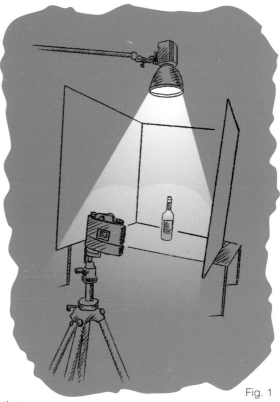

Fig. 1

METERING THE LIGHT: A hand-held flash meter was used to determine the image's exposure at an ISO of 100, Kodak's recommended speed for EPP film. After a series of images of the bottle were recorded, the pepper was placed on the set and the bottle removed. The existing lighting and exposure were also desired for the pepper, so no changes were made to the lighting or camera settings.

INTO THE COMPUTER: Three images, the woman, the bottle and the pepper, were scanned in order to transform the analog information to digital information. Using a Macintosh IIfx computer and Painter software, the images were opened and brought up onto the computer's screen.

The first step would involve the image of the woman. Using both Photoshop and Painter programs, the image was turned at an angle and made to look like a painter's palette by making "strokes" of color on the image's background with a Wacom tablet. In addition, the corners of the palette were manipulated to give the artistic effect of a rolling wave, and a circle was created to provide the palette's thumb hole.

Next, the images of the bottle and pepper were independently removed from their white background and placed into the image as desired. To create the effect of the bottle top

coming though the palette's hole, a series of masks was created in Photoshop to remove the bottom portion of the bottle.

The final enhanced image was saved to the computer's hard drive, and the image was later written back to film.

LOOKING BACK: With the assistance of a digital editing system, your photographs can become powerful components that can be used again and again in many different ways. I used the same photographs of the bottle and the pepper to create another promotional photograph. The two images were highly embraced by the client, and the advertisement to promote their color separation services was highly successful.

YURI BENITEZ

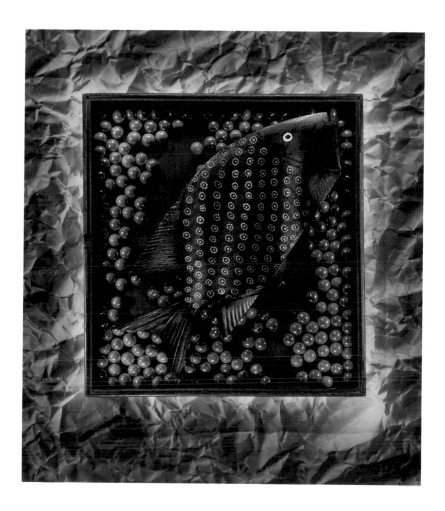

M E X I C O

Born and raised in Mexico City, Yuri Benitez was introduced to photography as a credit in his traditional school. Liking it very much, and despite encouragement to develop a "broader knowledge career" in college, Benitez opened a studio at age 21 with partner Fernando Cagigas. Today their Alumbra Estudio is well accepted among the industrial and advertising community in Mexico City.

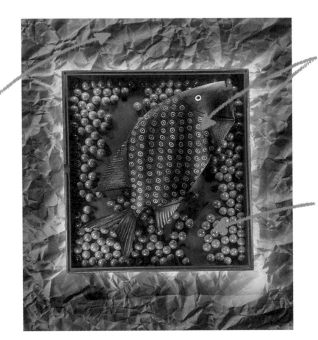

Low light source casts shadows showing the surface textrure of the paper.

Bright areas created with flashlight.

Tungsten light used to illuminate the entire set.

PHOTO NAME: The Fish With Marbles.

PHOTOGRAPHER: Yuri Benitez, Alumbra Estudio, Mexico City. Mexico.

ASSIGNMENT: This was one of 12 images created for Kodak Mexico which was familiar with my imagery and photographic style. I was given total creative freedom for the project, keeping in mind that a vertical format was preferred because the images would later be used in advertisements and marketing pieces to support Kodak products.

FILM: Kodak Professional 64T Tungsten (EPY). 64 ISO rated at 64.

CLIENT: Eastman Kodak, Mexico.

CAMERA: Sinar 4X5.

LENS: 210mm.

ABOUT THE SHOT: The image title, "Fish With Marbles," was partly derived from the Spanish name for marbles of this type called "aguitas," meaning "little waters." This was part of the symbolism between the fish and water.

THE SETUP: The most difficult part of the image was not technical but conceptual. Knowing that the people at Kodak were confident about the ideas I would display in the images, I was compelled to maintain a style according to their expectations. For me, the images needed to portray a sense of surrealism around the theme of traditional Mexican craftsmanship.

The set consisted of four key elements: the fish, the marbles, the box and a piece of crumpled seamless paper. I began by gathering props at a flea market known for selling crafts. It was there that I found the wooden fish which became the image's foundation. Keeping in line with this theme, I obtained the aguitas or "little waters" (marbles) at a shop near my studio. The box, which I already had in the studio, offered a practical shooting surface (it contained the fish and marbles) and added rustic contrast to the color and texture of the image.

Having been very attracted to the technique of "painting with light," and greatly inspired by the works of Aaron Jones, I experimented with using small flash lights to illuminate portions of my images. These flash lights were slightly modified with black cardboard snoots to direct the light in different shapes. Although this technique works in some ways, it is fairly limiting and I hope to one day invest in Aaron Jones' Hosemaster system.

Fig. 1

Knowing that the lights from the flashlights were tungsten balanced at 3200 degrees Kelvin (k), I elected to work with tungsten film, Kodak's 64T, which has a recommended ISO of 64. Testing this film, however, showed results at ISO 100, which I preferred. In addition to the flashlight illumination, the set was lit with a single tungsten light with a fresnel lens. This light was positioned behind and to the right of the set (Fig.1) To avoid a color shift from the flash tube, which has a color temperature of 5500 degrees, only the tungsten modeling light of the strobe head was used.

METERING THE LIGHT: The exposure would be taken in two parts. First, the tungsten modeling light of the strobe was exposed for 4 seconds at f32. This exposure was determined by taking an incident meter reading of the light.

EXPOSING THE FILM: Prior to exposing the final film, the image's exposure, focus and lighting were tested using Polaroid 64T. The exposure took place in two steps: first the tungsten light was turned on to create the image's base exposure, then the flashlights were used to "paint" specific areas of the image. Care had to be taken to maintain repeatable distances and timing during the light painting portion of the image so that each sheet of film would be similar. It took several test exposures on Polaroid to fine tune the image before the final film was recorded.

YURI BENITEZ

When it was time to expose the final film, the Kodak Ektachrome film was loaded and placed into the camera. With the camera's shutter placed on the "T" setting and the studio's lights turned off, the camera lens was opened and the tungsten modeling light from the strobe turned on for 4 seconds. (NOTE: The camera aperture was f/32.) During this time the tungsten modeling light created the only exposure. Once this part of the exposure was complete, the modeling light was turned off, leaving the studio in darkness.

Next, the flashlight with the wide opening was turned on and each side of the box was "painted" for about 10 seconds. Care was taken to only illuminate the sides of the box. The flashlights were then switched, so the narrow snoot could be used, and the fish's fins, mouth and eye were "painted" for 10 seconds each. Finally, three straight lines of light were created on the body of the fish by shining a narrow beam of light down the side of the fish for 20 seconds in each position. The shutter was then closed, completing the exposure.

I hope this information will be useful to others. I want to emphasize the importance of experimentation. Although this write-up is very methodical, the actual experience was strewn with trial-and-error.

URS BUHLMAN

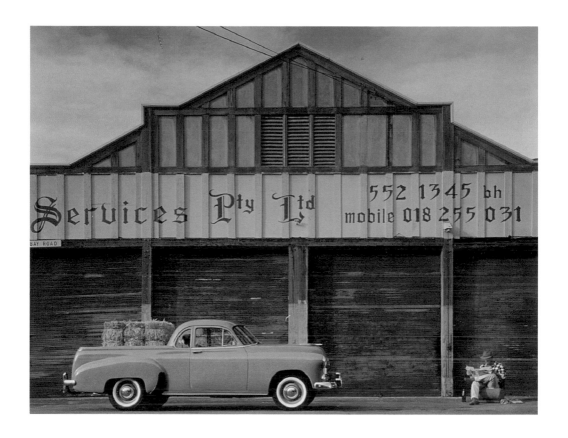

A U S T R A L I A

Born in Switzerland in 1962, Urs Buhlman moved to Australia when he was 10. Influenced by his father, a graphic designer, Buhlman started his photography career in 1983. After working with top advertising companies he freelanced, specializing in Annual Reports. A change of focus toward advertising photography led Buhlman to open his own studio in Mosman, New South Wales, in 1991.

URS BUHLMAN

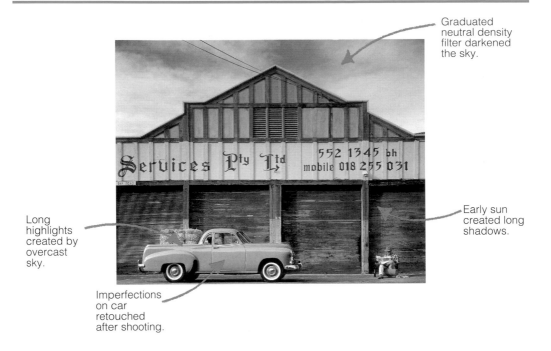

Graduated neutral density filter darkened the sky.

Early sun created long shadows.

Long highlights created by overcast sky.

Imperfections on car retouched after shooting.

PHOTO NAME: "1951 Chev"

PHOTOGRAPHER: Urs Buhlman.Urs Buhlman Photography, Sydney, New South Wales. Australia.

ASSIGNMENT: A printer wanted to produce an antiquated image to use in a self promotional brochure. The photograph needed to convey the feeling of solitude and overall have a warm color balance. The location and type of automobile were left open to myself and the art director. Because the brochure would use a 350 dot line screen, the 4x5 format was selected.

FILM: 4x5 Kodak Ektachrome Professional, EPP 100, rated at 100 ISO.

EXPOSURE: 1/15 at f16 1/2.

CLIENT: RT Kelly.

ART DIRECTOR: Michael Webb.

CAMERA: Sinar P2, 4x5.

LENS: 150mm f5.6 Schneider Symmar.

PRE-PRODUCTION: Location, an automobile, and the talent needed to be arranged for the shoot. The location, a building in an older section of Sydney, immediately came to mind when the job came in, because of its rustic and warm feeling. A local Chevy club offered a variety of cars, but the 1951 suited the image the best. The owner of the car ended up as the talent.

The location was scouted at various times of the day to evaluate the lighting. Unlike most car shots, the light at both sunrise and sunset didn't complement the location or car. A large building to the rear of the set blocked off the horizon and the majority of the "magic" light that would normally create long soft highlights on a car. However, the direct sun, slightly diffused by cloud cover worked perfect. This light created exceptional detail and texture in the building and still wasn't too hard for the car.

THE SETUP: The shooting time was set for around 10 o'clock. There wouldn't be much time to shoot because the sun at this time of day was moving fast, and it would only pass between the buildings for about a half an hour.

The car and talent showed up several hours before the shoot. When the Chevy arrived it was detailed, and the bales of straw were loaded into the back. The chair and other small props were added for character.

A Sinar P2 4x5 view camera with a 150mm were set up on a tripod facing directly into the building. A 150mm was the lens of choice because it offered a wide perspective without any image distortion. Three filters were placed in front of the lens during the exposure. An 81B added a warm color balance to the entire image, and two graduated neutral density filters - a 2 stop normal and a 1 stop tobacco - knocked down the exposure in the sky . The tobacco filter added a warm tone to the sky that complemented the color of the building.

Ektachrome 100 plus was selected because of its good shadow detail and color saturation.

METERING THE LIGHT: The exposure was determined by using an incident meter and then calculating the compensation for the filters. The minimum depth of field was used to get the fastest shutter speed possible. The final film was shot at 1/15 at f16 1/2.

RETOUCHING: A small dent in the side of the car and a window sticker were removed when the films went to the printer for separations.

YURI A. BENITEZ

M E X I C O

Born and raised in Mexico City, Yuri Benitez was introduced to photography as a credit in his traditional school. Liking it very much, and despite encouragement to develop a "broader knowledge career" in college, Benitez opened a studio at age 21 with partner Fernando Cagigas. Today their Alumbra Estudio is well accepted among the industrial and advertising community in Mexico City.

Edge light created by strobe above set.

Toast suspended by monofilament fishing line.

Painted cloud background lit by bare bulb strobe.

Large soft box illuminates face of toaster.

Cards add fill light and keep studio from reflecting in toaster.

PHOTO NAME: The Toaster.

PHOTOGRAPHER: Yuri Benitez, Alumbra Studio, Colonia Napoles, Mexico City. Mexico.

ASSIGNMENT: Photographed for a portfolio piece, but mainly for fun and personal satisfaction, this shot took about a day of preparation and three hours to shoot.

FILM: 4x5 Kodak Ektachrome 6105, 100 ISO rated at 100 ISO.

CAMERA: Sinar C.

LENS: Schneider 150mm, f/5.6.

THE SETUP: With the toaster put into position, the first step was to determine the best camera angle and lens size. A 150mm lens was selected because it was slightly wide and would help to emphasize the feeling of the toast flying overhead. The camera angle was just at table height, allowing the toast to be viewed from below. At this point, the camera was locked into position and the toaster was temporarily removed. This now allowed the appropriate amount of sand to be placed into the image area without wasting any time. The styling of the sand, and exact positioning of the toaster were fine tuned by viewing the set through the camera and making any needed changes. A canvas painting of a cloudy sky was then hung at the rear of the set, being sure the distance from the set to the canvas would be appropriate.

Monofilament fishing line, strung across the top of the set in rows, provided a simple frame work on which the toast was supported. These lines were retouched out later on the film by an artist. This technique of retouching was not as clean as it could have been; next time it will be done digitally on a computer system. (Fig. 1)

The light source, which would illuminate the toaster, needed to be large and have a diffused quality. The type of light, in this case a large softbox to the right of the camera, created a continuous specular reflection on the front face of the toaster. This reflection only reflected the white fabric of the softbox, not revealing a reflection of an obvious light device. Two medium sized white reflector boards located on the left side of the set added fill light to the side of the toaster and provided a clean surface to appear as a reflection.

The second light to be put into position was a bare bulb strobe which lit the background. This light was located just off the floor on a small light stand, and a few feet from the background. Light from the bare bulb fell off in a circular pattern; the brightest portion of the burst was positioned just behind the toaster and slightly below the table. Some light also spilled upwards illuminating the bottom sides of the toast.

Fig. 1

Above the set, pointing down, a final strobe head was put into place. This light, fixed with a normal Norman reflector, gave the image some specular form, adding a specular highlight on the top front of the toaster. This light also created an edge light on the tops of the toast, separating them from the background.

Once the set was completed, incident meter readings were taken of the shadow areas, and the exposure was adjusted to take into account 1/2 stop light loss for bellows compensation. The final image was exposed at f32 1/3 at 1/60 of a second.

PER-ERIK BERGLUND

S W E D E N

Born in 1953, Per-Erik Berglund attended Photography and Art School prior to becoming a commercial photographer's assistant. In 1981, he opened his own studio, Znapshot. Berglund's work, represented in Sweden and Germany, is in various fields of commercial photography, including still life, fashion and slide show production. He also exhibits artistic images.

Grid on main light focuses light to the center of the set.

Spacers placed between flat objects help to give depth to the image.

Each object is carefully styled.

White fill cards add light to shadows, revealing detail.

PHOTO NAME: Jag Kysste Din Huvudgärd (I Kissed Your Pillow.)

PHOTOGRAPHER: Per-Erik Berglund, Znapshot AB, Stockholm. Sweden.

ASSIGNMENT: This image was created as part of an exhibition which was shown in a Stockholm gallery. The owner of the gallery, who was also a paper manufacturer, was interested in Polaroid image transferring. The shot will also appear as a self promotion in European Creative Portfolio.

FILM: 8x10 Kodak Ektachrome 64, ISO 64 rated at ISO 64.

CLIENT: Svenskt Papper.

CAMERA: Sinar P2, 8x10.

LENS: Rodenstock Sironar-N, 360mm.

SETUP: In order to capture all of the intricate details of the image, we settled on 8x10 as the format for the shot. The camera was positioned with the lens pointing straight down. So that the camera wasn't too high, making the image difficult to view, the set was constructed on the floor of the studio.

Lighting consisted of two strobes positioned at the top, left of the set. One strobe, the main source of illumination, was fixed with a white soft reflector and honeycomb grid. This produced a semi-soft light quality, providing shadow form to reveal textures and consistent illumination across the set. The second strobe, with the standard silver reflector and grid, was positioned so the path of light traveled over the top of the set and hit two white reflector boards on the other side. By filling in the shadow side of the set, more detail could be recorded in the shadow areas. (Fig. 1)

An 81 EF filter was added to the camera lens to warm up the color balance of the entire image. A Sinar Booster and Minolta Flash Meter III were used to

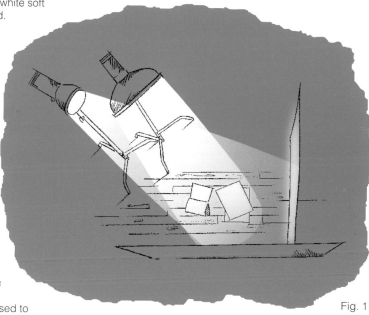

Fig. 1

take a meter reading directly from the film plane. This system utilizes a small probe which slides into the rear standard of the camera, allowing reflective readings to be taken of the image. Bellows extension and filter are automatically accounted for, as the reading is taken directly through the camera. In this case, a grey card was placed into the image for the reading, 1/125 at f32. This small aperture guaranteed that the image would be totally sharp.

The key to making this image work, especially when shooting on 8x10, was the styling of the props. Because the objects placed into the set were all relatively flat, spacers were placed between many of them to give the image dimension. Close attention was paid to the positioning of each element before any film was exposed. Once the set was completed, a Polaroid was shot to check the exposure and image design.

AARON JONES

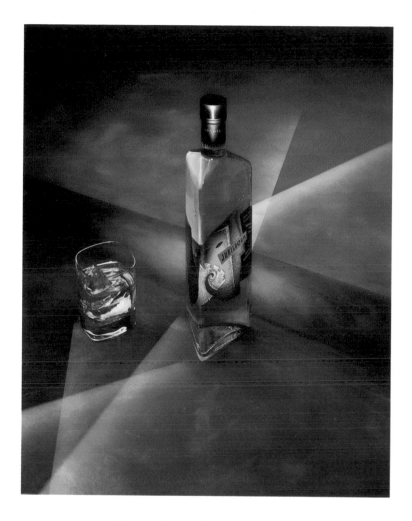

A M E R I C A

At 36, Aaron Jones sold his woodworking business in Oregon to pursue a career in photojournalism. Moving quickly into advertising photography, with no commercial experience, Jones began to shoot advertisements for Boeing 747. Relocated in Santa Fe, New Mexico, the self-taught Jones is noted for special lighting techniques and the painterly style he's applied to still life, sets, people photography and motion picture film.

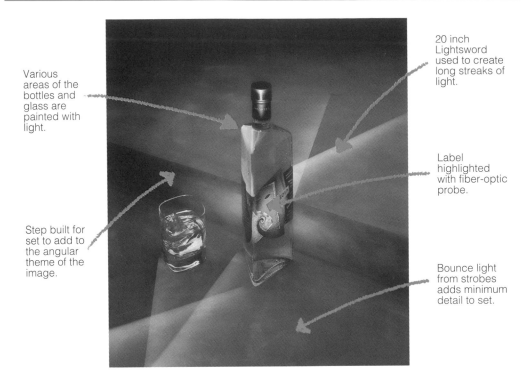

Various areas of the bottles and glass are painted with light.

Step built for set to add to the angular theme of the image.

20 inch Lightsword used to create long streaks of light.

Label highlighted with fiber-optic probe.

Bounce light from strobes adds minimum detail to set.

PHOTO NAME: Jublaeum.

PHOTOGRAPHER: Aaron Jones, Aaron Jones Studios, Santa Fe, New Mexico. U.S.A.

ASSIGNMENT: I was chosen to photograph the introductory ad for a new liquor, "Jublaeum," by Dean Hansen, an art director at Fallon McElligott. He wanted an image with a painterly look that also clearly showed the unique label and triangular bottle. The original layout showed three bottles laying at different angles so the viewer could clearly see the shape.

CLIENT: Fallon McElligott.

FILM: Kodak Ektachrome 100 Plus Professional, (EPP). 100 ISO rated at 100.

CAMERA: Large Format, 8x10.

ABOUT THE SHOT: The unique lighting of this image was created during a long exposure using a combination of strobe lights and the Hosemaster light painting system.

A Hosemaster is a fiber-optic lighting device which allows the photographer to "paint" light into specific areas of the image. A daylight (5500 Kelvin) light source, contained in the main unit, is carried through a narrow fiber-optic cable. The flexible cable is hand held which

allows for precise illumination of desired areas of an image. Unique creative effects can be achieved by attaching various snoots and "swords" to the cable's end. These attachments can project different patterns and qualities of light.

In addition, the Hosemaster system contains an exterior shutter/filter system for the camera. The shutter has a window that can be manually opened and closed from controls at the end of the fiber-optic cable. This removes any chance of camera movement and simplifies producing this type of image. The filter holder, attached to the back of the shutter, is also controlled from the fiber-optic cable. When the shutter switch is held down, the filter frame flips up, covering the shutter window. For this shot, a diffusion filter was placed into the filter window.

THE SET-UP: A small table-top set was constructed for the shot. It featured the bottle and a glass placed in front of a step made of hand-painted wood. The step, which ran diagonally across the picture area, played off of the angularity of the bottle and added more dimension to the image.

In order to show the shape of the bottle, it was necessary to have the camera at a high angle. I would be using an 8x10 view camera for the shoot to provide the client with the sharpest image possible. The camera, placed on a large studio camera stand, could easily be moved up and down for positioning. Located just in front of the camera lens, the Hosemaster shutter system was put into place.

Two strobe heads with reflectors would be used to add ambient light to the set. (See Fig. I) Located behind the set, these strobes were positioned directly at the ceiling. By bouncing these direct light sources off of this large area, a soft quality of ambient light filled the set. Although I did not meter these lights, I did know, based on experience, that the value of this ambient light would be just enough to add detail to the shadows.

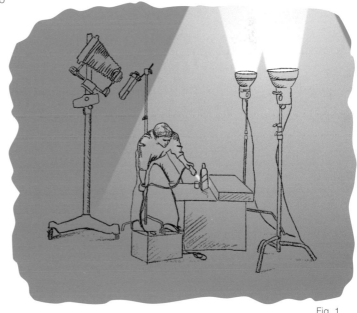

Fig. 1

The highlights of the image were created with the Hosemaster. Using the 20-inch Lightsword, the angular rays of light coming from the bottle were created. The Lightsword was placed face down on the surface of the set and moved slowly for 2 to 4 seconds in each position. Next, the Lightsword was replaced with a 6mm probe attachment. This probe emits a narrow beam of light. The probe was used to light the label of the bottle, the shot glass and to create a glow from behind the bottle. The glow was achieved by holding the probe behind the bottle for a total of six seconds, three seconds on each side. (See Dissection #1) The color balance was warmed by adding both an 81D and a .05 magenta filter to the lens.

The final film was processed in our Jobo ATL-3 processor. This enabled us to see the results of our shoot right away and make any needed changes. In the end, the style and impact of the image was exactly what the art director needed. The photograph was used for consumer magazine and bus board advertising.

Top of bottle lit with probe for 5 seconds.

Back of glass is illuminated with 6mm probe for 6 seconds.

20 inch Lightsword is placed on table surface and moved slowly for 2-4 seconds in each position.

20 inch Lightsword is placed on table surface and moved slowly for 2-4 seconds in each position.

Step and label lit with probe for 6 seconds.

Bottle is back lit from both sides with probe for 4-6 seconds.

Dissection 1.

PAKARNWIT VATHAKANON

T H A I L A N D

Softbox, with heavy fill flat-lights vase.

Perfect registration critical for merging images together.

Box painted on canvas background.

PHOTO NAME: Vasan Wangpaitoon.

PHOTOGRAPHER: Pakarnwit Vathakanon.
Pia & Pop LP, Bangkok.Thailand.

ASSIGNMENT: Spa advertising, from Osothsapha, one of the foremost multi-billion dollar consumer products corporations, was producing a corporate advertisement. The advertisement was to convey the idea of "timeless value." The original idea was to project a thousand year old pot, a watch, and a photograph of the client's first establishment, onto the ground. After studying the visual for a few days, the original layout was put aside. Under the direction of Uab Sanasen, one of the top artists in Thialand, the shot took the shape of a pot combined with a canvas background. The final image would determine the entire layout. No limitations were put on the creativity or dimensions of the photograph. The client was present during the entire shoot.

FILM: 4x5 Kodak Ektachrome Professional, EPP 100, rated at 100 ISO.

CLIENT: Osothsapha (Teck Heng Yoo).

AGENCY: Spa Advertising.

ART DIRECTOR: None.

STYLIST: Sukanya Hongrattanawong.

ARTIST: Sirapak Phrompha.

CAMERA: Sinar P2, 4x5.

LENS: Rodenstock 300mm.

ABOUT THE SHOT: Two exposures on a single sheet of film, one of each of the two sets that were constructed, created this merged multiple exposure.

THE SETUP SET 1; THE POT: The pot, which was furnished by the client from their private collection, was placed on a piece of black fabric three meters from the camera. One medium-sized softbox was positioned on the left side of the pot. Because the distance to the subject was close, the quality of light was very soft. The right side of the pot was filled in with a large piece of foamboard. Once the lighting was set, black velvet was hung behind the set. This velvet and the velvet under the pot ensured that only the pot would be exposed in this shot.

A Broncolor probe, which meters the light off of the film plane, was used to take a reading. Film plane metering is a reflective system, and therefore measures for 18% grey. In this case the meter read a zero value (18%). It was necessary to increase the power of the strobe one stop to bring the pot to its 36% value (true tone), requested by the art director. A Polaroid type 55, which produces both a positive and a negative was then shot. The negative was dried and then carefully taped to the ground glass so that it lined up with the vase through the lens. The positions of the Foba camera stand were marked for both setups.

Camera position 2

Fig.1

The camera's position for this setup was referred to as position #1.

THE SETUP SET 2; THE BACKGROUND AND BOX: With the Polaroid negative on the ground glass, the camera was rotated 90° on the Foba. Again, all of the camera stand positions were marked. A new white canvas was hung and moved three meters out in front of the camera. (NOTE: 3 meters was the same distance between the pot and camera in set #1). A tungsten light was turned on and placed directly behind the ground glass, being careful not to get the camera too hot. With the camera at its smallest aperture, the negative of the Polaroid was projected through the camera and onto the background. (A small aperture was used to project the sharpest image possible). The shape of the vase was carefully traced on to the canvas and then painted black. This allowed the image from set #1 to be exposed perfectly in this area. The background, which included the box base for the vase, was then painted in by an artist to match the texture and color of the pot. (Fig. 2)

This set was flat lit by two umbrellas at 45° off the background axis. A film plane meter reading was taken of the outer area of the canvas. The strobe output was adjusted until the reading matched Set #1 at a 36% value of +1 so the tonality of the pot and background would be equal. This camera position was referred to as position #2.

EXPOSING THE FILM: 4x5 film holders were loaded and the bottom of the film was taped to the holder to avoid film movement between exposures. The Foba and camera were placed into position #1. It was critical that the camera stand was perfectly aligned so that the two exposures didn't overlap. The Polaroid negative was left in place during the entire shoot to double check the alignment. The first exposure of the pot was then taken. Next, the camera moved into position #2 and the background was exposed into the areas surrounding the pot. This double exposure created the illusion of the pot being part of the painted canvas.

Fig. 2

JONG-IN CHOI

K O R E A

Dappled light is created by light passing through glass bricks.

Fill cards add light to shadow areas.

Hard light passes between glass blocks.

PHOTO NAME: Untitled.

PHOTOGRAPHER: Jong - In Choi, Seoul, Korea.

ASSIGNMENT: This image was created as part of an exhibition which was shown in Gain Gallery Korea. It was later used in a self promotion campaign.

FILM: Kodak Ektachrome Professional 64 Tungsten. 64 ISO rated at 64.

EXPOSURE: 30 seconds at f/45 and ⅓.

FILTER: 81A warming.

CAMERA: 4x5 view camera.

LENS: Rodenstock Sironar-n, 210mm.

THE SETUP: As a photographer, I enjoy building the set and creating the lighting, based on the feeling of the subject and the emotion I wish for the image to convey. For this image I selected a dried skate fish, cod and some anchovies as subject matter to be placed on custom painted paper and clothing. With the image I had in mind, I wanted to show texture and keep a rough surface feel to the background.

The lighting consisted of two 600 watt Lowel Omni tungsten lights which were placed on the left of the set, just above the surface of the table. Each light from each source was spotted to create more illumination on the skate fish, making it the focus of the image. I prefer to

work with specular or hard light sources for the imagery I create because they offer more visual impact. Had this image been lit with a large soft light source, the impact of the image would have been lost.

In front of the two lights, a series of glass blocks were positioned so the light would both pass between and through them. This created the sporadic patterns of light on the left side of the image. The opposite side and top of the set were lit by using various acrylic mirrors and reflectors which bounced light into scattered areas of the image. (See Fig. 1)

The film used for this image was Kodak Tungsten 64T which, because of my experience, I strongly believe is ideal for long exposures. Several shots were taken, moving the positioning of the props slightly from time to time for a variety of compositions from which to choose.

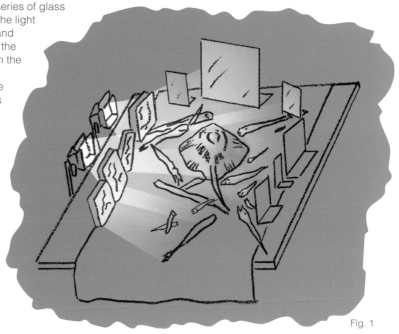

Fig. 1

AARON JONES

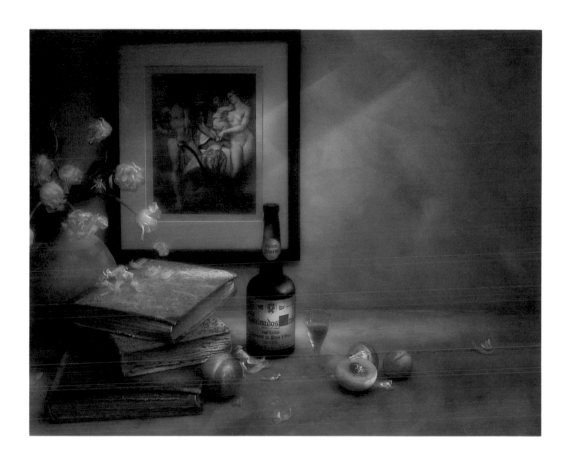

A M E R I C A

At 36, Aaron Jones sold his woodworking business in Oregon to pursue a career in photojournalism. Moving quickly into advertising photography, with no commercial experience, Jones began to shoot advertisements for Boeing 747. Relocated in Santa Fe, New Mexico, the self-taught Jones is noted for special lighting techniques and the painterly style he's applied to still life, sets, people photography and motion picture film.

AARON JONES

Pool of light painted on picture.

Lightsword paints in lines of light.

Hosemaster with #3 soft filter paints in pool of light.

Hosemaster with #3 soft filter paints in pool of light.

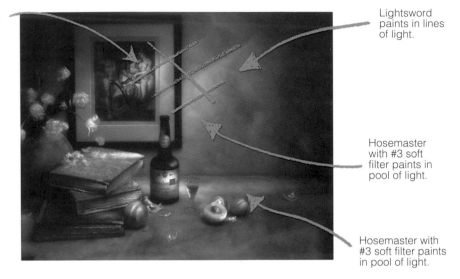

PHOTO NAME: Alvados.

PHOTOGRAPHER: Aaron Jones. Aaron Jones Photography, Hosemaster Aaron Jones, Inc., Santa Fe, New Mexico. U.S.A.

FILM: Kodak Ektachrome Professional, EPP 100, rated at 100 ISO.

EXPOSURE: f/32, Bulb.

CAMERA: 8x10 Toyo.

LENS: 360mm, Schneider.

ABOUT THIS SHOT: The unique lighting of this image was created during a long exposure using a combination of strobe lights, and a Hosemaster light painting device.

A Hosemaster is a fiberoptic lighting device which allows the photographer to paint light into specific area of the image. A daylight (5500 Kelvin) light source, contained in the main unit, is carried through a narrow fiberoptic cable. The flexible cable is hand held, and it allows for precise illumination of desired areas of an image. Unique creative effects can be achieved by attaching various snoots and funnels to the cable's end. These attachments can project both different patterns and qualities of light.

The Hosemaster system contains an exterior shutter/filter system for the camera as well. The shutter has a window that can manually be opened and closed from controls at the end of the fiberoptic cable. This removes any chance of camera movement and simplifies producing this type of image. The filter holder, attached to the back of the shutter, is also controlled from the fiberoptic cable. When the shutter switch is held down, the filter frame flips up, covering the shutter window with a chosen filter. (Fig 1)

THE SETUP: Two custom painted boards were used to create the stage for this set. One board was placed on top of two sawhorses, and the other was supported as a wall behind the set.

An 8x10 camera, chosen because it renders an extremely sharp image, was placed in front, looking down slightly onto the set. The props were carefully positioned, being sure to develop a composition that would lead the viewer's eye through the image.

The overall ambient light was created by a large softbox postioned above the set, and slightly to the right. Large black flags were placed between the set and the softbox, cutting down the exposure on the outer edges of the frame and bringing more attention to the props.

Hosemaster shutter window.

Filter Holder

Fig. 1

SHOOTING: Part A; AMBIENT FILL: The large overhead softbox was used to generate fill light to the entire set. An incident meter reading of the flash exposure placed the proper exposure for the diffused value, or true tone, of the scene. This reading, f/16.5 at 1/60, was underexposed by setting the aperture of the camera at f/32. This underexposure created a base fill to the image area, giving slight detail to the entire image area.

With the studio in total darkness, the camera and Hosemaster shutters were opened. A Hosemaster #3 soft focus filter, locked into the filter holder, was moved in front of the lens, and the strobes were manually fired. To avoid any exposure between this and the next step, the Hosemaster shutter was closed.

Parts B & C; BACKGROUND GLOW/PAINTING: A 20" Lightsword, a Hosemaster attachment which resembles a fluorescent light tube, was fixed onto the end of the fiberoptic cable. The Lightsword would be moved into four positions, stopping only briefly at each point to make an exposure. These points are represented by the diagonal lines in dissection 1. The soft filter was again used for this element.

Once these exposures were complete, the Lightsword was removed and replaced with the normal lighting tip, a small rectangular opening. Three pools of light were painted into the image with the soft filter in place. These "pools" were created by moving the beam of light in a circular pattern during the exposure, being sure to close the exterior shutter between positions. The placement of these pools are shown in the first dissection.

Part D; DETAIL LIGHT PAINTING:

The final touches were applied by using various light control tips to highlight areas of the image. The type of tips used and their exposure times are shown in dissections 2 & 3.

Several sheets of film were shot and then processed in house in a Jobo ATL-3 Autolab. Light painting cannot be recreated exactly for each sheet of film, and therefore every sheet of film was different. This image was the favorite.

Hosemaster and Lightsword are registered trademarks of Aaron Jones, Inc.

PHOTO NAME: Alvados.

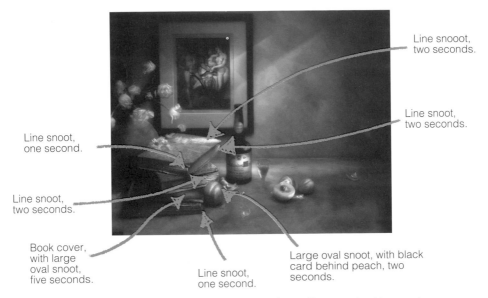

Line snooot, two seconds.

Line snoot, two seconds.

Line snoot, one second.

Line snoot, two seconds.

Book cover, with large oval snoot, five seconds.

Line snoot, one second.

Large oval snoot, with black card behind peach, two seconds.

PHOTOGRAPHER: Aaron Jones. Aaron Jones Photography, Hosemaster

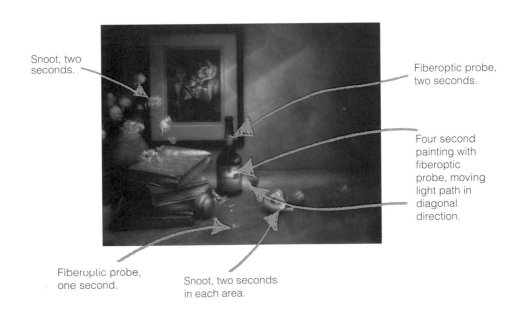

Snoot, two seconds.

Fiberoptic probe, two seconds.

Four second painting with fiberoptic probe, moving light path in diagonal direction.

Fiberoptic probe, one second.

Snoot, two seconds in each area.

SAVINI & RÜFENACHT

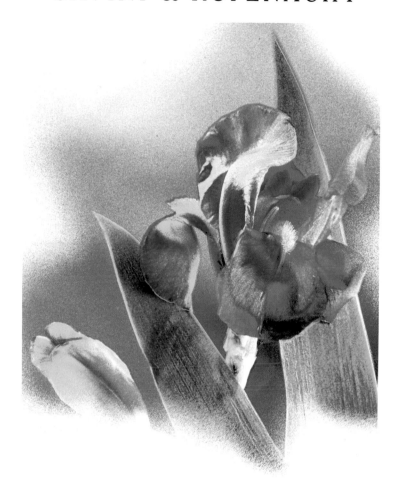

S W I T Z E R L A N D

Publicity photography requires good communications and teamwork. Dennis Savini and Irene Rufenacht exemplify that. Irene is a multi-functional organizer while Dennis has a sound basis in the widest range of the aspects of professional photography. This lets them go beyond the conventional perspective and create the unexpected, producing photographs that speak a language of their own.

SAVINI & RÜFENACHT

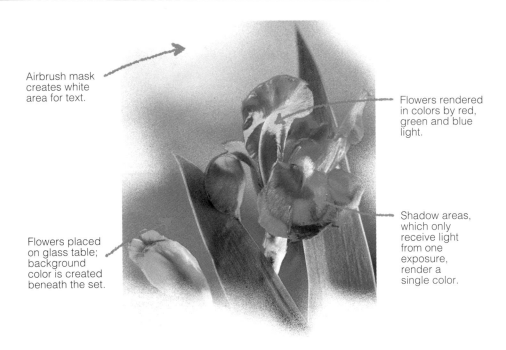

Airbrush mask creates white area for text.

Flowers rendered in colors by red, green and blue light.

Shadow areas, which only receive light from one exposure, render a single color.

Flowers placed on glass table; background color is created beneath the set.

PHOTO NAME: Iris.

PHOTOGRAPHER: Savini and Rufenacht, Werbefotographie, Zurich. Switzerland.

ASSIGNMENT: Joy, a German publishing house, was producing a set of cards featuring 60 of the world's most fragrant flowers. Initial production meetings included several people who helped influence the design and style of the project. Susanne Fisher-Rizzi, a well-known writer with floral expertise, was an important component to the project's success.

ART DIRECTOR: Markus Kuhn, Zurich.

CLIENT: Joy Publishing House, Germany.

FILM: Kodak Ektachrome 100 Plus Professional (EPP). 100 ISO rated at 100.

CAMERA: Sinar 4x5.

LENS: Nikkor AM/ED, 210mm.

ABOUT THE SHOT: This image is the result of a multiple exposure technique which mixes red, green and blue light on a single sheet of film.

PREPRODUCTION: It took more than a year to locate and coordinate the shooting of various plants and flowers. The task was exhausting, especially with the need to shoot the flowers while they were all in bloom. Some rare flowers were found with the help of several greenhouses throughout Europe.

THE SET-UP: The set consisted of two strobe heads. Strobe #1 lit the flowers on a glass table while head #2 illuminated the background beneath the glass.

Strobe #1 would be moved to three separate positions during the shot. (See Fig. 1) For the first exposure, strobe #1 was covered with a blue filter and placed on the left of the camera (position 1A). For exposure #2, the head was moved to the rear of the set (position 1B) and covered with a green filter. Finally, for exposure #3, it was moved to position 1C and covered with a red filter. Because white light is made up of these three primary colors, where all three colors met white light was created. In the areas where the light did not overlap, only a single color was exposed. Where two colors overlapped their complementary color was exposed. This effect is most visible in the shadow areas created when the light was moved between positions. This effect was exaggerated by removing the film holder from the camera between each exposure, purposely making the image out of register when the film shifted in its position.

Fig. 1

A white sheet of seamless paper, draped under the set, provided the background below the glass. The paper was lit by strobe head #2, with the path of light passing through a black mask (Fig. 2). This mask created the pattern of the background. Color gels applied to this light added to the creative color of the image as well. (NOTE: This effect was first shown by Maxwell in 1861 in his famous three color projection.)

METERING THE LIGHT: The exposure was determined by shooting a series of Polaroids and adjusting the lights accordingly. Each one of the three exposures for light #1 was 1/3 of the total, creating a full 1/1 exposure when the exposures were accumulated. The background exposure was made by a single pop from head #2.

FINISHING WORK: Once the film was E-6 processed, the hero chrome was selected. This image was used as a guide to create an airbrushed mask of the area surrounding the center of the image. This mask would create the white negative space at the outer borders of the images, allowing a clean area for the text on the final piece.

The original image and airbrush mask were combined by exposing each image separately onto a sheet of Kodak duplicating film. During this duplication process, the images could be adjusted in color and/or in exposure, as needed, to allow the entire set of images from the project to have a similar style and feeling.

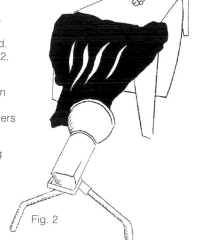

Fig. 2

DAVID KEMPINSKI

S W I T Z E R L A N D

Born in Dusseldorf, West-Germany, in 1953, David Kempinski went to the University of Zurich, in Switzerland, to study Psychology. From 1982 until 1988, Kempinski worked as a volunteer then an assistant to several photographers. He then opened his own studio, David Kempinski Fotostudio, in Zurich, where his primary focus is food, high tech and still life.

Mirrors add interesting patterns of light.

Specular light reveals texture of object.

Background created by backlighting three sheets of glass.

Main light at low angle defines shapes of buttons.

PHOTO NAME: Untitled.

PHOTOGRAPHER: David Kempinski, David Kempinski Photography, Zurich. Switzerland.

ASSIGNMENT: Zellweger Uster, who produces innovative instruments for measuring and controlling electricity, created this object which is designed to store electrical meter readings. The image ran 2 3/4 inches and was used on the cover of a brochure for the electrical industry.

FILM: 4x5 Kodak Ektachrome Tungsten 64T, 64 ISO rated at 64 ISO.

CLIENT: Zellweger Uster.

CAMERA: Sinar P2, 4x5.

LENS: Nikon 210mm ED, macro.

THE SETUP: The base of the set, located below the object, consisted of three different types of glass. The first piece, at the bottom of the set, was a sheet of normal, clear glass. Separated by small spacers, a sheet of Reflo-glass sat on top of the the normal glass. Reflo-glass is slightly less reflective than normal and is partially frosted. The top sheet of glass, where the object would sit, was a sheet of opaque plexi-glass. This structure would be used later to create the blue background behind the object.

The main light, a tungsten source with a fresnel lens, was selected because it allowed the path of the light to be concentrated to one spot. The light was placed at a low angle so it would strike the subject in a way which would best define the shape of the buttons. It was fortunate that the object had a perfect surface and that this low angle did not reveal any cosmetic flaws–especially at such a close perspective. A series of small mirrors, located just out of the camera view and positioned just opposite the main light, added an interesting and unique highlight to the shadow side of the object that also helped to define the shape of the buttons. Blue gels, taped to the outermost mirrors, added color to these highlights.

The set was filled with ambient light by placing a pair of strobe heads two feet above the set. These lights, pointed at the ceiling, added light which reduced the overall contrast of the image and helped to reveal some detail in the shadow areas.

A polarizing filter, added to the front of the main light, eliminated many of the undesired reflections. Two black flags, one on each side of the main light, were also added to protect the object from being struck by too much ambient light.

In most cases an 85B gel, the light conversion gel (light balancing) which changes the color temperature of daylight (5500° Kelvin) to tungsten (3200° Kelvin), would be placed in front of each strobe to balance the color temperature of the strobes to the tungsten film. However, a color shift, casting the cool blue strobe light into the shadows, was desired. This cool color temperature was enhanced by placing an 80A (conversion gel for changing tungsten to daylight) over the strobe heads. The main light color temperature was also enhanced by placing an 85B (daylight to tungsten) over the fresnel lens of the main light.

A bare bulb strobe was positioned directly under the bottom of the glass sheets to backlight the base of the set; this light was also filtered with an 80A gel to create a blue background.

EXPOSING THE FILM: No meter readings were taken; a series of Polaroids helped to arrive at the final exposure. The exposure took place in two parts, the first was an exposure of the main and fill lights, and the second was an exposure of the backlit glass. When it was time to shoot, a piece of black fabric was placed between the top two sheets of glass. This fabric was in place during the exposure of the fill and main lights and removed for the exposure of the glass. This eliminated any chance of light passing through the glass and exposing the floor below the set. Also, in order to obtain strong color saturation on the glass during the second exposure, it was essential that this area received no light from the first exposure.

This combination of exposures created a crisp image with color playing an important role in the image's impact.

RENÉ PERÉZ CATALÁN

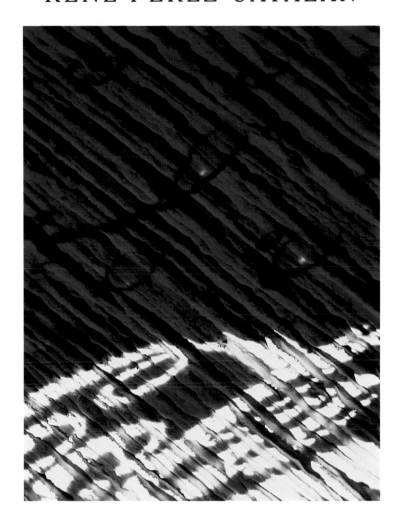

M E X I C O

A Mexican photographer with a strong design background, Rene Perez Catalan studied Graphic Communication Science. Early in his career he won first prize in the Commercial Category of Mexico's Professional Photographer's Annual Convention Awards. His love of diversification in commercial photography enables Catalan to do location, aerial and product shot photography with the same enthusiasm.

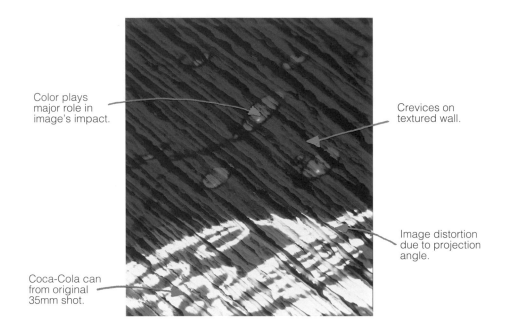

Color plays major role in image's impact.

Crevices on textured wall.

Image distortion due to projection angle.

Coca-Cola can from original 35mm shot.

PHOTO NAME: Coca Cola Abstract 5.

PHOTOGRAPHER: René Pérez Catalán, DF&DG, Col. Campestre Churubusco. Mexico.

ASSIGNMENT: In 1988 I was awarded first prize in the Mexican National/International convention with an abstract image of a Coke can. The award and image became the inspiration for a self study on the same subject matter. This image, Coca Cola Abstract 5, was a variation of the original Coke shot which I intend to enter in the next convention competition.

FILM: Shot #1: Kodak 120 EPP 100 ISO, rated at 100.

Shot #2: Kodak 120 EPT 160 ISO, rated at 160.

CAMERA: Medium Format.

LENS: 127mm.

THE SETUP, SHOT #1: Focusing on the impact of color, this image utilized a blue seamless paper background, splattered with red paint, and a crushed Coke can. The graphics of the shot were simple, yet bold and dynamic. A Hensel Monoflash 800 with a Softstar type softbox (42 inches in diameter) was used to light the set from above. Fill light was selectively added from the sides with small white cards. The overall quality of light was slightly hard, making the scene contrasty and the colors vibrant.

A series of Polaroids were shot at the incident meter's recommended exposure. With the dome aimed at the camera, the incident reading, 1/125 at f22, averaged in the highlight and shadow area. Minor adjustments in perspective and lighting were made before the film was exposed. It was necessary to add a 10cc (color correcting) filter to the lens to correct the color balance of the lighting/film emulsion combination. Once this film was E-6 processed, the "hero" shot was selected and a 35mm dupe slide was made. (Shot 1)

THE SETUP, SHOT #2: A 35mm slide projector was positioned near 30° off axis to a textured wall. The camera angle was parallel to the wall's surface so that it would not cause any lens distortion. Next, the duplicate slide of shot #1 was placed into the projector, and the image was cast along the wall. As the light from the projector scraped along the wall's jagged surface, a dynamic and abstract image of the Coke can appeared. (Fig. 1) Because the image in the projector bowed as it was heated by the projector, it was necessary to place the image into a glass slidemount.

Shot 1

Focus on the projected image fell off slightly on the slides of the image due to the projection angle. However, because the final image was only a small section of the projection, it was not a concern.

Again, an incident light meter was used to determine the exposure, 1 second at f8. Depth of field was not a concern because the subject area was flat. Several bracketed exposures were made for the final image.

Fig. 1

Here are a few tips, hints and a little insight from some of our contributing photographers who know the business and what it takes to make it!

YURI BENITEZ - MEXICO

I believe strongly in self promotion. It gives a photographer presence and can quickly build a reputation for your company. In Mexico, the big advertising agencies and a host of large companies are centralized in Mexico City. To target this market, we designed a campaign where everyone was sent four separate posters throughout the year. The posters were hand delivered by couriers.

 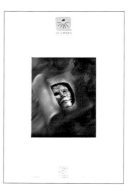

Every two months starting in April, the Art Directors, Creative Directors and Marketing Departments of the companies selected for our database of "targetables" (or clients) received the first poster. Every two months thereafter, they received another poster in the series. The posters feature images which show that our business is capable of creating both technically sound and innovative photographs. We try to dare our clients to go beyond the usual.

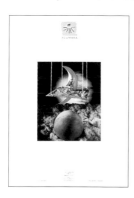 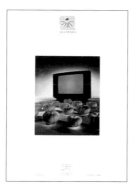

After the posters are sent, we prefer not to call them. It is our hope that we've persuaded them to call us! Our response to date has been very good, resulting in several new jobs and clients. Our posters for this year were also used in advertisements for Kodak, so people were impressed even more when they received their own posters.

The biggest problem we have found with direct mail is keeping our database up-to-date since people in the advertising business move like crazy. Keep on top of it!

DAN LIM - CANADA

Do your homework! One of the most difficult things for a young photographer is to break into the market place. Trust me, the assignments are few and the competition is stiff! So how does one get the attention of an Art Director? There are many ways to do so, but the one, and best piece of advise I can give to an up and coming photographer is to do your homework before showing your portfolio to an art director.

When researching a potential client, find out the following and build your presentation accordingly: Who is the Art Director? What kind of photography (i.e. food, fashion, travel, etc.) does he or she buy ? Who are the photographers already shooting for them? (From this you can determine the visual style that appeals to that particular Art Director.) Are the styles of the photographers they're using similar to yours?

MARKETING TIPS, PRO-HINTS & STUDIO TIME SAVERS

These questions should be asked before calling on an Art Director to show your work. Keep in mind that showing applicable work will increase both your chances of getting noticed and getting work. For example, if you really love to shoot fashion and cars then you should have separate portfolios that show only your fashion work and only your car shots. Think of it this way - would you go to a flower shop to buy tools? No, you wouldn't. The same logic applies when you show an Art Director your work. You wouldn't show your portfolio of fashion work to someone who only buys travel photos. If you don't have a lot of images to show on one particular subject, remember only to show the best images and only what is applicable. The axiom, "10 superlative images will always be superior to 20 mediocre ones," holds true in all cases.

Too many young photographers make the common mistake of having only one portfolio which consists of work ranging from baby pictures to studio still life shots. This is not to say that one has to specialize right away, but it is important to show only work that applies to the client you are pursuing. Art Directors are extremely busy people and nothing aggravates them more than to waste their time looking at a non applicable portfolio.

KEVIN SMYTH - U.S.A.

I've met a lot of photographers over the years. The financially successful ones are great marketers. Some are also fine photographers. Try to be both. Sad to say, being a great marketer is oftentimes more important.

Know what it costs to do a job. How long will it really take? Do you really know how to do it or are you going to experiment for a day or a week on your own time and materials? If you can't do it and make a profit on that job, you're better off to pass on doing it. This will save you more time than anything. I'm not talking about pro bono work here, I'm talking about a service for businesses that have money to pay for salaries, paid vacations, computers, fancy offices, health care for their employees and lawyers to write purchase orders. The reason photographers don't have these things is that they have let themselves be pushed down the food chain.

There are real businesses that are in the photography field. They are called stock agencies. Be aware of how they price photography. They first price their fees on usage: how many copies will be printed? How big will the image appear? Is it a trade or consumer ad or is it a cover of a magazine? These things raise the price a lot. Second, stock images are priced on scarcity. How hard is it to find the type of image being sold? In assignment work, keep in mind how difficult is it make the image.

Ask what the budget is for a job. If it is unrealistically low for the usage and the trouble to create it, say so! Most photographers would be stunned to learn what a company or an agency spends to have a "$75 catalog shot" separated. They most likely expect to use it for several years without further compensation to the photographer. If they are a manufacturer, they may expect to send dupes to all their clients to use in their catalogs. The printer, the separator and the Art Director get paid each time. Why not you? Be open and businesslike, but say so! If you don't get the job, don't assume it was because your price was too high. The job may not have happened for any number of reasons.

Keep your overhead low.

Experiment.

Keep the equipment you do have in good shape.

Get with a good stock agency Instead of taking a crummy assignment, call your stock agency, find out what they need and take some good stock shots that will bring you money down the road. Call PACA (the stock industry trade group) for a list of member agencies.

302

Here are two of my favorite quotes.

"When you get lucky, be ready." (Joe Baraban)

"Nowhere is it written that photographers have to be poor."(Jay Maisel)

JAY P. MORGAN - U.S.A.

We started our studio with a monthly calendar that was mailed to 5000 Art Directors each month. This was a full color piece that had a B&W image on the envelope to start the story. This monthly mailing went out for three years and put us on the map. People immediately thought that we were an established business. This positioned us in the arena where we wished to be.

I've always felt that if a person works in the advertising industry and doesn't advertise then that individual should go work digging ditches, as a tow truck operator or a person who sells shoes. Those would be better careers for someone who won't advertise. Perhaps a small sign reading "will work for food," might be the best investment. Why? Because if you don't advertise you're going to need it!

My feeling is that the photographic community must approach its art as a business, not something just done for fun. We act like Art Directors are doing us such a favor by giving us a job and paying us. We deserve to make good money. We drive the visual advertising process in this country. Products would be hard to see if they had to be carried door to door and there were no magazine ads. Life would be very boring if someone wasn't giving us good art for our visual experience. We are the visual print industry, let's be a business! In our studio, a job isn't a job until we get a purchase order, a signed estimate and a cash advance. These things clarify the process and protect us from a lot of problems.

I also think that photographers need to find themselves and not chase current trends. This business will beat you up if you listen to all of the opinions out there. Believe in yourself and commit yourself to your vision. In time, it will pay off!

JOHN STREET - AUSTRALIA

The main point I always try to get across is the importance of ethics - building long term relationships of trust and respect with clients while keeping all money matters straight. First and most important, be ethical in all your financial dealings. Give your clients a carefully worked out quote and stick to the accepted quote. Consider the use of Polaroid as an advantage to you, not to the client; therefore do not add great mark-ups.

At all times remember the client and treat all clients with respect. Attitude here is all important.

Communicate with all parties involved in a shoot. Brief the stylist, assistants, etc. Work as a team. You are trying to reach a common goal.

Drop the ego, the only life it has is yours.

Look after your clients' needs totally and always be prepared to shoot that extra sheet of film in order to get a better shot.

BE PROFITABLE! Life is more enjoyable when you can pay the rent. Pay your suppliers promptly; build a mutually beneficial relationship with both suppliers and clients. Take a good look at your overhead. See what you need; it may be very different from what you want.

MARKETING TIPS, PRO-HINTS & STUDIO TIME SAVERS

Getting started, you may not need a studio or a grand array of lights and camera gear that may seem essential. Getting into debt by financing purchases adds to your overhead and greatly increases the burden and the fear that you carry: fear that payments cannot be met; fear leading to dropping your fees to ensure that you get the job because you need the money; fear about discussing fees with clients; fear which cripples creativity and passions. Being debt free gives you the freedom to turn down jobs where an agency has a poor payment track record. It allows you the freedom to negotiate better prices when purchasing. Most important, it frees you up to be your creative best!

Don't trust an accountant to run your business. While you may feel that you are creative and not interested in the money side of the business, your objectives may be totally different from your accountants.

Never sign anything you don't understand.

Be it a Rolls Royce or a roll of toilet paper, give it your best shot!

Last and most important, remember to back yourself. You are only as good as the shot you are doing now!

TRISH K. PERRIN - U.S.A.

What has worked the very best for marketing our studio, besides newspaper ads, has been personal referral cards. Each client receives about 5 cards and gives them to a friend. They will, in return, receive one complimentary 8x10 for each client who comes into the studio. Multiple referrals can be accumulated and used toward purchasing framing or wall decor.

My latest idea came to me recently while starting a new children's studio. I designed invitation-style gift certificates. Each child I photograph receives four invitations with their own 4x5 picture on the cover. The invitations are for one complimentary session and are signed by the parents of the child. This makes the gift certificate appear to be a personal gift from them. And after all, what parent doesn't like to show off their child with pride? This gives them the perfect chance. Any time you can get your clients to work for you, your business has a chance to grow at an accelerated rate. The importance of referrals is that they reach an audience that conventional advertising may never reach. In addition, they are pre-sold when they come into your studio.

JOHN SEXTON - U.S.A.

Always show your BEST work. You can never anticipate the likes and dislikes of others. In other words, you will never make a photograph that everyone likes, try to do your very best so you will like every one of your photographs.

I always carry a viewing frame cut to the aspect ratio of the format I use. My frame is made from black vinyl, 4x5-inches in size with a 2 x 2.5 - inch rectangular opening in the center.

The opening is exactly $1/2$ the linear dimension of my film and is the same aspect ratio. The 4x5-inch size makes it easy to carry in my pants pocket at all times. By looking through this card I can quickly and easily visualize an image on a moment's notice. In addition, I can determine the focal length of lens needed by the eye-to-frame distance. A distance of about four inches gives the same field of view as an 8-inch (210mm) lens. This allows you to scope out a variety of view points without having to set up the camera and tripod and keep having to move around.

No one likes to make a mistake, but when you do... LEARN from them. I find my best new ideas come from technical and aesthetic mistakes.

Try not to over commit yourself. The hardest thing for me to say is "NO." It is important to take on only those tasks that you have the time and energy to do correctly.

In my darkroom I have installed "breadboards" in the counter my enlargers sit on. These are very useful. When needed, I can add counter space in an instant; and when not needed they can be cleared and slid back into the counter. I suggest these be considered everywhere in the darkroom and studio.

Also, rather than paper safes in the darkroom, I have a row of light tight drawers. These are easily constructed and plans are shown in numerous publications, including the Kodak book on darkroom construction. They work great!

AARON JONES - U.S.A.

As far as marketing, I believe the most important thing is to have images worth marketing. I see a lot of promo pieces and ads in source books with very mediocre images. Their marketing expenditures are a waste of money. I think it's important to have a diverse, balanced marketing program. My biggest success has been with direct mail.

Having our own Jobo processor has helped our business allowing the client and me to see results right away.

Have a good background in set building, painting, propping, etc... In the early days you'll be doing it all yourself.

Don't let concentrating on business and marketing overshadow your concentration on being creative. Maintain a balance.

DEAN COLLINS - U.S.A.

Make any image that you are creating a show! Even if the shot only requires one light, set-up five and don't use four of them. Make a simple product shot look like a large production, even if it doesn't need to be. Make your client feel like they are getting their money's worth and make them feel like you were worth every penny they spend.

If you have a studio with skylights, don't permanently cover them. Get someone to build you a pulley system so they can be opened and closed. Adding a little sunlight to an intense shoot does a world of good for everyone.

You better damn well be able to convince someone to buy what you want to sell. Selling what you make is what allows you to make what you want to sell.

DAVE AND MARK MONTIZAMBERT - CANADA

One of our favorite and most successful marketing ideas is our annual client party. Our most famous party is our Beer Fest called Montizambeerfest. We invite potential and present clients - usually around 200 people show up. The entertainment consists of 20 German dancers and one accordion player who perform for the evening in exchange for a promo shot. For refreshments we hire one of our clients - a meat/sausage manufacturer - to cook and serve various German delights and another client - a local beer brewer - to set up and serve beer on tap. The party creates a lot of talk about us, plus it shows off some of our creativity and ability to organize and execute a large project. The whole party costs only $1000.00, but it looks far more extravagant. Every year we are able to directly attribute at least one job that covers the cost of the party. We find that it is a great way to reminding our clients that we exist without begging for work. The real power of this marketing idea lies in the fact that we are giving something rather than asking for something.

TIME SAVER: The following shoot procedure really helps to speed up and keep even our most stressful shoots organized. (1) establish composition. (2) calculate depth of field required - set this aperture on the camera. (3) create lighting to that aperture. The exposure setting on the camera always represents middle gray. Now that you have established this setting, you can keep the following lighting brightnesses that you will create very clear in your mind because you have something to relate all your meter readings to.

For a correct exposure, make the light from the main-light that is striking the subject read the same aperture/shutter speed combination that is set on the camera. (Any bellows loss or filter factors are best dealt with by subtracting them from the ISO setting on the meter before you start metering.) With this established, you are now free to create without a lot of numbers cluttering your brain. Create shadow, specular highlight and background brightnesses. Predict and adjust their brightness values by taking reflective readings off them and comparing these readings to the established camera setting (middle gray).

Fig. 1

All photographers have great ideas. Very few ever execute them. Whenever I have a thought that I think is a worthwhile idea - whether it be a new technique, an idea for a shoot or a new marketing idea - I make sure that I put it in my Daytimer and plan a date or "critical path" that will see it gets done. I also try to include other people in its execution so that I feel more obliged to get it done. If I do not do this right away it will never happen. To procrastinate is to fail.

GADGET INVENTION: Our "shade box" has a dual purpose - it eliminates lens flare and it is designed to hold up to three home-made filters. It's construction consists of four pieces of heavy black card that are duct taped (black tape) together to make a square tube. Placed over one end of the square is a thick piece of foamcore with a circular hole cut in its center. This hole is the same diameter as the diameter of the lens being used. This piece is hinged onto one side of the box with duct tape, allowing the box to be flipped open. This allows the photographer the ability to focus on a bright, unfiltered subject when filters are placed into the box. Once you have focused, you close the box (it stays shut with velcro) and the filters are back in place in front of the lens. Filters are made to fit into the top of the box through a slit. Up to three separate filters can be placed in the box at one time. (Fig. 1)

For filtration, we use Roscolux gels which are made to be put over lights and not recommended for camera filtration. However, we have found these gels to be optically correct enough for shots where high resolution is not a concern. (When shooting people, I usually like to reduce the resolution and soften the shot a little.) The two gels I most commonly use are amber and Neutral Density. They are cut into a circle and taped over a circular hole cut into a piece of black card that is sized to fit into the shade box. For softening an image, I use two layers of black netting, called tulle. For a more diffused

look, I will often use a black sheer stocking stretched over the filter hole or a piece of clear acetate with some foreground grease smeared over it.

The beauty of this system is that it allows us more accurate focusing and the ability to change filters more quickly than screw or bayonet mount filters. Also, we have cut down the number of filters we need because we use this system with lenses of any size for all formats of cameras.

TIM MANTOANI - U.S.A.

There is absolutely nothing stopping you from achieving what you want. The important thing is to keep in mind that you can do anything you want, just not everything you want. Look deep inside yourself and find out what it is that you really have a passion for, what is it that puts a smile on your face everyday. Once you discover what that is, do it as much as you can and don't let anything stand in your way.

Many people don't understand how I can pour so much time into my photography. For me, photography is not a job, it is a lifestyle. Photography and my passion for creativity are part of my soul, they simply do not check out at five o'clock!

GADGET INVENTION: Replace the bulb in your darkroom safelight with a bulb made for a tanning booth. Cover the bulb with #25 red Rosco gel, then you can get a tan in the dark! If you have two safelights, replace your other bulb with a "growlight" and cover it with the same #25 gel. Now you can have a fern to keep you company! (We named our studio's fern "Rubin.") Don't worry, your paper will not be affected. Actually, on multi-contrast papers the shift in ultraviolet light is just enough to where the shoulder of the paper's curve is "flashed," causing the range of the paper to be expanded by one-half stop. This test has only been conducted on Kodak papers, specifically Polymax RC - FN, pearl surface. (NOTE: JUST KIDDING! I'M A PROFESSIONAL, KIDS DO NOT TRY THIS AT HOME. The first day an intern starts at our studio we tell them about the tanning light. We've had responses from, "No way!" to "Really?" The ones who say, "Really?" usually don't last too long!)

VIDEOS

Packed with Valuable

Information
& Ideas

For the
Imagemaker...

**FROM THE
IMAGEMAKERS!**

DAVE & MARK MONTIZAMBERT

TIM MANTOANI

BILL HOLSHEVNIKOFF

DEAN COLLINS

BY DEAN COLLINS PRODUCTIONS

· P H O T O G R A P H I C ·
VIDEO NOTES

First Edition A Dean Collins Production

FEATURING

TIM MANTOANI

CREATIVE PORTRAIT IMAGING

Tim Mantoani has been working closely with Dean Collins since he graduated from Brooks Institute in 1991. An accomplished photographer and writer, his articles and images have appeared around the world. His current portrait study of professional athletes illustrates his strong technical and creative talents.

CREATIVE PORTRAIT IMAGING
DISCOVER THE PORTRAIT TECHNIQUES BEHIND EACH IMAGE

ITEM **14014**

Tim Mantoani will share his technical expertise and demonstrate how an understanding of the science of photography can determine predictable results. You will see Tim in action as he shoots the "stars" from professional football, baseball, hockey, motorsports and more. *Video Notes* captures Tim's portrait techniques and the creative process behind each image. You will learn how specular highlights can contribute and help control the mood of an image plus useful lighting devices and their effects. Discover the tips and techniques on how to capture a feeling or emotion through the camera and how to promote a good atmosphere for your subjects.

NON MEMBERS PRICE $29.95
PROPASSPORT MEMBERS $26.95 DISCOUNT

USA credit card purchases / Call any time Toll Free 1-800-345-DEAN

FINELIGHT VIDEOS

neat stuff!

VOL.1 COMMERCIAL ILLUSTRATION/TABLETOP

The first segment of this tape explains how to control the total range of light on a highly reflective surface with a single light source. The second demonstrates neoning and multi-exposures.

ITEM **11001**

VOL.2 COMMERCIAL ILLUSTRATION/LARGE PRODUCTION

The "Heavenly Porsche" is detailed; from creating the mountain range and fog to building a lake in the studio. Collins then explains how to use time to create an illusion of speed with a motorcycle in the studio.

ITEM **11002**

VOL.5 COMMERCIAL PORTRAITURE/LOCATION

This video covers several environmental shoots including: executives on location, portraits on the beach utilizing the sun as a main light source, a glamour style look, and a relaxed outdoor shoot.

ITEM **11005**

VOL.6 GLAMOUR THROUGH CHROMAZONES

Through the use of CHROMAZONES, Collins uses a revolutionary method of producing precise background tones in glamour photography.

ITEM **11006**

VOL.9 TABLETOP CATALOG TECHNIQUES

Techniques in specular control are explained. Highly reflective surfaces of small products and the use of specular "gobos" are outlined in this informative volume, encompassing the same catalog as Volume 8. Also included is a special section on Dean's black and white film standardization especially suited for catalog photography.

ITEM **11009**

VOL.10 WEDDING SALES WITH MONTE ZUCKER

A photographic master & craftsman, Monte is known worldwide for his outstanding wedding photography and sales abilities. Dean Collins asks Monte Zucker the 20 most often asked questions in wedding photography.

ITEM **11010**

VIDEOS

VOL.3 CONTEMPORARY PORTRAITURE
Collins teaches lighting control through the proper use and understanding of reflective and incident light metering. He stresses new ideas in portraiture and predictability.

ITEM **11003**

VOL.4 COMMERCIAL PORTRAITURE/STUDIO
This tape details the use of an outdoor setting... indoors. Also, Collins again emphasizes the proper use of incident and reflective meters for complete control of your environment.

ITEM **11004**

VOL.7 TABLETOP THROUGH CHROMAZONE3
Creating illusion and dramatic impact is the subject of this tape as Collins takes the viewer through set building, composition, metering, and floating techniques. CHROMAZONES is detailed as it applies to tabletop images.

ITEM **11007**

VOL.8 FASHION/LOCATION
Total control of natural sunlight and the use of a portable strobe to simulate sunlight are detailed in this informative tape for a shopping mall catalog. Collins also explains the proper metering techniques for predicting every tone in a photograph.

ITEM **11008**

VOL.11 LOCATION/LARGE SET PRODUCTION
Collins and crew are documented as they light large area sets on location for a calendar produced for the U.S. Marines. This calendar, which features several models from *Playboy* and *Penthouse*. The lighting techniques necessary for this project range from direct sun to diffused sunlight as well as direct and diffused strobe lighting.

ITEM **11011**

NON MEMBERS PRICE
$39.95

PRO PASSPORT MEMBERS
$29.95
SAVE $10.00

Buy 9 Finelight Videos & Get 2 Free - Save $72.00

ITEM **11000**

USA credit card purchases / Call any time Toll-Free 1-800-345-DEAN

DEAN COLLINS LIVE

3-DIMENSIONAL CONTRAST

If you've ever seen photographer/lecturer Dean Collins' high energy seminar on "The Anatomy of a Working Studio", you've probably wished you could rewind and hear exactly what he said again and catch all the fine points you may have missed. Now you can! Every working photographer will benefit greatly from this concise program developed by the leader in photographic education. You can increase sales and profits with Collins' information on such topics as effective portfolio design, proven marketing techniques, black and white standardization, interior architectural lighting, tricks for innovative tabletop photography, indoor and outdoor fashion, and much more..

In this information-packed video, Collins explains in detail his theory of 3-D contrast and how an understanding of the control of light can lead to more effective visual communication. Through the use of detailed diagrams and stunning images, this tape reveals the keys to the complete control of photographic lighting. *Photographic Magazine* says: "It doesn't take long for the viewer to realize how precise Collins' methods are, and how complete his control is over the final image."

ITEM 11012

PRO PASSPORT MEMBERS DISCOUNT
NON MEMBERS PRICE $69.95
$59.95

ITEM 11013

PRO PASSPORT MEMBERS DISCOUNT
NON MEMBERS PRICE $29.95
$25.95

THE EDDIE ADAMS WORKSHOP

TAKE AN INSIDE LOOK AT THE FIELD OF PHOTOJOURNALISM.

This 60 minute video features premier photographers and editors in the field of photojournalism sharing their personal and professional experience with 100 new comers to the field.

Experience shooting on assignment as the students are led by photography team leaders such as Jodi Cobb, Mary Ellen Mark, David Alan Harvey and Gregory Heisler to name a few. All together, 200 people are brought together to participate in the exciting and unique workshop. "Barnstorm" captures the spirit, the enthusiasm, and camaraderie alive and thriving in photojournalism.

Eddie Adams, winner of the 1969 Pulitzer Prize and many other awards for photography, has covered wars, politics, sports, entertainment and high fashion. His photographs have appeared in many newspapers and magazines around the world.

BARNSTORM
FIRST EDITION

ITEM 18001

PRO PASSPORT MEMBERS DISCOUNT
NON MEMBERS PRICE $29.95
$19.95

EVERYTHING YOU EVER WANTED TO KNOW ABOUT...

METERING VOLUME 1

IN VOLUME #1 CANADIAN PHOTOGRAPHERS, DAVE AND MARK MONTIZAMBERT CLEARLY DEMONSTRATE:

- How and when to use an incident of reflective readings for accurate exposures every time.
- How to create your images within the tonal ranges of both photography and lithography (magazines, newsprint)
- How the zone system does and doesn't work.

ITEM 17001

NON MEMBERS PRICE **$39.95**
PRO PASSPORT MEMBERS **$29.95**
DISCOUNT

COLORZONING VOLUME 2

IN VOLUME #2 THE MONTIZAMBERTS PROVIDE THE KEY ASPECTS ON:

- How to set up and use your own color-zone system.
- How to create and predict backgrounds in color and in B&W with 100% accuracy.
- How to photograph glowing objects such as computers, LED readouts, liquor glows and flame.

ITEM 17002

NON MEMBERS PRICE **$39.95**
PRO PASSPORT MEMBERS **$29.95**
DISCOUNT

Dave & Mark Montizambert have operated their studio in Vancouver, Canada for over a decade. They studied under Dean Collins and are active photo-educators (teaching, lecturing, and writing).

This humorous 2 Volume series answers burning questions covering key aspects of photography.

BUY VOLUME 1 & 2 AND SAVE EVEN MORE.

Mark Dave
Montizambert

ITEM 17012

NON MEMBERS PRICE **$69.90**
PRO PASSPORT MEMBERS **$54.90**
DISCOUNT

USA credit card purchases / Call any time Toll-Free 1-800-345-DEAN

FILM & VIDEO LIGHTING TECHNIQUES

LIGHTING FACES

LIGHTING FACES is a comprehensive look at the art of lighting people. You'll learn how to use hard and soft light, and simple techniques for lighting different skin tones, people with eye glasses, and balding heads.

Discover which type of lighting instruments will give you the look you want, how to determine contrast ratios, and much more!

NON MEMBERS PRICE
$39.95

PROPASSPORT MEMBERS
DISCOUNT
$29.95

ITEM **20002**

ITEM **20001**

LIGHTING INTERVIEWS

LIGHTING INTERVIEWS provides detailed information for lighting a variety of interviews ranging from single-camera news and location setups to multi-camera studio programs. Learn to improve your EFP lighting, understand HMI (daylight balanced) lighting, and discover how to make your studio interviews look their best, regardless of the number of on-camera talent.

Bill Holshevnikoff has been lighting and shooting award winning broadcast, corporate and educational programming for over 13 years. Since that time, he has created stunning images for clients such as Newsweek, Buick, Sanyo, The BBC, American Airlines, ESPN, Ritz-Carlton Hotels, and many more.

As writer and director of more than a dozen Dean Collins educational videos, Bill has developed into one of the top educational video directors in the business. His experience as an educator also includes over 65 featured columns in popular publications such as American Cinematographer Magazine, Petersen's Photographic Magazine, and Video Systems.

The videos featured here are professionally produced tapes from the imagemakers for the imagemakers. These videos are an effective way for you to further understand the science, theory and application in producing professional images.

We are proud to offer these educational programs to Kodak ProPassport™ Members at a special price. For some of you, you may already be a member and are enjoying the benefits offered to you through the Kodak ProPassport™ program. Kodak ProPassport™ offers not only information on Kodak Professional products but also significant benefits via seminars, publications, videos, "800" numbers for technical support and hotel/shipping discounts.

Please take a few moments to become a part of this program. I believe that the Kodak ProPassport™ program is an excellent way to find out what is happening in our industry and to receive discounts on products that support you as a photographer.

Join Now! Write or fax to: ProPassport™ Network, Eastman Kodak Company, 343 State Street, Rochester NY 14650-0405, Department GN-DC. Fax: USA 716-724-5629 or contact your Kodak representative.

DEAN COLLINS

DEAN COLLINS PRODUCTIONS

USA CREDIT CARD PURCHASES - CALL ANY TIME TOLL-FREE

☎ 1-800-345-DEAN
3 3 2 6

OR CALL: USA 310-927-0419 / USA 619-543-9943
OR FAX YOUR ORDER: USA 310-927-3178

5- Digit Item No: QTY:	NAME OF ITEM	ITEM PRICE	TOTAL

☐ NTSC ☐ PAL PAL ORDERS - ADD $3.00 PER TAPE

	USA DELIVERY CHARGES ON ORDERS:	
Orders outside the USA shipped by airmail. First 15 items, add $30.00.	1-5 ITEMS................... $8.50 6-10 ITEMS...............$16.50 11-18 ITEMS.............$19.50	TOTAL AMOUNT OF ORDER
		SALES TAX (CA RES. ADD 7% to item TOTAL)
Larger orders subject to additional charges.		DELIVERY CHARGE
		SUBTOTAL
		TOTAL (U.S. Funds)

Other Shipping Requests - Please specify_____

PAYMENT OPTIONS:	
CHECK	Name_____
MONEY ORDER	Business_____
VISA	Mail/Ship Address_____
MASTERCARD	City_____State_____Zip/Code_____
	Country_____Fax: Country Code () City Code () Number_____
	_____Phone: Country Code () City Code () Number_____

☐ Yes, I'm eligible for the Kodak ProPassport™ discount prices listed.
 My Card number is _____

☐ Yes, I would like to become a member so I can receive the discounts, please send me the ProPassport™ application.

METHOD OF PAYMENT: (U.S. FUNDS ONLY, NO C.O.D) Please.

☐ Check ☐ Money order ☐ Visa ☐ Mastercard

Card No. _____ Expiration Date _____

Signature _____

SEND ORDER AND PAYMENT TO: IMAGE DATA

Please make checks and money orders payable to: P.O. Box 4459
Downey, CA 90241 U.S.A.

INTERNATIONAL VIDEO SUPPLY LISTING

We recommend that you photocopy this page and mail or fax your request to:

F A X :
IMAGE DATA, USA 619-543-9962

M A I L :
IMAGE DATA: 7515 Metropolitan Drive Suite 403, San Diego
CA 92108-4403 USA

Please send me the international video price list for:

C O U N T R Y :

☐ Australia ☐ Hong Kong

☐ Canada ☐ Korea

☐ New Zealand ☐ United Kingdom

☐ Other_____

Name _____

Business_____

Mail/Ship Address_____

City _____State _____Zip/Code _____

Country_____Fax: Country Code () City Code () Number_____

_____Phone: Country Code () City Code () Number_____

DEAN COLLINS PRODUCTIONS

USA CREDIT CARD PURCHASES - **CALL ANY TIME TOLL-FREE**

☎ 1-800-345-DEAN
3 3 2 6

OR CALL: USA 310-927-0419 / USA 619-543-9943
OR FAX YOUR ORDER: USA 310-927-3178

5- Digit Item No:	QTY:	NAME OF ITEM	ITEM PRICE	TOTAL

☐ NTSC ☐ PAL PAL ORDERS - ADD $3.00 PER TAPE

	USA DELIVERY CHARGES ON ORDERS:	
Orders outside the USA shipped by air-mail. FIrst 1-5 items, add $30.00. Larger orders subject to additional charges.	1 5 ITEMS.................. $8.50 6-10 ITEMS...............$16.50 11-18 ITEMS.............$19.50	TOTAL AMOUNT OF ORDER
		SALES TAX (CA RES. ADD 7% to item TOTAL)
		DELIVERY CHARGE
		SUBTOTAL
		TOTAL (U.S. Funds)

Other Shipping Requests - Please specify_____

PAYMENT OPTIONS: CHECK MONEY ORDER VISA MASTERCARD	Name_____ Business _____ Mail/Ship Address_____ City _____State _____Zip/Code _____ Country_____Fax: Country Code () City Code () Number_____ _____Phone: Country Code () City Code () Number_____

☐ Yes, I'm eligible for the Kodak ProPassport™ discount prices listed.

 My Card number is _____

☐ Yes, I would like to become a member so I can receive the discounts, please send me the ProPassport™ application.

METHOD OF PAYMENT: (U.S. FUNDS ONLY, NO C.O.D) Please.

☐ Check ☐ Money order ☐ Visa ☐ Mastercard

Card No. _____ Expiration Date _____

Signature
SEND ORDER AND PAYMENT TO: IMAGE DATA

Please make checks and money orders payable to: P.O. Box 4459
Downey, CA 90241 U.S.A.

VIDEOS

VIDEOS

VIDEOS

IMAGE DATA
P.O. Box 4459
Downey, CA 90241
USA